# PHOTOGRAPHY IN CALIFORNIA 1945 – 1980

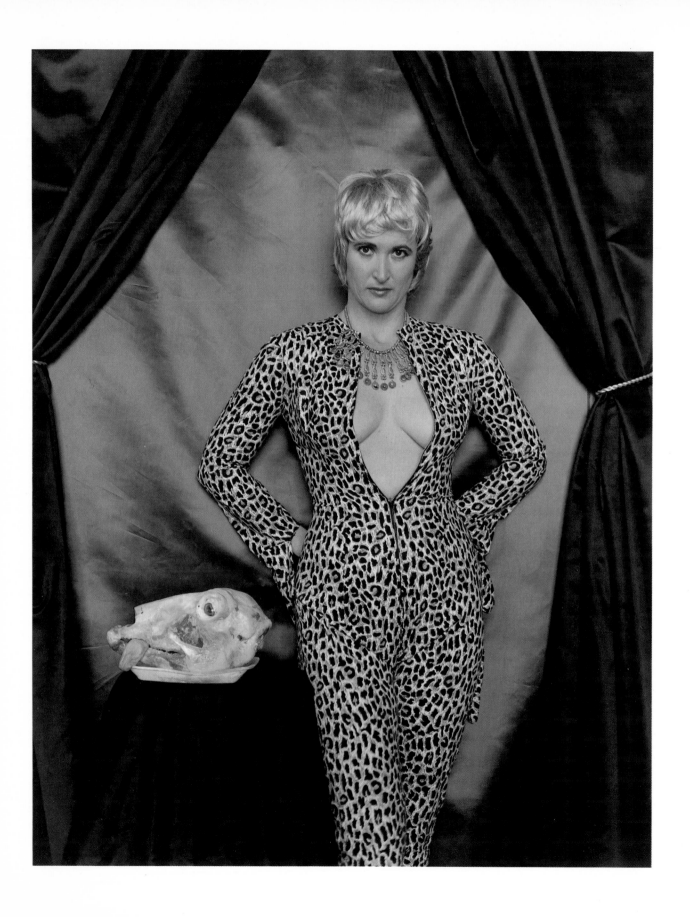

# PHOTOGRAPHY IN CALIFORNIA 1945 – 1980

LOUISE KATZMAN

FOREWORD BY HENRY T. HOPKINS

INTRODUCTION BY VAN DEREN COKE

HUDSON HILLS PRESS, NEW YORK, IN ASSOCIATION WITH THE SAN FRANCISCO MUSEUM OF MODERN ART

This book is published on the occasion of the exhibition *Photography in California: 1945–1980*, organized by the San Francisco Museum of Modern Art and generously supported by Leslie J. Kitselman and a grant from the National Endowment for the Arts. The San Franscisco Museum of Modern Art is supported in part by the San Francisco Hotel Tax Fund.

Schedule of the Exhibition:
*January 12–March 11, 1984*
San Francisco Museum of Modern Art

*April 6–June 10, 1984*
Akron Art Museum, Ohio

*June 28–August 19, 1984*
The Corcoran Art Gallery, Washington, D.C.

*September 7–October 21, 1984*
Los Angeles Municipal Art Gallery,
Barnsdall Park

*November 9–December 30, 1984*
Herbert F. Johnson Museum of Art,
Cornell University, Ithaca, New York

*February 15–April 14, 1985*
The High Museum of Art, Atlanta

*June 7–August 4, 1985*
Museum Folkwang, Essen, West Germany

*September 6–November 3, 1985*
Musée National d'Art Moderne,
Centre Georges Pompidou, Paris

*January 8–February 24, 1986*
Museum of Photographic Arts, San Diego

Frontispiece:
Judy Dater, *Woman in Leopard Suit,*
1982/1983

Cover photographs:
*Front:* Jo Ann Callis, *Man at Table,* 1977
*Back:* Robert Heinecken, *Lessons in Posing Subjects/Simulated Animal Skin Garments,* 1982

First Edition

© 1984 by the San Francisco Museum
of Modern Art
Van Ness Avenue at McAllister Street
San Francisco, California 94102-4582

Published in the United States by
Hudson Hills Press, Inc., Suite 301,
220 Fifth Avenue, New York, NY 10001.
Distributed in the United States
by Viking Penguin Inc.
Distributed in the United Kingdom, Eire,
Europe, Israel, the Middle East, and South
Africa by Phaidon Press Limited.
Distributed in Australia, New Zealand,
Papua New Guinea, and Fiji by Australia
and New Zealand Book Co. Pty. Limited.

Editor and Publisher: Paul Anbinder
Copy Editor: William Dyckes
Designer: James Wageman
Composition: U.S. Lithograph Inc.
Manufactured in Hong Kong by Mandarin
Offset Marketing (H.K.) Ltd.

Library of Congress
Cataloging in Publication Data

Katzman, Louise, 1949–
Photography in California, 1945–1980

Bibliography: p.
Includes index.
1. Photography—California—History.   I. San
Francisco Museum of Modern Art.   II. Title.
TR24.C2K37   1984   770'.9794   83-17170
ISBN 0-933920-45-8

# CONTENTS

# LENDERS TO THE EXHIBITION

**Private Lenders**

Michael Bishop, Boston

Ellen Brooks, San Francisco

Jerry Burchard, San Francisco

Jo Ann Callis, Culver City,
California

Linda Connor, San Anselmo,
California

Eileen Cowin, Venice, California

Doris and Darryl Curran,
Los Angeles

Judy Dater, San Anselmo,
California

Joe Deal, Riverside, California

John Divola, Venice, California

Robert Fichter, Tallahassee, Florida

Hal Fischer, San Francisco

Vida Freeman, Northridge,
California

Anthony Friedkin, Santa Monica,
California

Jack Fulton, San Rafael, California

Phillip Galgiani, San Francisco

Jim Goldberg, San Francisco

Judith Golden, Tucson, Arizona

John Gutmann, San Francisco

Robert Heinecken, Los Angeles
and Chicago

Harvey Himelfarb, Davis, California

Pirkle Jones, Mill Valley, California

Barbara Kasten, Los Angeles

Victor Landweber, Los Angeles

Richard Lorenz, San Francisco

Gregory MacGregor, Oakland,
California

Mike Mandel, Santa Cruz,
California

Kenneth McGowan, New York

Jerry McMillan, Pasadena,
California

Roger Minick, Vallejo, California

Carolyn and Virgil Mirano, Venice,
California

Richard Misrach, Emeryville,
California

Jack Moore, Los Altos,
California

Patrick Nagatani, Los Angeles

Arthur Ollman, San Diego

Bill Owens, Livermore, California

Donna-Lee Phillips, Bodega,
California

Leland Rice, Inglewood, California

Jackie and Manny Silverman,
Beverly Hills, California

Larry Sultan, Greenbrae, California

Lew Thomas, San Francisco

Todd Walker, Tucson, Arizona

Jack Welpott, San Francisco

Henry Wessel, Jr., Point Richmond,
California

Don Worth, Mill Valley, California

Max Yavno, Los Angeles

**Institutions and Galleries**

Castelli Graphics, New York

Charles Cowles Gallery, New York

Delahunty Gallery, Dallas

Foster Goldstrom Fine Arts,
San Francisco

Fraenkel Gallery, San Francisco

Grapestake Gallery, San Francisco

G. Ray Hawkins Gallery,
Los Angeles

Museum of Contemporary Art,
Los Angeles

San Francisco Museum of Modern
Art

Tortue Gallery, Santa Monica,
California

Lewis Baltz

Ruth Bernhard

Michael Bishop

Ellen Brooks

John Brumfield

Wynn Bullock

Jerry Burchard

Jo Ann Callis

Linda Connor

Eileen Cowin

Robert Cumming

Darryl Curran

Judy Dater

Joe Deal

John Divola

Robert Fichter

Hal Fischer

Robbert Flick

Vida Freeman

Anthony Friedkin

Jack Fulton

Phillip Galgiani

Jim Goldberg

Judith Golden

John Gutmann

Robert Heinecken

Harvey Himelfarb

Pirkle Jones

Barbara Kasten

Victor Landweber

Gregory MacGregor

Mike Mandel

Kenneth McGowan

Jerry McMillan

Roger Minick

Richard Misrach

Patrick Nagatani

Arthur Ollman

Bill Owens

Donna-Lee Phillips

Leland Rice

Larry Sultan

Edmund Teske

Lew Thomas

Todd Walker

Jack Welpott

Henry Wessel, Jr.

Minor White

Don Worth

Max Yavno

*Photography in California: 1945–1980* presents the work of fifty photographers of varying degrees of national recognition who have chosen to live and to work in California during the past several decades. Due to the introduction of new cameras and films, as well as better educational facilities, there has been an international explosion of photographic activity since the end of World War II. Nowhere has this explosion been more dramatically felt than in California, where a strong heritage of photography had been established before the turn of the century.

The San Francisco Museum of Modern Art has been collecting photographs since the 1930s, under the guidance of John Humphrey and, more recently, the directorship of Van Deren Coke. Over one-third of the nearly two hundred and fifty prints in the exhibition have been drawn from the museum's collection.

The exhibition was conceived and curated by Louise Katzman, Assistant Curator, as her first full-scale solo enterprise. Her success and the interest in California photography can be judged by the fact that the exhibition will travel to six other museums in the United States as well as to the Museum Folkwang in Essen, West Germany, and the Musée National d'Art Moderne, Centre Georges Pompidou, in Paris— the most extensive tour of any exhibition originated by the staff of the San Francisco Museum of Modern Art. Louise Katzman's commitment to the project was tested when, in the middle of the effort, she gave birth to her first child—a daughter, Chloe—and, two months later, accompanied her husband, Ned Kurabi, when he assumed a new position in Saudi Arabia. She has returned three times during the past year to pursue her research and arrange for the publication of the catalog so that the exhibition could open on schedule. Such dedication is to be commended.

Henry T. Hopkins, *Director*

The realization of a project of this magnitude could not have been possible without the assistance and support of a great many people, all of whom I would like to thank. I would especially like to extend my gratitude to those who graciously allowed me and my colleague Irene Borger to interview them and to use the information from the transcripts in the text of this book. To the artists in the exhibition I wish to offer my appreciation for the patience and assistance which this complex exhibition demanded. To those artists I was unable to include because of space limitations, but who generously sent viewing material, I offer my thanks and regrets.

My colleagues at the museum were generous and essential to the accomplishment of the project in many ways. First and foremost, I would like to thank Van Deren Coke, Director, Department of Photography, for his initial confidence in my ideas, which directed my thinking toward a book and major exhibition. Without Van's persistent professional and personal encouragement, his invaluable criticism, and knowledgeable historical perspective, this project would not have evolved as it has. My gratitude cannot equal his steadfast inspiration during some difficult professional and personal situations. Henry Hopkins, Director of the Museum, heartened me to pursue this idea as an exhibition and continually provided reassurance and personal support. Karen Tsujimoto, Curator, offered welcome words of encouragement at crucial times.

Extenuating personal circumstances forced me to rely heavily on the capabilities of Patti Carroll, Curatorial Assistant, Department of Photography, and Anne Munroe, Curatorial Assistant, to handle the difficult and multifaceted in-house organizational details. Patti, working with unimaginable diligence and dedication, transcribed the artists' interviews and took on the enormous task of communicating with each artist for the necessary information. She over-

saw getting photographs for the book, matting and framing, and produced the checklist. Anne, whose good nature became so welcome during the periods of intense pressure, proved invaluable in coordinating all aspects of the copy for the book. She also gave thoughtful editorial comments and insightful ideas on the structuring of the copy, as well as putting together the bibliography and artists' biographies.

Debra Neese, Associate Registrar, took on the formidable task of coordinating the transportation of works to be viewed, as well as the national and international circulation of the exhibition. Carol Rossett assisted Debra with great spirit and competence, and sent out loan forms to the artists. Jeanne Collins, Public Relations Director, and her assistant Kytti Morgan did a superb job on that aspect of the exhibition, both locally and nationally, as did Robert Whyte, Director of Education, and his assistant Beau Takahara in organizing related educational activities. Julius Wasserstein and his crew, as always with grace and swiftness, facilitated the installation of the photographs. Suzanne Anderson, Graphic Designer, imaginatively produced the exhibition poster, invitations, and signage. Cecilia Franklin, Controller, and Toby Kahn, Bookshop Manager, offered much-needed advice concerning the financial aspects of the exhibition and book, respectively. I would also like to thank Jackie Nemerovski, Associate Director for Development, and Beverly Buhnerkempe, Senior Assistant Controller, for their professional support at various times during this undertaking. Diana duPont, Research Assistant, was both gracious and helpful in coordinating all matters related to the works included in the exhibition from the Museum's permanent collection. Diana was assisted at various times by volunteers and interns Sarah Spencer, Sara Leith, Arthur Fox, and Mary O'Toole.

Others outside of the museum were essential to the success of the exhibition. Irene Borger thoughtfully and diligently interviewed artists and provided insights, and helped to sustain my energy both professionally and personally. Paul Anbinder, President of Hudson Hills Press, expressed enthusiasm early on and was sensitive to the needs of the project. Paul Karlstrom, West Coast Regional Director of the Archives of American Art, Smithsonian Institution, generously arranged for financial assistance for the transcription of several taped interviews. He also initiated broader accessibility for some of the transcribed tapes by requesting that they be donated to the Archives holdings. I would also like to thank Leslie Kitselman for her generous financial contribution and spirited interest. The National Endowment for the Arts also provided financial assistance.

There were numerous volunteers who gave of their time. In particular I would like to thank Robin Venuti, a former staff member, Marriam Cramer Ring, and Fran Shalom for providing me with ample research material. Mary Pezzuto, Kathy Butler, Terry Gerald, and Debby Lawn also did a fine job in researching the period. Other volunteers who worked in a variety of capacities, so important to an exhibition of this scope, include Richard Kemp, Billy Paul, Anne Miller, and Carol Singer.

I would also like to thank my brother David Katzman for his keen editorial comments. Support from my friends Lisa Bayne, Trisha Garlock, Nona Ghent, Samira and Remo Morelli, Jill and Dennis Norman, and Will and Diane Washington was greatly appreciated. Brenda Bath ably typed the first draft of the manuscript and offered warmhearted aid. My parents, Henry and Berdie Katzman, as always, provided an incredible amount of psychological and physical assistance, from taking care of my new baby and cooking dinners to just being there during some rather difficult times.

To my husband Ned Kurabi, I dedicate this book. He weathered trying periods as a result of my constant involvement in this huge project at a time when major changes were taking place in our personal lives. His confidence and assistance were remarkably unwavering.

Louise Katzman, *Assistant Curator*

This overall review of the post-World War II history of photography in California gives us a better understanding of the complex factors that shaped the imagery and ideas that prevailed during the period. Curator Louise Katzman has been able to weave back and forth successfully through the maze of contrasting directions followed by California's large and very active photography community. Interpretations of the roles of individuals as well as the evolution of support systems pin down some of the reasons why photography developed quite differently in the West than it did in the East. Katzman tells us of significant influences and attitudes, fostered by the California environment. She also deals with the major personalities, and shows how like-minded photographers grouped together to gain attention and then, under the pressures of new challenges, dissolved their associations and appeared on the scene as influential individuals.

It is interesting to note that, unlike their New York City-based counterparts, photographers in California rarely seem to have thought of their cameras as a means of bringing about social change. Subjects dear to Easterners, such as derelicts on sidewalks or families gathered on the steps of their homes, are rarely seen in the 1960s and 1970s work of California photographers. The California sunshine seems somehow to purify the environment, however tawdry it might be. There is a sense of optimism in pictures made in California, not bleakness of spirit or concern that society will forget its weaker members.

Katzman has succeeded in conveying the verve and excitement of the period while cataloging the events that caused the ferment. The freewheeling quality of life in California had as much influence on one kind of photography as the dramatic landscape had on another. While concentrating on the development of particular styles, she has revealed the essential factors that led to the special evolution of creative photography in the state. There was in San Francisco and Los Angeles a mutual concern for photography as a means of personal expression. The sense of a shared community of ideas has changed as photography became a commodity and teaching positions diminished in number. A very competitive and quarrelsome quality replaced the feeling of camaraderie that had prevailed in what is now looked upon as a Golden Age. How this took place figures in the story Katzman tells.

A history of the effects of academic ease gives her report of the college and university support of photography a double-edged quality, for it can be surmised that patronage of this kind has had negative as well as positive aspects. What matters today is the degree of parochial conservatism this support and the dictates of the marketplace are having on younger photographers. There is no less interest in photography today—quite the contrary—but fewer "guerrillas" are using the camera to test the medium's effectiveness as a means of challenging entrenched ideas.

The work of both Minor White and Robert Heinecken stands like a pair of bookends holding erect a varied library of ideas about the use of photography in California as a medium for artistic expression. On the right is White, with his mysterious landscapes and poetic pictures of people, and on the left is Heinecken, with his tough and pulsating images— each with a commitment to his own aesthetic.

White, Bullock, Worth, and others of their persuasion sought and seek to create an equivalent to classical music and poetry. Heinecken, Darryl Curran, and even Judith Golden—with her impish self-portraits in the dozen roles she likes to assume—are also related to music and poetry; in this case to the dissonant voices of rock and the sounds and words of Allen Ginsberg. White and Bullock were, and Worth is,

extremely exact-minded photographers. These three, among a number of other followers of Ansel Adams and Edward Weston, have produced clear, resonantly poetic images that encourage us to wander off in our imagination on fanciful journeys. They furnish our mundane world with places where there can still be a believable mythology, for they link an objective love of nature with visionary evocations of the wonderland of plants, the sea, rocks, and clouds.

Related, but much more attuned to contemporary concerns, is the work of Richard Misrach. His light-blasted cactus desertscapes and grand-vista southwestern landscapes nevertheless maintain the romantic aura of the West. White and company reassure those who are timid, whereas Heinecken disturbs many people by the rawness of his pictures. He is a kind of beer-hall leader, while White and Bullock have entered the pantheon as sanctified gurus. Heinecken's crowd is dedicated to pulling up roots rather than celebrating the trees which grow from them. Heinecken has an especially canny understanding of the role of the media in determining the views of the general public. With his insights and abilities to act on his responses, he has tapped this source of imagery and in doing so has changed the direction of photography not only in California but also throughout the country.

Then there are those who have remained calm in the face of the California ferment. Robbert Flick, in his block-by-block, brittle, and understated reports of a city's layout, and Lewis Baltz, in his precise series on new constructions, deal with ideas about today's socio-systemic world in which land values shape urban geography, building design, and eventually the lives of people. Baltz's restraint and reserve separate him from Joe Deal, whose intent is to focus our attention on the clutter of cityscapes. Finely tuned geometry seems to be his game, but this is a facade. A close reading of his images and their titles suggests that his pictures would be suitable for inclusion in a time capsule to tell us about the strange structures man has built.

Some of the other idea people—Robert Cumming, Hal Fischer, Mike Mandel and Larry Sultan, Donna-Lee Phillips, and Lew Thomas—though they all make straight photographs, have escaped with wit and insight from timeworn traditions by using the camera to test the ability of words or literary concepts to make connections that are more meaningful than would be possible through either medium alone.

Those who still believe that photographs can help change society think these idea-people fiddle while Rome burns. Pirkle Jones is one of the few represented in Katzman's selection who still makes documents of a social nature. Jim Goldberg also documents the plight of people, but in a special way. He has truly touched a raw nerve with his heartfelt, simple pictures which cause us to pause and ponder the dreary existence of low-income people living in cheap hotels in San Francisco. More in keeping with today's sensibilities are Gregory MacGregor's humorous pseudotechnical pictures and Patrick Nagatani's Cibachrome, fantasylike *Star Wars* views of the next century, which show the effects of the military-industrial complex on the country.

Two of the state's senior photographers who made a real contribution to the acceptance of serious creative photography in California are Edmund Teske and Todd Walker. Early on they adopted solarization to convey sensory overtones, well before blatant sexuality became commonplace. It is good to see Katzman's recognition of the role these men played, for they were inspirations to younger Southern California photographers because of their use of unconventional processes and their willingness to share what they knew about technical matters.

Psychology and perception became the focus of much innovative photography in California in the past decade and a half. Judy Dater represents this direction with her psychological self-portraits, made with trepidation at the age of forty. This direction is also represented by other means: Ellen Brooks, using miniature plastic soap-opera people, and Eileen Cowin, with staged moments from life's everyday tragedies and triumphs, have created narrative pictures that relate to film sequences in Hollywood grade-B sitcoms.

The recent pictures Katzman has selected seem to indicate a growing involvement with imagery that attracts attention through an emphasis on color outside of its descriptive role. Add this to another loud message, that content has now become for photographers the juxtaposition of forms with forms and new perceptions of forms in space, and we have a profile of the major concerns of many of the younger, venturesome photographers in California. While not ex-actly radical today, in overall artistic terms, the work of photographers dealing with such problems is innovative in comparison to what is being done in other parts of the country.

The works reproduced here merely indicate the great variety of work that has been associated with California photography in the recent past and which continues today. As we sense that the tried-and-true directions are in danger of being eclipsed, we can also see a susceptibility to newness for its own sake.

Katzman has selected fifty photographers. While one may quarrel with her choices, we learn a great deal from them about what made photography in California tick with a different rhythm. We also get a preview of what is in store for creative photography during the next decade.

Van Deren Coke, *Director, Department of Photography*

# PUSHING THE BOUNDARIES

## BY LOUISE KATZMAN

John Gutmann, *"Time Flies . . . Save Now,"* 1947/1980, from the series *Documents of the Street*, gelatin silver print, 10¼ × 11¹⁵⁄₁₆″ (26.1 × 30.4). Courtesy of the artist

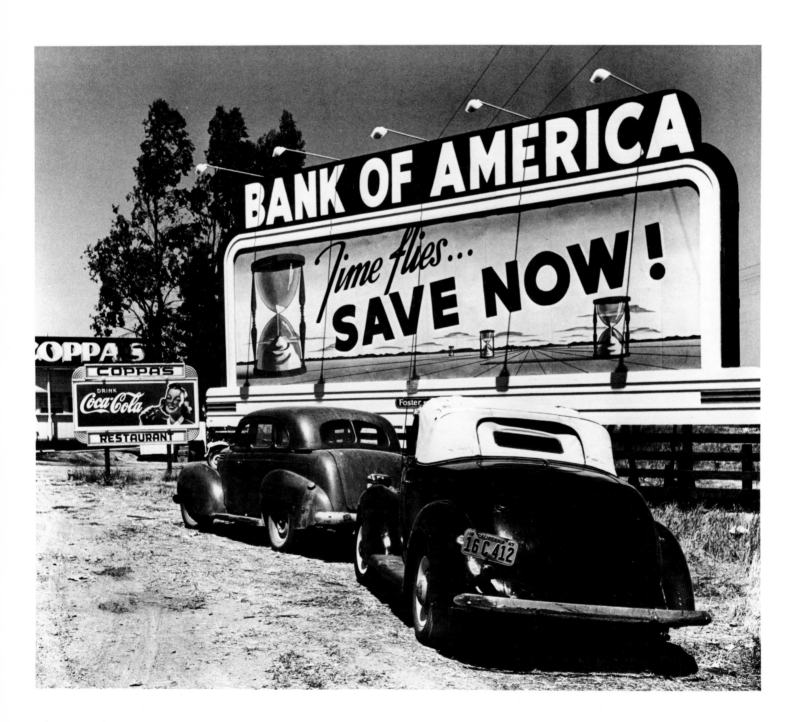

# THE SCHOOLING OF PHOTOGRAPHY:

## 1945–1959

In the years since the end of World War II, photography in America has moved away from the formalist tenets which view the camera as a machine for recording events and representing reality, and embraced a far broader interpretation of the medium as a form of artistic expression. California, largely through its numerous college and university photography programs, has been at the forefront of this development, providing an exceptionally fertile environment for photography to develop as an art form by encouraging the acceptance of new approaches, cultivating a large number of photographers, and training a knowledgeable audience.

Political, social, and cultural events that took place after the war played an important role in shaping the California milieu. To better understand the circumstances that have made the Golden State such a productive region in photography, it might be helpful to review quickly the high points of America's history during this period.

The Second World War had made Americans aware of the need to develop a global view. Along with jubilant feelings that stemmed from their country's triumph abroad, they felt a growing uneasiness over the destructive potential of their weapon of victory, for the atomic bomb had the power to annihilate whole cities. Pride in the country's new position of strength in world affairs was balanced by a recognition of the difficulties and responsibilities that went with world leadership. The Soviet Union had continued to expand its influence in Europe, and the threat became inescapably obvious when the Russians exploded their first atomic bomb in 1949. The Cold War had begun —and though it would be far less costly in terms of human life, it was as serious to America's citizens as the previous one.

The Cold War dominated not only American diplomacy but everyday life as well. The media interpreted the statements of noted scientists to mean imminent doom, and politicians played on the general uneasiness. When North Korea invaded the South, a fear of Communist domination propelled the nation into sending American troops to foreign shores once again. On the home front, Senator Joseph P. McCarthy launched a witch hunt to purge purported Communist influences from every aspect of American life. His overzealous and often emotionally charged accusations had a devastating effect on both personal liberty and artistic growth.

A new spirit began to prevail in the mid-fifties. With the Korean War over and McCarthyism losing its hold on the country's mentality, Americans were ready for a change. They wanted to erase all thoughts of war and the insecurities of a tenuous peace. The shortages of World War II were gone and the economy was booming. Postwar affluence had created a middle class with an unprecedented purchasing power and desire to consume. The forty-hour work week became the rule, leaving more time for leisure activities. There was also a significant increase in the birthrate.

Interest in photography in the United States was influenced both directly and indirectly by the war. For one thing, it had promoted technological advances in equipment and films. Japan had made notable improvements in the design of lenses, and Japanese business made good use of these in the development of its camera industry after the war. Sales to American servicemen in that country helped spread the word of improved products, as did professionals like W. Eugene Smith during World War II and David Douglas Duncan during the Korean War, who used lightweight equipment for photo-reports seen in newspapers and magazines. As early as 1956, approximately four-and-one-half million dollars worth of Japanese cameras were being imported by the United States.[1]

Among the innovations that stimulated mass interest in photography in the years after the war was the instant-picture process marketed by the Polaroid Corporation in 1948. The immediate production of the print had great appeal to the amateur photographer. Other improvements, including films that required less light, automatic exposure meters, and simpler printing systems, helped begin a shift from black-and-white to color and from color transparencies to prints.

Picture magazines helped acquaint the public with the medium. According to photographer Ruth Bernhard:[2]

> Certainly *Life* and *Look* magazines had an influence on the public's craving for visual images and interest in photography in the 1950s. Both magazines were important in developing an audience for photography.

Television, which became readily available by 1950, had great mass appeal and played a role in encouraging interest in visual imagery. By watching variety and comedy shows and real-life situation dramas, viewers became accustomed, on a daily basis, to observing the world around them through the picture medium.

The most direct influence on the growth of photography in the postwar years may well have been the Servicemen's Readjustment Act, commonly known as the G.I. Bill. By enabling veterans to attend college at nominal cost, the government triggered a rapid and extraordinary growth in the student population, which was especially significant in California. This in turn encouraged a variety of course offerings. Photography, which had not been frequently taught even in art schools before the war, was one of the new arrivals— as were the people who were hired to teach it. Jack Welpott, a veteran who became both photographer and teacher, observed:[3]

> After World War II the universities and colleges expanded like mad and, of course, they needed courses and faculty to deal with this. Photography snuck in the back door. . . . Before World War II no college or university would have hired a photographer to teach a photo course.

It is through educational institutions such as the ones

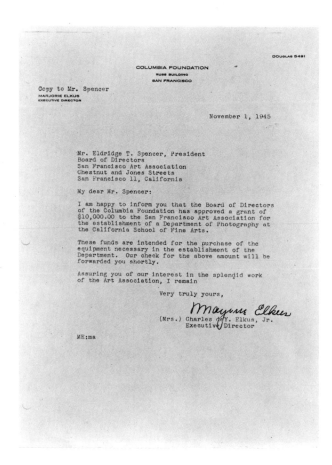

Letter dated November 1, 1945, approving initial $10,000 grant to establish a department of photography at the California School of Fine Arts (now the San Francisco Art Institute)

in California which will be discussed here, that photography as a form of artistic expression came to have meaning for a larger audience. During the early years of the postwar period, however, there was a distinct separation in the approaches to teaching photography in the northern and southern regions of the state. Schools in the south tended to concentrate on vocational training, whereas in the north, both creative pursuits and professional proficiency were emphasized.

This difference may have been the result of the strong tradition of creative photography in the northern part of the state. As early as 1922 Edward Weston had begun to establish the basis of what would come to be known as the "West Coast Style"—an approach that stressed fine-print quality, sharpness of detail, and realism. Weston's use of the medium was distinct from the popular pictorialist manner of softly focused and grainy pictures that narrated imagined stories. His vision was reaffirmed in 1932 by the formation of Group f/64 by a number of Northern California photographers who shared his tastes. They

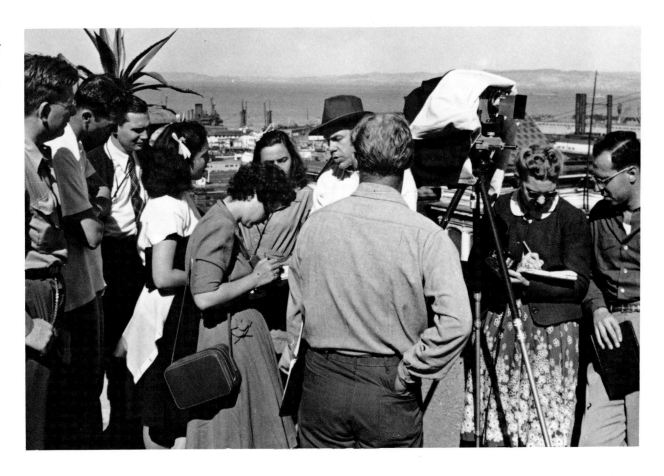

achieved their goals by using large-format cameras that produced negatives of at least four by five inches, maximizing the depth of focus by stopping the lens down to a very tiny opening (usually f/64), and tending to select subjects such as landscapes and still-life objects that would remain motionless, thereby enabling the photographer to control closely the angle and intensity of the light during the exposure.

One of the first and most important institutions to offer a program in photography in Northern California was the California School of Fine Arts (CSFA).[4] In 1944, Ansel Adams, who had been a member of Group f/64, was invited by the school's wartime president, Eldridge T. Spencer, to outline a plan for a department of photography, "as part of a plan to update an old, comfortable academic private art school."[5] By the fall of 1945 Spencer had informed Adams that the Columbia Foundation had given the school a $10,000 grant to set up the department.

The program was divided into lectures, shoot-ing sessions, darkroom time, and critiques, but its principal feature was Adams himself. Pirkle Jones, who became a student and later a teacher at the school, recalls that:[6]

Word was out that Ansel Adams was forming a department of photography. . . . I heard about this back East. I was very excited about coming out here to go to school.

In the summer of 1946, shortly after the department was launched, Adams hired Minor White as an instructor. White had studied art history at Columbia University and worked for a year with Beaumont and Nancy Newhall and as a photographer at the Museum of Modern Art in New York. His ideas had been greatly influenced by conversations with Alfred Stieglitz, one of the twentieth century's greatest photographers. Stieglitz had been an early advocate of "straight photography," which presents objects in a direct and unadorned manner—often to emphasize

their monumentality and presence. To his own work, White applied Stieglitz's theory about "equivalents," in which the photograph of an object suggests a state of mind or an emotional state. White believed that photography should be both a means of personal expression—a way for photographers to discover themselves through the camera—and a form of communication. As he later described his approach to teaching, "the student was encouraged to see privately and at the same time driven to enact the ideal of professionalism."[7] After Adams moved into an advisory capacity, White became the director of the department, remaining at the school until 1952, when he joined the curatorial staff of George Eastman House in Rochester, New York.[8]

While it was not the first curriculum offered in the study of photography, the program at CSFA was unique at that time because it stressed creativity as well as technical proficiency. Adams taught his Zone System, which involved "previsualizing" the placement of the entire range of tones in the final print and selecting the most effective exposure and development times. The implementation of such sophisticated techniques enabled students to present work that was professionally executed. At the same time, mainly due to White's presence, students at CSFA learned to appreciate and use the camera as a means of individual interpretation.

A number of the Bay Area's important photographers were invited to appear as guest lecturers —among them f/64's Imogen Cunningham, documentary photographer Dorothea Lange, and, of course, Edward Weston. Students remember the highlight of the academic year as having been the five-day journey to Point Lobos in the Carmel area, which included a visit with Weston in his studio.

In the same year that Adams and White began teaching at the School of Fine Arts, another important educational program in photography began to take shape at San Francisco State College.[9] John Gutmann, who had been teaching painting and drawing there for several years, had long since recognized the need for courses in photography:[10]

I wanted a photography department within the art department. . . . I came back from the war more convinced than ever that photography and . . . cinema were potentially the most important media in

picture-making of this century. . . . But there was a certain amount of resistance in terms of financial matters, and there were no facilities at the time. I had to work at the old campus in a lab which was really the darkroom for the physical-education people when they took X-ray pictures of all the students.

Originally trained as a painter in his native Germany, Gutmann had taken up photojournalism as an occupation shortly before he arrived in the United States in 1933. Viewing America with a fresh and inspired eye, he was able to reveal aspects of American life that had been overlooked, seeing the cities in a way that his American colleagues could not. "In their minds, it was a familiar thing," he has said. "To me it was exotic and fascinating."[11] Gutmann had a broad view of photography, and he approached the teaching of it as an exciting visual art with unlimited possibilities. Indeed, he became so involved with teaching that his own work did not gain national recognition until the seventies.

Only one or two classes in photography were taught at the college at first, but by 1949 a full master's program was offered.[12] Because of the popularity of the program, Gutmann was able to design excellent darkroom facilities when the school moved to its new campus in 1952.

In Southern California the educational institutions had a different orientation, concentrating on teaching photography as a means of making a living. The different emphasis was partly a result of the greater number of commercial jobs available to photographers in Los Angeles, where the postwar boom in the film and, later, the television industries opened many new possibilities. Moreover, the warm climate, the increasing number of jobs, and the appeal of the region encouraged a general population growth that created more work for photographers, who in turn needed to improve their skills.

Todd Walker, a successful commercial photographer who later dedicated himself to more creative work, remembers that the opportunities for study were rather limited:[13]

The two schools that were available in Southern California taught how to become a professional photographer. One was Art Center,

which was in L.A., and close enough so that I could get to it. The other was William Mortensen's at Laguna Beach. . . . I went to Art Center and took a six-week course which was . . . designed for people who were working in the field to update what they were doing.

The Art Center School of Design remained the most important institution for the instruction of photography in Southern California until the early sixties.[14] One of its prime attractions was Will Connell, who had helped found it in 1931 and continued to teach there for the next thirty years. A highly respected commercial photographer who worked in Hollywood, he had a flair for the dramatic and an imaginative eye.

Connell was a devoted teacher and a master of technique, but professional facility was not the only goal at the Art Center. Teachers Fred Archer and, in particular, Edward Kaminski, encouraged an understanding of the creative potential of the medium. Kaminski had studied in Europe and had been influenced by the major art movements there, particularly Surrealism. His teaching was an inspiration to many students, among them Wynn Bullock, who attended the school in the late thirties and attributed much of his interest in experimentation to Kaminski's early support. Todd Walker remembers Kaminski's viewpoint:[15]

> It was the idea of really exploring what you were doing, and devoting yourself to it . . . before you attempted to represent it in some way. Also the idea of experimenting. The print was not a precious thing. You could go in and tear it apart any way you wanted. He had an openness to exploration. He introduced me to the idea that there was something other than calendar art.

The Mortensen School of Photography in Laguna Beach was founded in 1932 and continued to train photographers until 1955. William Mortensen, a skilled craftsman, had a taste for dramatic subject matter, and frequently dressed his models in elaborate costumes to portray allegories or great events from history. Mortensen used a variety of techniques to add color to his portraits, including the application of pigments by hand—an unusual approach for a photographer at that time. During the thirties Mortensen supported his pictorialist style publicly in

a running debate in the pages of *Camera Craft* magazine, opposing Edward Weston's and Ansel Adams's endorsement of unmanipulated imagery.

While photography students on the Pacific Coast were being taught the rudiments of making a fine print, and still lifes and landscapes tended to be their primary subject matter, photography on the Atlantic Coast was far more spontaneous and documentary in nature. Although the differences in approach are generally accepted as an East Coast versus West Coast distinction, it is much more accurate to narrow it down to New York versus San Francisco. Photographers in Southern California concentrated on commercial work, and only their Bay Area colleagues were still practicing the concepts of Group f/64.

Stylistic differences, however, may be partially attributed to the dissimilarities of the landscapes on the two coasts. Ruth Bernhard, who was born in Germany and moved to California in the 1930s, has observed:[16]

> In the West, the creative photographer is influenced by the sea, the mountains, and the landscape in general. And on the East Coast, particularly [for] New York photographers, the influence is the mass of humanity and tall buildings.

The geographic location of each region may also have contributed to stylistic differences. This seemed evident during and after the Second World War. The newspapers and the picture magazines in New York displayed the horrors of the war with greater frequency than their counterparts in the West, and also published images of the daily activities of citizens in wartime. Emotions may have been intensified in the East by the first-hand accounts of many Europeans, among them a number of well-known artists, who had been moving into New York since the thirties in order to escape Hitler and the war. In contrast, West Coast photographers at this time continued to concentrate mostly on depicting the peaceful and appealing landscape or motionless objects. It appeared as if these photographers were physically and ideationally distant from the realities of the war.

There was also a difference in the attitude on the part of museums. Museums in New York had begun to take photography seriously much earlier than

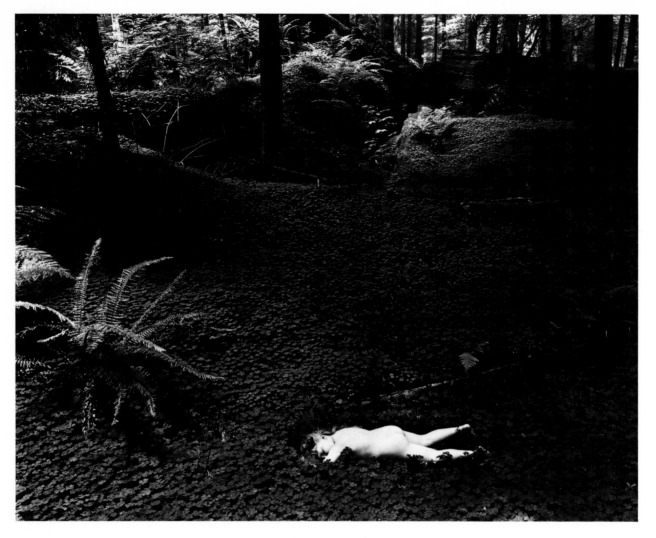

Wynn Bullock, *Child in the Forest*, 1954, gelatin silver print, 7½ × 9½″ (19.1 × 24.2). San Francisco Museum of Modern Art, Anonymous Loan. This was the most popular photograph in the Museum of Modern Art exhibition, *The Family of Man*

museums in California did, and their encouragement and exhibitions proved to exert another influence on East Coast styles. The Museum of Modern Art was the most important catalyst of the time, and Edward Steichen, the director of the department of photography and the curator of exhibitions, had a great effect on photographers and public alike. This is most clearly seen in his 1955 landmark show *The Family of Man*, which brought a new respectability to photojournalism and fostered a popular view of the photograph as a form of mass communication about the social habitude of man. Through the exhibition and the extremely popular book that recorded it, Steichen made the public aware of the great visual impact and emotional power of photography. But although much credit is due Steichen for increasing the mass appeal of the medium, it would be twenty years before the

public would come to appreciate photography as a fine art.[17]

No curator or museum director exercised a comparable force on the West Coast. In fact, the only major public influence in the fifties was the magazine *Aperture*, which began under Minor White's editorship in San Francisco in 1952. It was the first critical journal devoted to photography since Stieglitz published *Camera Work* from 1903 to 1917. *Aperture* became the principal forum for the discussion of the differences between the attitudes of the two regions and, in the words of one critic, "laid the groundwork for wider acceptance of photography as an art form."[18]

White's philosophical and aesthetic interests were in opposition to the humanistic concepts that Steichen stressed in *The Family of Man*. As Jonathan Green noted, instead of popularizing photography, White

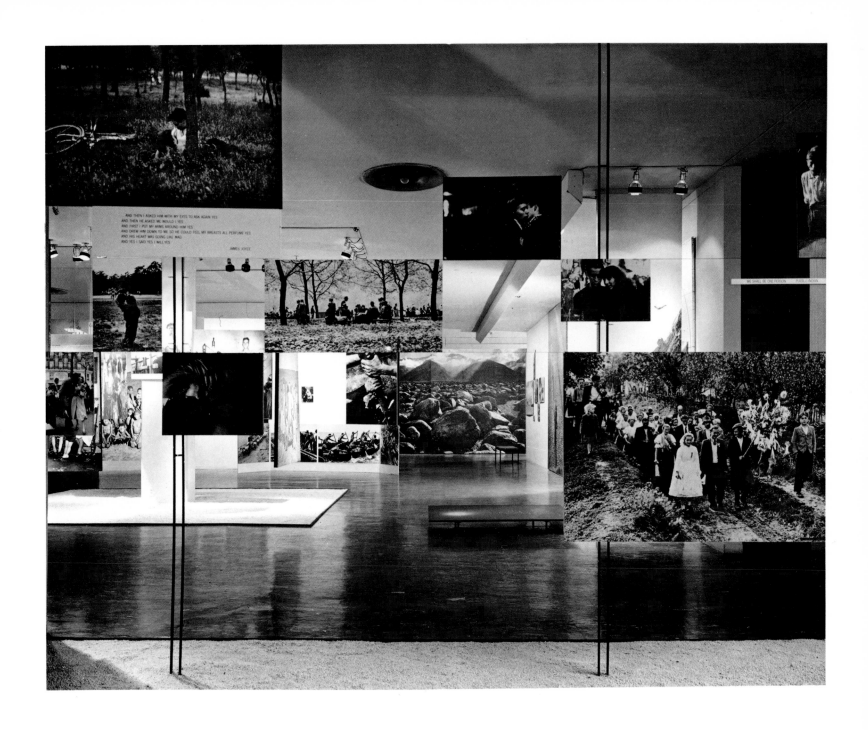

Installation view of the
exhibition *The Family of
Man*, January 24–May 8,
1955, the Museum of
Modern Art, New York

provided "a distinct departure from the styles and manners sanctioned by complacent popular opinion."[19] He directed his audience toward a symbolic interpretation of an image beyond its surface representation and "shared the poet's belief that words could make one see more clearly."[20] It is not surprising that White found allies among the Beat poets and writers Allen Ginsberg, Jack Kerouac, and Gary Snyder, who were the new literary generation of San Francisco.[21] White in turn embraced many of their tenets, which "shunned popular mentality and searched for direct, mystical, religious contact and experience," for he had long been "interested in Oriental religions and had been continually pursuing the contemplative life."[22]

As San Francisco ushered in its renaissance of poetry, art, and music, White may have been encouraged by the numerous publications that appeared there. Like the Beats, "who wanted art mixed with, if not street life itself, at least with a free flow of other arts, philosophies, and politics,"[23] White sought to incorporate Eastern philosophy in both his articles and his photographs. In the vanguard of a movement that would bring about changes not only in photography but also in all of American culture, White's concentration on the poetic symbolism and communicative power of the image would be echoed in the self-expression preached by the Hippie movement of the sixties.

Much of White's support in the fifties came from the photographic community of the San Francisco area, who, although few in number, were nevertheless quite active. Don Worth recalls that:[24]

> You could count the number of people almost on one hand—Wynn Bullock, Imogen [Cunningham], Dorothea Lange. And the Newhalls [Beaumont and Nancy] came out every summer to visit Ansel, so there was a community. They were all highly dedicated people.

During that period Imogen Cunningham, who photographed people and plants with equal aplomb, continued to work in her Russian Hill studio and home. Dorothea Lange, whose empathetic studies of the poor in the Depression had exerted an important influence on documentary photography, was still active. And three others who had been connected with f/64—Sonya Noskowiak, Alma Lavenson, and Peter

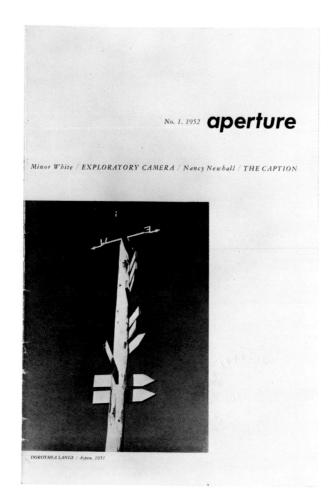

No. 1, 1952 **aperture**

*Minor White* / EXPLORATORY CAMERA / *Nancy Newhall* / THE CAPTION

DOROTHEA LANGE / Aspen, 1951

Stackpole (who had been one of the first staff photographers of *Life* magazine)—were still working and part of the community.

Ruth Bernhard, whose pictures of sensual nudes and intriguing inanimate objects had been inspired by Weston's work, has commented on life in San Francisco after she moved there in 1953:[25]

> I was able to pursue my life and meet other people who shared my interests. It seemed more concentrated. Perhaps Ansel was the reason. I also met Minor White at Ansel's, [and he] became very important to me. We spent many hours talking. . . . Through him, I was introduced to *Aperture* and the many photographers and writers who were represented in it.

Other Bay Area photographers who were both active and influential in the period and continued to be so include Walter Chappell, Paul Caponigro, Vilem

Kriz, and William Garnett. Chappell, who had known White in Portland, spent several years photographing in the San Francisco area at the end of the forties. His startling nudes were in contrast to the suggestive and somewhat romantic depictions of his contemporaries. Caponigro was stationed in San Francisco with the U.S. Army in the fifties, and studied with Benjamin Chin—who had been a student of Adams and White. He returned to the city after his service, and became known for his pictures of delicate landscapes and plant forms, which remain unique in spirit and quietly revealing. Kriz arrived in the Bay Area directly from his native Prague, Czechoslovakia, in 1952, bringing a style of his own that grew out of a childhood exposure to Surrealism. Garnett, who was a successful commercial photographer at the time (and who now teaches at the University of California at Berkeley), is best known for his aerial photographs. These convert the landscape into appealing abstract shapes and patterns.

Another community of sorts formed around the ailing Edward Weston in Carmel—approximately a hundred miles south of the Bay Area. Although he was no longer making pictures, Weston continued to attract a transient parade of worshippers until his death in 1958. His images and writings had encouraged a dedicated group of followers.

Wynn Bullock was one of those who were deeply moved by Weston. After a chance meeting in 1948, when Bullock was nearly fifty, he "completely regenerated his photographic ideas and effected a radical change in direction."[26] His early work had been experimental in nature, and he had even obtained a patent on a method of controlling line effects in solarization. In 1950 he began an intensive period of creative photography in which he achieved an unusual presence by establishing dynamic relationships among objects with contrasting tonal qualities.

Brett Weston also owes a great deal to his father, who introduced him to photography when he was still quite young. The son was quick to develop his own style, and though he often photographs objects similar to those his father did, he tends to treat them quite differently. In contrast to the older Weston's focus on the beauty or corporeality of an object, he is more interested in the abstract qualities of a photograph. He allows the forms to achieve their own identity as they interact on the flat plane, creating tensions within the boundaries of the picture frame. Weston still lives in Carmel Valley.

In San Francisco and the Carmel area, photographers were highly supportive of each other's personal work even though they were in competition for commercial work. In Southern California, however, there was little sense of community. In contrast to the enclave of image-makers who met at Adams's house or other informal gatherings to exchange ideas and information, those who lived and worked in the Los Angeles area only shared a professional organization. According to Todd Walker, "The community in Southern California was based around the ASMP [American Society of Magazine Photographers]. That was the only photographic community there was."[27]

Being more isolated, the Southern Californians were also less affected by traditions like that of straight photography in the north. Their commercial work was finely crafted, but it was also shaped to fulfill specific assignments—which tended to lead them into greater diversity of techniques and imagery.

Todd Walker is a fine example of a respected

23

Southern California photographer of that period. Although he did a lot of important commercial work, he also experimented with a broad variety of techniques in his personal work, including multiple printing, negative/positive reversals, and offset lithography. Indeed, few photographers have applied so many processes to alter the traditional silver print (the standard black-and-white image printed on paper) with as much persistence or with such exciting results as Walker did. Still, it was not until the sixties, when Walker received encouragement from Robert Heinecken and the group that gathered around him at UCLA, that Walker began to give his personal work the time and attention it deserved.

Shirley Burden is another creative/commercial photographer from the south. A producer of training films during the war, he opened a still-photography studio in the latter half of the forties and became seriously interested in photography as a fine art in the fifties. His personal work has concentrated on photojournalistic essays about people, among them *I Wonder Why, God Is My Life,* and *Behold Thy Mother.* Burden is almost better known for his generous support of other people's work. He gave Minor White money to help keep *Aperture* alive in the fifties, gathered photographs from Los Angeles for Steichen's *The Family of Man,* worked with Dorothea Lange on the preparation of her 1965 retrospective at the Museum of Modern Art in New York, and later became a member of the photography committee of that museum.

Edmund Teske was already a photographer when he moved from his native Chicago to Los Angeles in 1943. He had done work for architect Frank Lloyd Wright and was associated with Chicago's New Bauhaus: American School of Design, where he discovered the work and ideas of artist-photographer László Moholy-Nagy.[28] More influential, however, was his friendship with Man Ray, whom Teske met in Hollywood. Ray was an American photographer who had lived in Paris, where he joined the Surrealist movement. He had been one of the first to experiment with the photogram (a shadow print made by placing objects on photographic paper in a darkroom and exposing it to light). Teske was impressed by the fact that Man Ray "worked with all the inherent abilities of photography. . . . Man Ray was doing solarization . . . and was one of the first to use the capabilities of photography as a pure kind of expression."[29]

Teske began to employ a variety of processes, including solarization and multiple printing, which give a mysterious and dreamlike quality to his images. Because his work did not fall into either the purist movement of the north or the commercial work of the south, Teske remained outside any community until Heinecken invited him to teach at UCLA in the sixties.

Max Yavno, born and educated in New York City, decided to stay in California after his discharge there at the end of the Second World War. Although he had been a member of the Photo League in New York, Yavno remained independent from any group in the West, and developed his career as a commercial photographer. His photographs are clear and detailed documents of the common man which reveal aspects of daily urban life in America without making judgments. After the forties, Yavno did not exhibit again until he decided to devote himself full-time to creative work in 1975.

Several other commercial photographers who are respected today were also working in the southern part of the state. George Hoyningen-Heune moved from Paris and worked in Hollywood after 1946; George Hurrell, who came to California in 1925, has continued to create brooding and dramatic portraits of celebrities; Paul Outerbridge, Jr., moved to Laguna Beach, California, in 1943, where he opened a portrait studio and wrote a column for *U.S. Camera* magazine until his death in 1959.

If acquiring a good education in photography or landing commercial assignments had become readily possible in California by the end of the mid-fifties, opportunities to exhibit or publish creative work were few and infrequent. As John Upton remembers the situation:[30]

> There were a lot of people who were willing to discourage you about becoming a photographer, and there seemingly were no outlets. No one was publishing books except Ansel. Imogen hadn't published anything. She occasionally published a photograph in a magazine or something, but no one was doing monographs. There were very few exhibitions. The San Francisco Museum [of Art] was the most active in showing photographs.

In the north, the San Francisco Museum of Art

was the institution that proved most responsive to showing photography.[31] John Humphrey, who joined the museum in 1935, was appointed curator of prints in 1941, and though he did not devote his full attention to photography until 1970, he organized an impressive number of photography exhibitions (more than thirty of them between 1945 and 1950).[32]

Both the California Palace of the Legion of Honor and the M. H. de Young Memorial Museum (which hosted the first Group f/64 show in 1932) occasionally presented photography shows in the postwar period. By and large, however, these exhibitions were built around humanistic themes.

One group that banded together to stimulate interest and opportunities was the Bay Area Photographers, which included, among others, Ruth Bernhard, Imogen Cunningham, Paul Hassel, Pirkle Jones, and Gini and Jerry Stoll. They began in 1955, hoping "that the new organization could offer encouragement, stimulus, and an outlet for their creative efforts. . . . It is unique in that all [of the work exhibited] must be new."[33] They stayed together long enough to put on *San Francisco Weekend* in the fall of 1955—an exhibition comprising 107 images of the city taken by 28 photographers over a single weekend.

In the south, few institutions were willing to show photographs, save for the Los Angeles County Museum, which hung such shows as *17 Americans* in 1948 and *Man in Our Changing World* in 1952.[34] The California Museum of Science and Industry hosted a few shows during this time.

There were also not many chances for national exposure in shows that originated outside of California other than in the few shows organized by the Museum of Modern Art in New York. One noteworthy exception was *Creative Photography—1956*, which was organized by Van Deren Coke, then a businessman in Lexington, Kentucky. It was sponsored by the Lexington Camera Club and held at the Art Gallery of the University of Kentucky. This was a landmark exhibition for West Coast photographers, for ten of the seventeen artists were from California: Ansel Adams, Ruth Bernhard, Wynn Bullock, Larry Colwell, Don Ross, Dody Warren, Brett Weston, Edward Weston, Minor White, and Charles Wong. *Aperture* published the catalog as its spring issue in 1956, and the 1957 *U.S. Camera Annual* gave it special attention, reproducing a substantial number of images from the show.

Coke's selection reflected a dramatic departure from the point of view expressed in Steichen's exhibition only a year earlier. In *The Family of Man*, the theme had overshadowed the individuality and personal expression of each artist, but the emphasis of the new show was clearly on the creative possibilities of the medium. This shifting of perspectives was reinforced in 1959 by Beaumont Newhall's *Photography at Mid-Century* exhibition at George Eastman House, in which he described photography as most importantly "a means of visual expression and interpretation."[35]

As museums were slow to recognize photography, so were galleries. In fact, not until the late sixties was the medium taken seriously by enough collectors to sustain even one gallery devoted strictly to photography. In the fifties Helen Gee was able to maintain the Limelight Gallery and Cafe in New York, but no comparable gallery managed to survive in the West.

In Los Angeles, Jake Zeitlin's Bookstore and Gallery is still most remembered. Todd Walker made his first visit there while he was a student at the Art Center in the forties, and he describes the gallery part as having been in the back room, "with one twenty-five-watt lightbulb in the center, [and] about six prints of Weston's stuck on with pins on some shelves."[36]

Although there were few exhibition spaces, a number of magazines provided public exposure for photographers. A few popular magazines were aimed directly at the amateur and semi-professional photography market. *Camera 35, Popular Photography,* and *Modern Photography* catered largely to the hobbyist. *U.S. Camera* and its *Annual,* on the other hand, were considered more of a showcase for the work of creative and illustrative photographers. There, perhaps more than any other place except *Aperture,* photographers were able to learn about what others were thinking and doing.

Other than magazines, photographers had virtually no opportunities to publish their creative work. "They'd say that the public wouldn't buy it," Pirkle Jones recalls.[37] But the market hadn't been adequately tested since so few books on the subject had been produced. Wright Morris had succeeded in the forties, publishing three books that were unique in their juxtaposition of words and images—but he had begun as a writer:[38]

It occurred to me that I was using words to *construct,* as well as evoke, an image. Why not —since it was possible—take pictures of the objects that had held such interest for me? I got a camera, and a few months later, in the streets and alleys of neighboring small towns . . . I began to take the photographs characteristic of *The Inhabitants:* a washtub and dishpan in the clutter on a rear stoop; the weathered boards and the pattern of openings in a chicken shed.

Another notable exception to the paucity of photographic books appeared in 1958. A young photographer named Robert Frank, who had immigrated to the United States from Switzerland in 1947, found a foreign publisher for his book *Les Américains.* The book would have an impressive effect on the direction of American photography when it appeared in English in the following year. The tone of the pictures was sharp, detached, and sometimes even blatantly critical—a far cry from those dignified glimpses into the lives of the poor-but-noble working class that had been typical of the documentary style during the Depression. Frank's images were casually framed and grainy—a radical departure from the precise and often elegant work of people like Dorothea Lange or Henri Cartier-Bresson. In *Les Américains,* said Jack Kerouac, photographer Frank had "sucked a sad poem right out of America onto film, taking rank among the tragic poets of the world."[39]

Frank's book pointed to changes in American lifestyles that had begun in the fifties with the Beats of San Francisco and which would continue through the period of disenchantment and revolt that was to mark the sixties. These changes would also be reflected in photography.

Unless otherwise indicated, all quotes from photographers and members of the California photography community were taken from a series of interviews conducted by the author and Irene Borger from 1980 to 1982.

Louise Katzman interviewed the following: Lewis Baltz, Ruth Bernhard, Ellen Brooks, Edna Bullock, Robert Cumming, Judy Dater, Hal Fischer, Jack Fulton, Judith Golden, John Gutmann, Therese Heyman, Helen Johnston, Pirkle Jones, Mike Mandel, Richard Misrach, Arthur Ollman, Fred Parker, Leland Rice, Larry Sultan, Lew Thomas, Todd Walker, Don Worth, John Spence Weir, Jack Welpott, and Henry Wessel, Jr.

Irene Borger interviewed the following: John Brumfield, Jerry Burchfield, Jo Ann Callis, Eileen Cowin, Darryl Curran, John Divola, David Fahey, Robert Fichter, Robbert Flick, Robert Heinecken, Graham Howe, James Hugunin, Barbara Kasten, Victor Landweber, Claudia and Randolph Laub, Kenneth McGowan, Jerry McMillan, Sheila Pinkel, Noel K. Rubaloff, Ed Sievers, Arthur Taussig, Edmund Teske, John Upton, Robert Von Sternberg, Stephen White, and Max Yavno.

The transcripts from the interviews with David Fahey, Hal Fischer, Robbert Flick, John Gutmann, Mike Mandel and Larry Sultan, Leland Rice, Todd Walker, and Don Worth are available through the Archives of American Art, Smithsonian Institution, Washington, D.C., as part of their California Oral History Project.

# NOTES

1. "A Decade of Boom," *Popular Photography* (December 1958), p. 150.

2. Interview with the author.

3. Interview with the author.

4. Since 1961, the San Francisco Art Institute.

5. Minor White, "A Unique Experience in Teaching Photography," *Aperture*, 4 (1956), p. 151.

6. Interview with the author. Jones has remained in the Bay Area, where he has collaborated on several photographic essays, including *Death of a Valley*, with Dorothea Lange.

7. White, op. cit., p. 153.

8. The name was changed to the International Museum of Photography at George Eastman House in 1970—and then back to George Eastman House in 1982.

9. Since 1974, called San Francisco State University.

10. Interview with the author.

11. Ibid.

12. Jim Hall and Ira Latour were among the first staff members to be hired.

13. Interview with the author.

14. The school moved from Los Angeles to Pasadena in 1976.

15. Interview with the author.

16. Interview with the author.

17. Beaumont Newhall, who had directed the department before Steichen's arrival, and subsequently moved to George Eastman House, had also displayed a reluctance to accept photography as an interpretive medium. His writings and exhibitions of this period treated the photograph primarily as a representation of the real world. (See, for example, his article "Photographing the Reality of the Abstract," *Aperture* 4 (1956), p. 32.)

18. Helen Gee, *Photography of the Fifties: An American Perspective* (Tucson: Center for Creative Photography, 1980), p. 14.

19. Jonathan Green, "*Aperture* in the '50s: The Word and the Way," *Afterimage* 6 (March 1979), p. 12.

20. Ibid., p. 11.

21. While Abstract Expressionism was being supported by the Eastern art establishment and becoming the dominant style in New York, White's colleagues at CSFA—namely Mark Rothko, Clyfford Still, and Ad Reinhardt—were also giving momentum to the movement, albeit in a San Francisco manner, which would affect an entire generation of Bay Area painters. White, however, remained more closely aligned with the Beats.

22. Green, op. cit., p. 12.

23. Peter Plagens, *Sunshine Muse* (New York: Praeger Publishers, 1974), p. 78.

24. Interview with the author.

25. Interview with the author.

26. Gerry Badger, *Wynn Bullock* (London: Royal Photographic Society, 1975), p. 207.

27. Interview with the author.

28. Moholy-Nagy's avant-garde approach to the exploration of materials, and his belief that a photograph is a visual experience, was contrary to nearly all that was accepted in American photography circles at that time. His founding of the New Bauhaus (later the Institute of Design of the Illinois Institute of Technology) in 1938–39 had a relatively far-reaching effect. Moholy-Nagy's ideas were passed on by those he directly influenced —such as Edmund Teske and Henry Holmes Smith (whose students at Indiana University included Robert Fichter and Jack Welpott)—and by succeeding generations of students who learned modified versions of his concepts—Linda Connor and Eileen Cowin, for example, studied at the Institute of Design; Robert Fichter went on to teach at UCLA and Jack Welpott at San Francisco State University. The extent of Moholy-Nagy's influence was first brought to my attention during a conversation with Van Deren Coke. For further information, see Coke's *Avant-Garde Photography in Germany 1919–1939* (New York: Pantheon Books, 1982).

29. Interview with Irene Borger.

30. Interview with Irene Borger.

31. Since 1975, the San Francisco Museum of Modern Art.

32. One of the more important shows, *Perceptions* (1954), was done in cooperation with a group of local photographers. It was their own decision, however, to exhibit the work without titles or the artists' names.

33. Phiz Mozesson, "The Bay Area Photographers," *Aperture* 4 (1956), p. 75.

34. Called the Los Angeles County Museum of Art since 1961.

35. Beaumont Newhall, *Photography at Mid-Century* (Rochester, N.Y.: George Eastman House, 1959), n.p.

36. Interview with the author.

37. Interview with the author.

38. Wright Morris, "Three Francs Bought Me a Bowl of Borscht," *The New York Times Book Review*, April 10, 1983, p. 3.

39. Jack Kerouac, introduction to *The Americans* (New York: Grove Press, 1959), p. vi.

124 John Gutmann,
*The Oracle,* 1949/1981

123 John Gutmann,
*The Cigaret,* 1949/1981

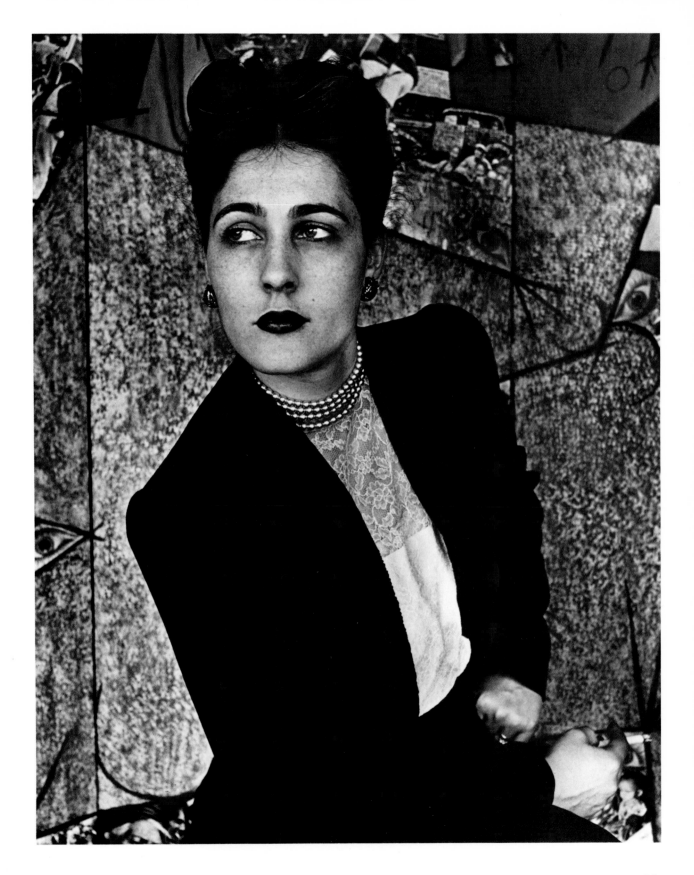

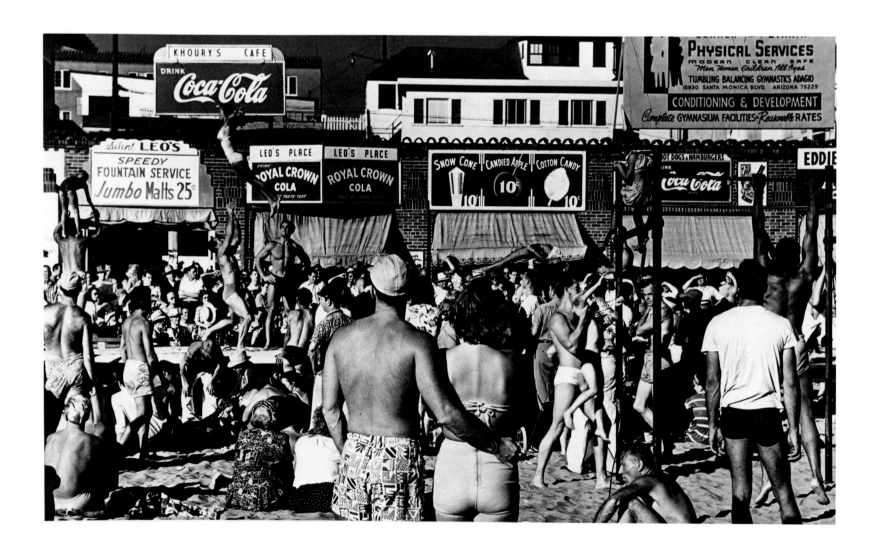

244 Max Yavno, *Santa Monica Beach*, 1949

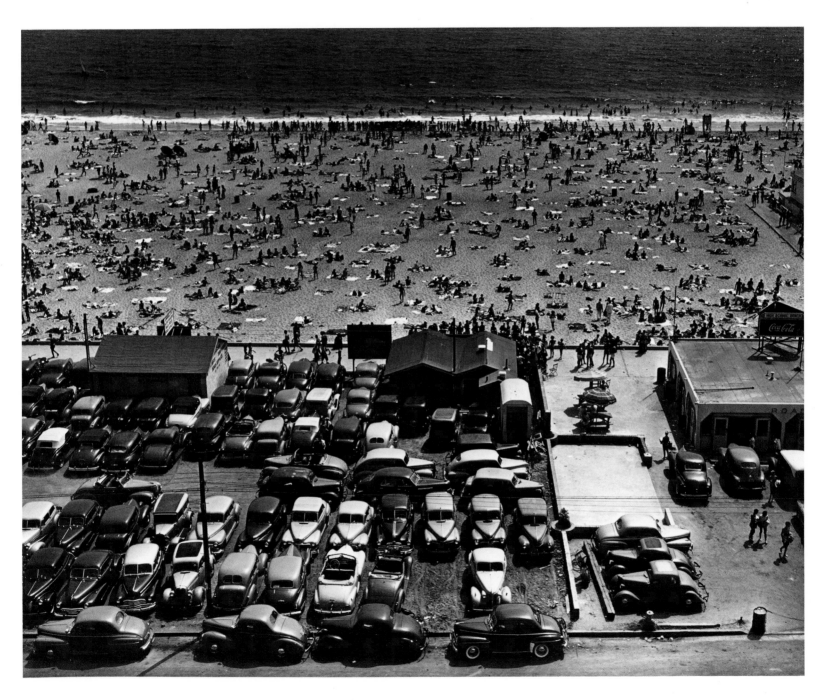

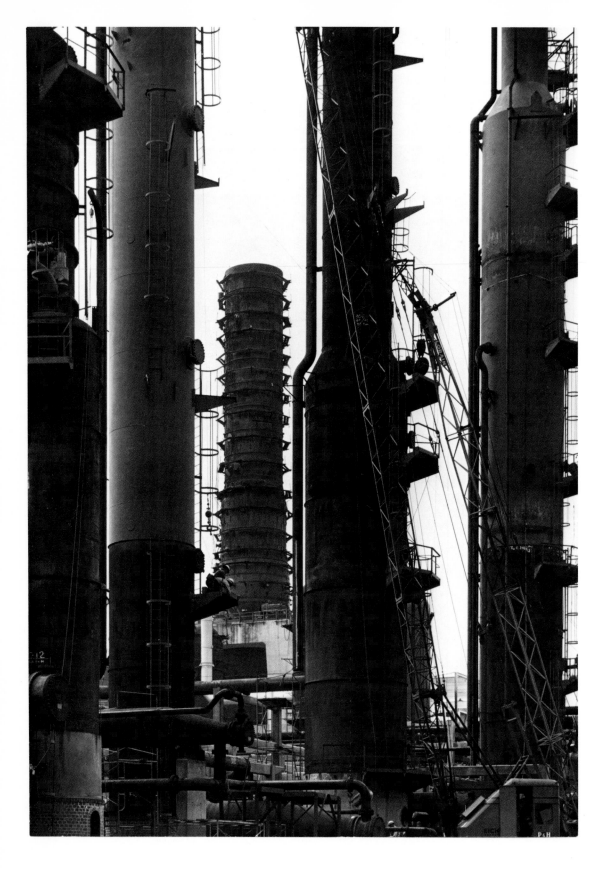

137 Pirkle Jones, *Untitled*, 1957

139 Pirkle Jones, *Untitled*, 1957

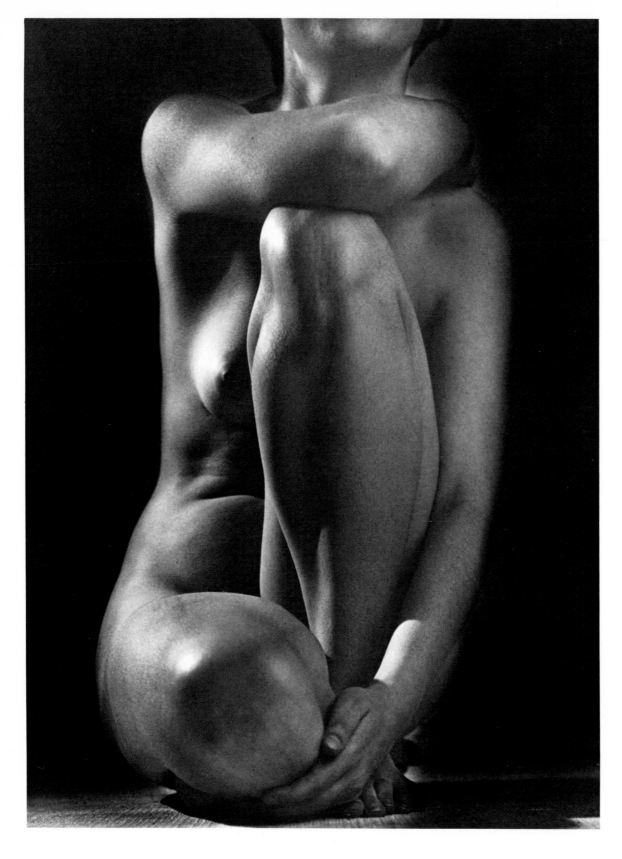

8 Ruth Bernhard, *Classic Torso,* 1952/1980

34

10 Ruth Bernhard, *Seated Figure—Joan Folding*, 1962/1980

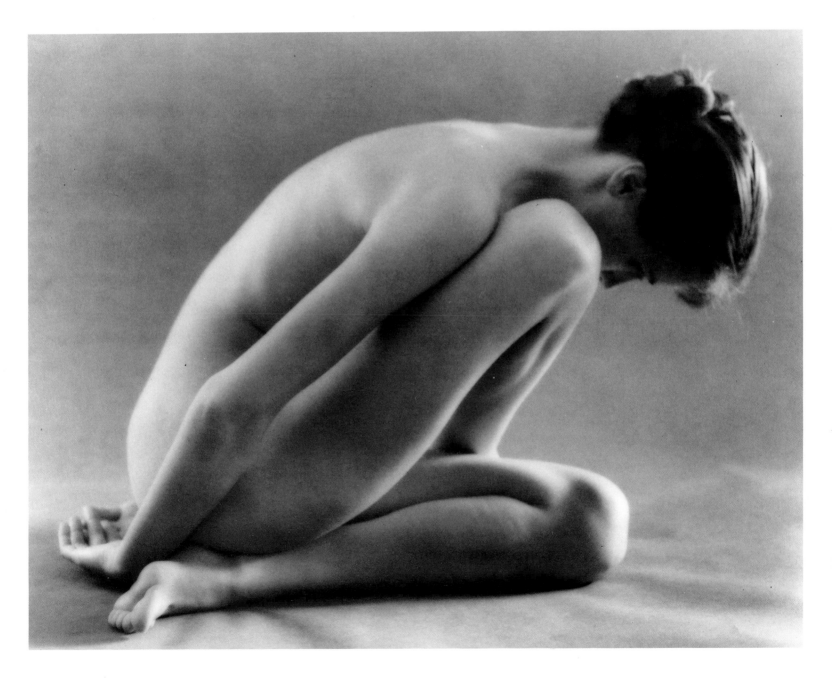

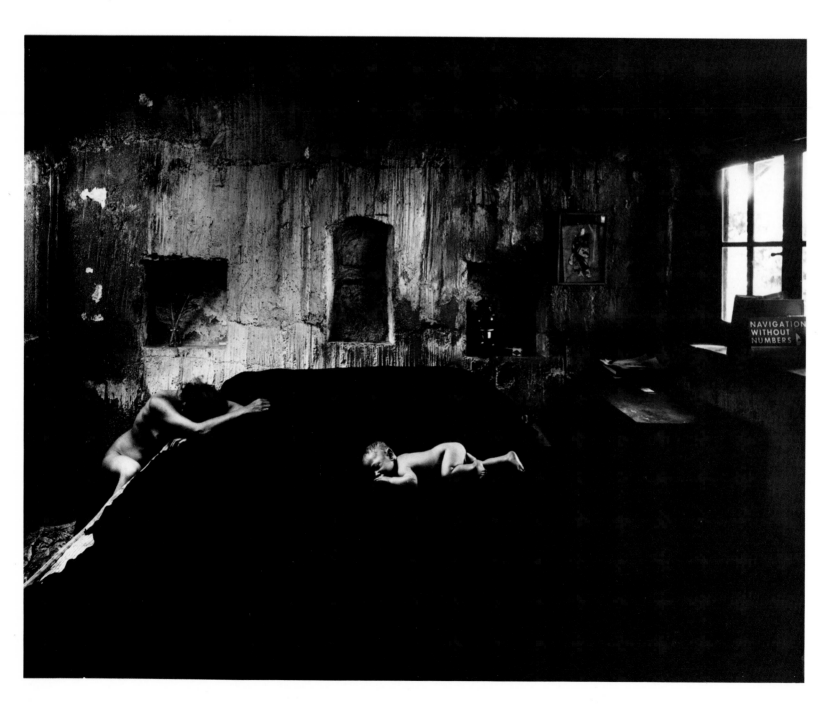

21 Wynn Bullock,
*The Logs*, 1957

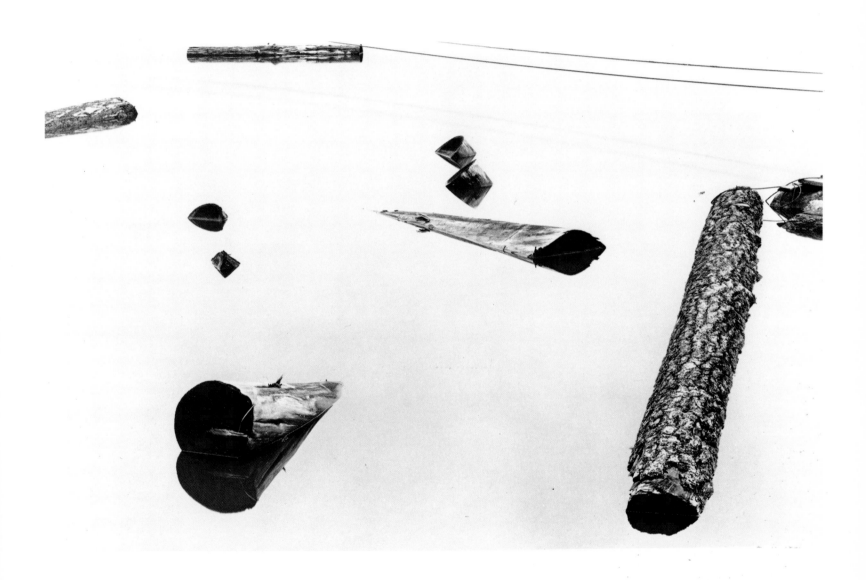

233 Minor White, *Bad Lands, South Dakota*, 1959

209 Edmund Teske,
*Untitled*, c. 1962

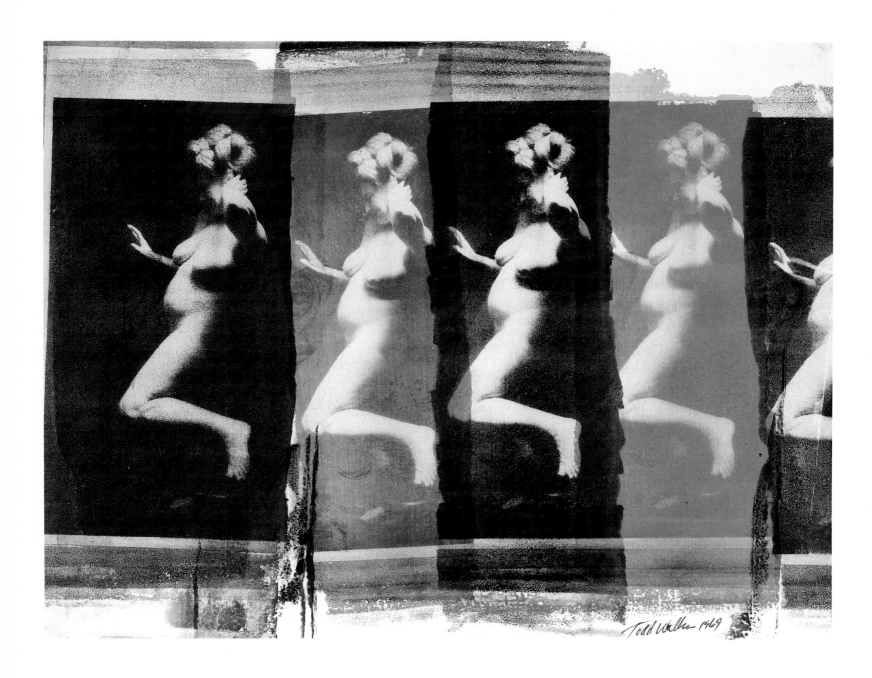

217 Todd Walker, *Untitled*, 1969

The inauguration of John F. Kennedy ushered in the sixties and an era of optimism in America. Along with the promise of a new energy in its foreign policy, the administration revealed its arrogance in its attempts to police the affairs of other countries in the Bay of Pigs invasion, the Cuban missile crisis, and an increasing involvement in Southeast Asia. By 1965, only two years after Lyndon Johnson had become president, there were 184,000 Americans fighting in Vietnam.[1]

It was not long before Americans became discontented with their country's involvement on foreign shores and began to express criticism. The questioning of the government's policies may have been encouraged by the baby-boom generation that was reaching adulthood at the time. These children had grown up in a period of increasing prosperity so that the values of security, consensus, and the status quo—so important to their parents—had relatively little meaning for them. Recognizing their economic and social advantages, many of them felt a kind of collective guilt as well as a political sensitivity to the inequities of American life that had previously been ignored or swept under the social rug. These young adults grew increasingly perplexed and alienated by the poverty and by the racial prejudices of affluent America, and began to voice their objections by joining the Civil Rights and Black Power movements.

The protest movements of this period grew faster than any had before, partly accelerated by the media, which brought the activities to the attention of the public. The media were also responsible to some degree for the unrest since they had propagated images of the "average American" family that created greater expectations on the part of the poor. The protests and demonstrations by small groups became magnified through the media coverage and were made to appear more important than they were. It appeared as if the cities and campuses of the country were soon to be in a state of near-anarchy.

While many young affluent adults joined the rebellion of the poor against the lack of opportunities, other middle-class students who had rejected the values of their parents began to seek new experiences and lifestyles through drugs, music, and alternative ways of living. The hippies who were drawn to San Francisco created their own culture of "flower children." Communal living experiments thrived around the country. The New Left and the counterculture grew, spurred by the increasing desire for a reevaluation of lifestyles. By mid-decade these movements coalesced with anti-Vietnam War protests, leading in turn to criticisms of the universities, particularly those with connections to the military-industrial complex. Almost simultaneously, the women's movement was reborn, first with the publication in 1963 of *The Feminine Mystique* and then with the founding of the National Organization of Women in 1966, a union of older women activists and the younger feminists of the baby boom.

The new political spirit had its counterpart in the arts, which also underwent a renewal of energy. Photography in particular benefited from the changes of the times as it became more widely recognized as a popular medium. This was evident in the amateur as well as the professional photography magazines, where it became common to read about the artist's interpretation and the selective process, a clear departure from the previous decade, when emphasis had been on the symbolic meanings of the image. By the end of the decade there were few arguments about photography being an art; manipulation and experimentation had become the major subjects of discussion.

While in the fifties photography courses had multiplied as a result of the influx of the G.I. Bill students, now the baby-boom generation sustained a new

growth. The questioning of accepted values and the attitude toward alternative lifestyles was evident in the schools in California. There was a general migration toward studying the humanities and the liberal arts as a further rejection of the establishment, which had always favored such practical disciplines as business or engineering. The students' interest in experimentation not only encouraged the study of photography, but also led to a greater diversity in the courses offered and the kind of art being made. Mike Mandel commented on the period:[2]

> We are . . . products of the sixties and seventies antiwar student movement, which was a big part in my becoming an artist rather than a lawyer—as I thought I was going to be in junior high school. The change in attitude in "What are you going to do with your life?" allowed me to reevaluate . . . and go into esoteric pursuits such as photography. There was a great sense of idealism that occurred in the 1960s which allowed people like us to break out of our bonds.

Larry Sultan, who has frequently collaborated with Mandel on photographic projects, agreed:[3]

> I think that is a real important point. Had we grown up in the fifties, I was certainly programmed to be a young Jewish lawyer, and so was Mike. In our work there is a continual questioning and struggle about art having a social conscience.

Don Worth, who taught at San Francisco State in the sixties, saw a great dedication to personal growth as indicated by the attention his students gave to their work. He felt this was a reflection of the times:[4]

> Hearing them talk about staying up until three in the morning printing, you knew something was happening. . . . That came about because the hippie idea was "do your own thing—don't worry about making a living."

The movie *Blow-up*, directed by Michelangelo Antonioni in 1966, seemed to personify the new dreams of personal freedom. Its portrayal of the spirited and open sexual pursuits of its young protagonist, a successful fashion photographer, validated the changing values and the ways in which young people sought to achieve happiness.

New differences in style between the northern and southern sections of the state began to emerge during the sixties. Many photographers have observed that there are similar distinctions in the physical environment, and Leland Rice has put it in these words:[5]

> I've always talked about L.A. being a horizontal experience, whereas San Francisco is primarily a vertical experience. San Francisco, even though it's making great strides to contemporize its skyline and its overall appearance in some respects, still has a very strong allegiance to the Victorian, turn-of-the-century era. L.A. doesn't have any of that. L.A.'s allegiance is to a Mexican and Spanish flavor.

A sense of tradition was evident in other areas than architecture. The long and consistent history of photography in the Bay Area had given the straight approach of Adams and Weston an inertia that had made it difficult for new developments to occur. Through the sixties, however, a new philosophy evolved from the ideas of people like Minor White—as well as from the social and political changes that were taking place at that time.

In the north, San Francisco State University and the San Francisco Art Institute continued to offer the most active and important programs, and each created its own community. At State, the graduate program flourished under the leadership of Jack Welpott, who had been hired in 1959. He had studied at Indiana University under Henry Holmes Smith, whose ideas had been influenced by Moholy-Nagy. As a teacher, Welpott encouraged the West Coast style, but he utilized a modified version of the New Bauhaus methodology:[6]

> I never got into a heavy Bauhaus orientation like Henry, but he left me with a definition of photography that has always served me: namely, that photography is light, light-sensitive material, and the modulation of light. Many of the assignments that I gave were Bauhaus-influenced.

Welpott demanded the technical mastery necessary to achieve fine print quality, but he also aimed at expanding his students' perceptions and making them view the photograph as an expressive form of communication. Discussion of the symbolic meanings of

Still from Michelangelo Antonioni's film *Blow-up*, 1966

images or the psychological concerns of the image-maker were a central part of his classes. John Gutmann observed that:[7]

> Jack Welpott's greatest strength was probably his relationship to his students. He was a very good instructor in the graduate program, so that the most mature students became quite stimulated by his teaching. He has turned out a great number of really successful young photographers. Many of his students were getting into photography as exhibiting artists and also as teachers. Some of these people are exhibiting in the most important galleries in the country.

In 1960 Don Worth was hired as a slide librarian and photo technician at State. As the demand for classes grew, so did the need for teachers, and Worth was soon asked to teach full-time. His own work carries on the tradition of the fine-quality print with his exquisitely rendered images of plant forms and the California landscape.

Students enjoyed the atmosphere at San Francisco State, and, more important, felt stimulated by each other's ideas. A close-knit group developed that included a number of those who were later to make national reputations for themselves. Among them were Michael Bishop, Judy Dater, Edward Douglas, Michael Harris, Harvey Himelfarb, Don Renfrow, Leland Rice, Charles Roitz, John Spence Weir, and, later, Timo Tauno Pajunen. As the time for graduation drew near, they began to think about ways in which they might be able to continue their association.

47

John Spence Weir, *Untitled*, 1967/1970, from the *Visual Dialogue Foundation Founders Portfolio*, 1970, 5/15, gelatin silver print, $3^{15}/_{16} \times 11^{3}/_{8}''$ (10.0 × 28.9). San Francisco Museum of Modern Art, William L. Gerstle Collection, William L. Gerstle Fund Purchase, 70.28.9

With Leland Rice providing the impetus, the students got together to organize the Visual Dialogue Foundation in 1969. According to Weir, "The main intent was to simply be together . . . as a group of photographers who were genuinely interested in photography, and to show our work."[8]

The members felt that in addition to offering support for each other's work they would be able to accomplish more as a group than they could as individuals. They were confident that if they worked with a sense of direction and presented good exhibitions, they would find an appreciative audience.

Most of their activities were social, for, as Leland Rice describes it:[9]

> We all seemed to have similar attitudes and compatible exchanges. . . . We really enjoyed them, and we knew we couldn't [continue them at] State because we were all graduating. . . . Plus, it allowed us, with Jack [Welpott] and Don [Worth] and a few other people in the community like Oliver Gagliani, to be on a peer level. We were no longer teacher and student.

The members of the VDF succeeded in organizing two exhibitions—the first held to coincide with the regional meeting of the Society for Photographic Education (SPE) in 1969, the second at the Friends of Photography in Carmel, in 1972— and publishing a portfolio of the members' work. The group disbanded around 1973 after their original goals were met and several of the members left the Bay Area.

At the San Francisco Art Institute the curriculum developed somewhat differently—and not as

quickly. There was no single person on the faculty who was able to produce the kind of dynamic effect that Welpott had introduced at State, and the formalist tenets of Adams and White remained in force well into the sixties. The school was going through changes, and the students felt little guidance—as Lewis Baltz remembers:[10]

> It was a rather painful time of transition for the school: most of the old faculty was leaving and the new faculty had not arrived. . . . There was a general mood of confusion. . . . The school's reputation was that it was a place of total freedom, which was true—but it was a freedom born out of hopelessness. One was free to do anything one wished, but nothing one did mattered.

Morley Baer, John Collier, Richard Conrat, and Paul Hassel were all faculty members in the first part of the decade. Blair Stapp became chairman of the department in 1966 when the graduate program was begun. Jerry Burchard, who had received his BFA from the institute in 1960, when the students were still working with large-format cameras, returned there as a teacher in 1966. In the meantime he had worked in New York City, where he was won over to the 35mm camera. Relying heavily on a wide-angle lens and using long exposures—often at night—he gave his images a slightly out-of-focus quality and an air of mystery that soon came to be associated with the school.

Others with diverse backgrounds joined the staff

Photograph taken by Harvey Himmelfarb and used for the cover of the invitation to the opening of a Visual Dialogue Foundation exhibition at Imageworks in Cambridge, Massachusetts, on November 18, 1971. Front row, from left to right: Linda Connor, Michael Bishop, Jack Welpott, his son Matt Welpott, Timo Tauno Pajunen, and Susan Pajunen. Back row: Mimi Harris, Mike Harris, unidentified guest, Karl Folsom, John Spence Weir, Judy Dater, Victoria Weir, and Steven Soltar

in this period, notably Jack Fulton and Linda Connor, who arrived in 1968. Both made use of other mediums in teaching and encouraged their students to think beyond traditional silver-print techniques. Fulton, who had been influenced by his artist friends William T. Wiley and Peter Voulkos, is best known for narrative works that combine his photographs with stream-of-consciousness writings. Connor experimented in the sixties with photographing compositions made up of three-dimensional objects arranged on two-dimensional pictures.

The California College of Arts and Crafts in Oakland had offered a BFA with an emphasis in photography for some years, but it was not until Robert Forth joined the faculty in 1968 that the subject was given serious attention. Forth, who had studied with Smith at Indiana, brought in a number of part-time teachers, among them Welpott and Rice, and a series of outside lecturers that included Imogen Cunningham, Linda Connor, and Judy Dater.[11]

Photography courses flourished elsewhere in the Bay Area during the sixties, and not only at institutions that offered degrees. The University of California Extension program in San Francisco, under the directorship of Clyde Smith in the mid-sixties, followed by John Pearson, was unique in that anyone

from the community could attend; if enough students did not sign up to cover the expenses of the course, it was simply not offered.[12] Photographers from outside the area also participated, coming in to give one-day or one-week workshops.

On the Berkeley campus across the bay another untraditional program was set up in 1961 by the Associated Students of the University of California. David Bohn, the first director of the ASUC Studio, describes it as "a workshop for students, faculty, and employees."[13] It gives no degrees or credits, but it does offer an alternative to the formalism of the university.[14] As Richard Misrach remembers:[15]

There were some photography classes on campus, but they were in the design department. Because of the loose atmosphere, [the Studio] drew a lot of very bright people down there, and . . . some really good work was being done. There were people on the staff that were very good. . . . Bohn and [Roger] Minick had a lot of integrity [and] the levels of priorities were real clear. They were interested in making pictures that were both technically proficient and somehow creative and personally oriented. There was no idea of making money.[16]

In the southern part of the state, a different approach to the medium was evolving. The absence of powerful, singular tastemakers like Adams, the relative isolation of individual artists across the cities of the south, and the few photography programs in the schools had impeded the growth of one particular style. On the other hand, it had created a situation in which diversity and innovation were possible.

The greatest single influence in the south may well have been the local art world. A great surge of activity took place in the early sixties that led to a regional style that was dubbed the "L.A. Look." Artists like Billy Al Bengston, Larry Bell, Robert Irwin, Craig Kauffman, and John McCracken had made a big break with tradition by adopting new materials such as glass, resins, and plastics, which they crafted into unusual forms, borrowing techniques from the industries that produced and used them.

In the schools, the most influential figure of the sixties was Robert Heinecken of UCLA, who had been a student of printmaking when he was first introduced to the medium by instructor Don Chipper-

field. It was because of Chipperfield's recommendation that Heinecken began teaching photography in the UCLA Extension division while he was still a graduate student. When the art division underwent changes in 1961, Heinecken initiated photography into the fine-arts curriculum. In 1962 the graduate program began.[17]

Heinecken's background as both artist and photographer encouraged him to be particularly open to new combinations and processes, as Judith Golden confirms:[18]

I think Heinecken has been incredibly influential in breaking down the tradition of how the camera is used. He never even had a camera himself. He always used images he got from other places for his work, so his attitude was that of playing with the process.

Heinecken uses a variety of materials and methods: standard silver-print photographic paper, photo-sensitized fabrics, high-contrast copy film, acrylic, chalk, collage elements, offset lithography, and transfers. His interest in three-dimensional forms has been influential in expanding the uses of the medium. Many of his images are taken directly from magazines, television, and advertisements, and he frequently combines them in ways that make the viewer aware of the manipulations of the mass media. He has likened his style to guerrilla warfare, saying that, "with a strange sense of propriety or humor, I like to go into something, shake it up, and disappear."[19]

It is no doubt due to Heinecken that non-silver work—photographs produced with techniques such as lithography, etching, or hand-coloring—has come to be associated with UCLA. In actuality there has been a great deal of diversity in the students' work. This also may be a result of Heinecken, who holds no allegiance to a particular style of photography and has never imposed any on his students. Rather, he seems to possess a special ability to discover the specific strengths in each individual's work and to nurture whatever direction they take. Sheila Pinkel has said of him:[20]

Heinecken was extraordinary. The program at UCLA accommodated exploration. The predominant idea was to have a real experience discovering something for yourself in the process. Aside from

that, there wasn't a direction of photography put forth. . . . The thing they had in common was the intensity of that investigation, rather than any idea.

Heinecken offered an even broader perspective to his students after he became part of an evolving national network through SPE. Nathan Lyons was the prime mover behind the formation of this organization, created in 1962, whose purpose was to provide a much-needed forum for teachers of photography at the university level. Through the yearly meetings and, later on, the more frequent regional conferences, Heinecken met many photographers and became aware of what was being done all over the country.

It was precisely because of his contact with a broader network that Heinecken met and invited Robert Fichter to teach at UCLA, first in 1968 and again in 1975. Fichter became another major influence at the school. Like Heinecken, Fichter had an undergraduate degree in printmaking and painting, and he shared some of the other man's thinking. As Fichter remembers their first meeting:[21]

> We had a lot of really good conversations and the same kind of sensibility. A kind of tongue-in-cheek exploitation . . . of the rigidities of other people's minds; tweaking the bourgeoisie in a funny way.

With his enthusiasm and gregarious nature, Fichter was responsible for bringing people together socially as well as professionally. He would organize gatherings on Sunday afternoons, asking people to show their work or join in critiques. John Upton comments:[22]

> That kind of community thing got started when Bob Fichter was out here, when he used to have photo meetings once a week. . . . We found that we could tolerate each other. There was much more social interaction with the L.A. people than there was with the people in other areas.

Fichter was also a gifted teacher who sometimes went even further than Heinecken in encouraging students to expand their horizons. In Darryl Curran's opinion:[23]

> Fichter is the key figure. He brought everything together, he was the catalyst for all this. Fichter was the one who sought out Todd Walker and asked him how to do gum printing. . . . When Fichter taught those techniques it encouraged that kind of work.

Fichter also brought a national perspective to the university. Because he had studied with Jerry Uelsmann at the University of Florida in Gainesville and then with Henry Holmes Smith at Indiana University, and had worked at George Eastman House

in Rochester, he was more aware than most of the local photographers of what was going on in the rest of the country. Moreover, he had established many contacts and was able to recommend people for exhibitions and to keep the UCLA group informed of events taking place outside California. He was a prime link to a broader network of activity.

Even before photography was offered for academic credit in the university, Don Chipperfield had introduced it into the program at UCLA Extension. Its students, like those of the San Francisco Extension, are drawn from the community at large, and while they may not have as broad a background in art as matriculated students do, they are often more mature. The Extension's course of study allows for greater concentration on photography than the regular academic program does, and it is exceptional for the wide range of subjects offered and for the incredible number of people who have taught there.[24]

While UCLA was the center of greatest activity and influence during this period, many of the small schools were also quite active and often played important roles.[25] One of the more interesting examples is Orange Coast College, a two-year community college in Costa Mesa. John Upton, who had studied at the San Francisco Art Institute and later returned to Southern California to work as a commercial photographer, had been teaching a class at a local school when he discovered Orange Coast. It was a very casual beginning: "I just walked in and said, 'Is photography taught here?' One person had been teaching it and they wanted to expand the program."[26]

Upton became chairman of the department, and the program grew from 100 students in 1965 to 1,500 ten years later. Forty classes are now offered by the college, and an extensive lecture program brings in people from outside.[27] Typical of the varied faculty is Barbara Kasten, whose original background was in textiles. Her photographs are usually based on design elements with a constructivist sensibility; recent large color prints are elegantly orchestrated compositions of linear and geometric forms that play their dimensionality against the completed two-dimensional image.

The four-year program at California State University at Fullerton also grew rapidly during this period. According to Darryl Curran, this is because many Orange Coast students wanted to continue studying, and Fullerton was the closest place. There was no developmental plan for photography:[28]

It just snowballed. We offered these courses, and enrollment was always at its peak. . . . It just kept going until we had an MA in photography starting in 1970.

Curran had studied at UCLA before there was a photography program, taking his degree in design; he returned for a master's degree in art in 1964. Hired at Fullerton in 1967 because of his dual background, he began teaching graphics and photography there in 1967. Curran has tended to make use of combinations of printmaking techniques, as well as collage and cyanotype (blueprint), juxtaposing a variety of images. His work offers viewers different and imaginative perspectives on everyday cultural symbols, altering their accepted meanings. He is recognized as one of the major influences in support of the new aesthetic directions that took form in the Los Angeles area at this time. Jerry Burchfield, who also became a faculty member at Fullerton, recalls:[29]

The orientation was to get you to think beyond just making pictures . . . to get you to try and deal with your own thoughts and ideas and put something into them. Darryl used to talk about how anybody could make a good picture; it's the ideas that count. The other thing was to try and get the students to start thinking professionally in terms of creating portfolios and groups of work . . . [and] following through ideas. . . . There was a lot of influence toward process, and also toward a more conceptual manner.

California State University at Northridge also began to offer photography in the sixties—again as part of a degree in printmaking. Nevertheless, the list of teachers has been an impressive one that includes such people as Robert Brown, Todd Walker, Ed Sievers, Robert von Sternberg, and Vida Freeman.

Jerry McMillan has exerted the most important influence at Northridge. He had studied at Chouinard and the Art Center, and had maintained close friendships with a number of artists, particularly Ed Ruscha, who came to prominence as a painter in the heyday of the "L.A. Look." Because of these associations, he has continued to stress the interaction of photography with the other arts in his teaching at Northridge.

"If you come here with a narrow mind and a limited scope of what photography is," he has said, "then we are going to change that attitude a lot."[30] This interest in other mediums also shows up in the variety of concepts and materials in his own work. He has no qualms about saying:[31]

I don't think that photography is an art form in itself at all. It's just another tool that has unique characteristics which are no different from a paintbrush or a pencil.

McMillan often photographs setups—situations fabricated only to be photographed—that are so skillfully rendered they do not immediately appear to be photographs. This illusion is effected by the transformation that occurs when a three-dimensional form is flattened into a two-dimensional representation of it. In some of his earlier work, photographs were printed inside torn paper bags, and an illusion of space was suggested in the picture by its juxtaposition with a three-dimensional object. In his more recent work McMillan has suggested dimensionality with photographs of drawings and cut-outs.

Educational institutions had a broad impact on photography in both parts of the state in the sixties. Initially they helped to validate the medium as an art form since, beginning in the fifties, photography was usually taught by the art or design departments. As it gained a standing of its own, the medium also gained respect. Perhaps more important, the schools provided people with the opportunity to concentrate, discover, and discuss. Sheila Pinkel confirms:[32]

It was . . . probably the most vigorous time of my life. I have never worked so intensely. It was like an elevator ride of the soul. Every week I was just on fire, doing more work. Every week I would discover things about myself and ideas that were just mind-blowing.

Another important result of the schools' attention to photography was that they became an important source of financial support for art photographers. Lewis Baltz comments:[33]

The chief contribution of schools . . . is that they offered employment in a related field to innumerable photographers. . . . They helped keep body and soul together, and have become a major patron of photographers.

A fourth contribution came in the form of creating an educated audience from those students who studied photography and did not become professionals—or who simply came into contact with the art through the activities and exhibitions connected with the photography departments. These people became an important segment of the audience for photography and an essential part of carrying it from the schools and into the community.

Finally, the schools are where the support system among photographers has its roots. It begins at the undergraduate level, where students and teachers exchange ideas and create a community of shared interests. It is extended by the local and national contacts of the teachers, primarily through the organizations they belong to. The network grows as students become teachers and move to new schools. Keeping in touch, they help each other by exchanging news, recommending people for jobs, and organizing exhibitions.

The network was easy to create because there were so few people in photography in the sixties and because they tended to band together and share their sources. Graham Howe observes that even today:[34]

My painting friends are surprised about how much cooperation there is between photographers here. . . . There are jealousies among painters . . . [that] don't exist in photography. In photography we build our own support for survival.

A good example of how the network functioned in the sixties can be found in the rise of Fred Parker, who, in the course of a few years, went from student to curator. Studying at the University of California at Davis, Parker had the opportunity to be a summer intern at George Eastman House in 1968. With the knowledge he acquired and the contacts he made in the East, Parker was able to organize several exhibitions at Davis. This gave him an unusual amount of exposure because no one else in a similar position was showing East Coast work in California. Before he left Davis, he began work on *California Photographers 1970*, which was shown there, at the Oakland Museum, and at the Pasadena Art Museum—where he was hired directly from the school:[35]

All of a sudden I was the curator of photography in Southern California. . . . I had an office at a prestigious institution. [All because] I had a couple of catalogs under my belt. I knew a few people in the East.

Parker was not really exaggerating when he described himself as the curator of Southern California. The Los Angeles County Museum of Art occasionally presented exhibitions, including the work of Man Ray and Dorothea Lange, but Pasadena had a better record. Although infrequent in the period before Parker's arrival, their shows had reflected a greater interest in new work. Jerry McMillan, Frederick Sommer, Edmund Teske, and Don Worth were among those whose photographs had been exhibited there.

In the north, the museum situation was somewhat better. John Humphrey at the San Francisco Museum of Art continued to pay a great deal of attention to photography, often presenting as many as four shows a year. Among the local photographers whose work he had shown were Ansel Adams, Ruth Marion-Baruch, Pirkle Jones, and Alma Lavenson, as well as others in group shows.

The M. H. de Young Memorial Museum had hosted a few shows during this period, including the work of Don Worth and Joanne Leonard. The Oakland Museum, which had been showing photographs on and off since the 1930s, made a firm commitment in the mid-sixties to collect California material. The gift of Dorothea Lange's entire collection of prints and 40,000 negatives in 1965, given to the museum after her death by her husband Paul Taylor, made its holdings more significant.[36] Not long after this, the museum received two substantial grants to purchase more photographs, and in 1972 Therese Heyman was appointed senior curator of prints and photography. The museum continues to have a very strong exhibition program in this area.

During the sixties, several key exhibitions around the country revealed, and perhaps even stimulated, changes in style and attitude. Two shows at the Museum of Modern Art in New York treated photography in much the same way as the other arts. *The Sense of Abstraction*, in 1960, likened certain images to abstract art; the catalog of *The Photographer's Eye*, 1966, contained an essay by John Szarkowski—who had succeeded Steichen as director of the department

of photography—that emphasized the "fine art" tradition of the medium.

At George Eastman House, Nathan Lyons curated exhibitions that were influential in publicizing new concepts. *Contemporary Photography: Toward a Social Landscape*, 1966, argued against the idea of the photograph as a mirror of reality; the significance of photography lies in its ability to represent ideas rather than simply to serve as illustrative material. In *Photography in the Twentieth Century*, 1967, Lyons stressed the perceptual process, suggesting that the photograph is not a substitute reality, but has a presence in its own right. Approximately one-quarter of the photographers in that exhibition were from California.

With *The Persistence of Vision*, 1967, Lyons validated the new attitudes about altering the traditional print through a variety of methods as a form of visual expression:[37]

> Today the photograph is being considered as a relative artifact of metaphoric concern, much in the same sense as an automobile, comic strip, or soup can. . . . The application of the photographic image in combination with or separated from its traditional reference point presents a searching question that does not challenge photography's position, but reaffirms its significance.

To many, this exhibition revealed new possibilities in photography and provided directions for future explorations. Two years later, with *Vision and Expression*, a show that covered a broad range of concepts and included over two hundred photographers (nearly ten percent of them from California), Lyons seemed to synthesize all of the movements of the decade.[38]

In 1967, a group of photography aficionados gathered at the home of Ansel Adams to discuss the formation of a nonprofit organization that would support the growing needs of creative photography in a variety of ways. The Friends of Photography was established in June of that year with the opening of the Carmel Photography Center at Sunset Center in Carmel. Since that time the Friends have actively organized exhibitions, held lectures, seminars, and workshops, awarded fellowships, and published books, monographs, and (since 1972) a quarterly magazine called *Untitled*. The board of trustees includes a num-

Leland Rice, *Untitled*, 1969, gelatin silver print, 10⅜ × 10⅜" (26.4 × 26.4). San Francisco Museum of Modern Art, Margery Mann Memorial Collection, Gift of Tom Vasey, 78.113. The photograph was used on the cover of the exhibition catalog for Fred Parker's *California Photographers: 1970*

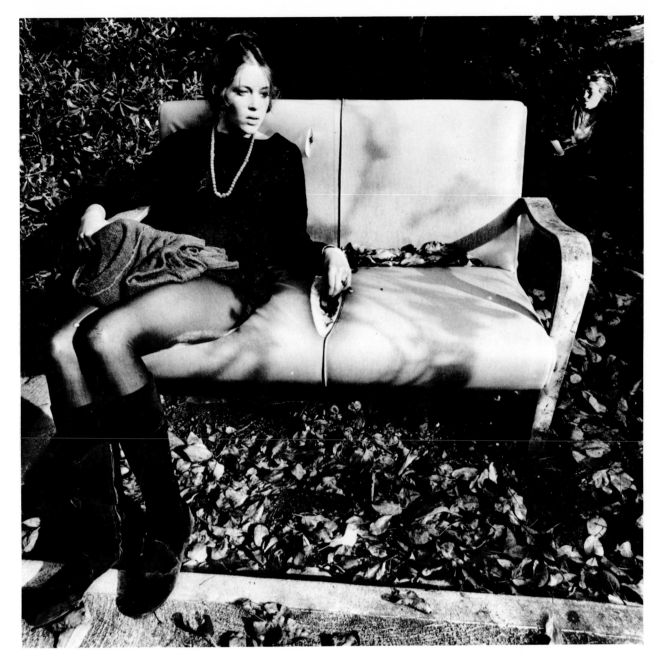

ber of well-known photographers, and the organization has an extensive membership. It is currently headed by its fourth director, James Alinder.

The sixties finally saw the start of galleries that were able to make a financial success of selling photography. One of the major initiators was Helen Johnston, who opened the Focus Gallery in San Francisco in 1966; still open today, it is the longest-lived gallery in the United States devoted exclusively to photography.[39] Johnston had worked in the public re-

lations section of the M. H. de Young Memorial Museum, where she got the idea of opening a gallery when she observed the popularity of the photography exhibitions there. It was, nevertheless, an extremely daring thing to do—as a number of people who followed her example discovered the hard way. As Margery Mann and Sam Ehrlich pointed out in an article two years later:[40]

There is no photographer in the West who can

live on what he earns from selling his prints off the gallery walls. . . . There are only a handful of people who collect photographs.

Photography publications were also slow to evolve in the sixties, with exhibition catalogs serving as the principal conduit of new ideas. Few magazines seemed interested in photography. In the north, *San Francisco Camera* appeared in 1969. In the south, Margery Mann fostered intelligent criticism through a regular column on photography in *Artforum* (a general art magazine that had been launched in San Francisco in 1962) and wrote articles for *Popular Photography* and *Camera 35* magazines.

Books of photographs were still rare, and it was not until Nathan Lyons published *Photographers on Photography* that essays by major photographers, as well as biographical and bibliographical references to them and their work, were brought together for the first time in one volume.

Artist Ed Ruscha, in particular, encouraged a trend by self-publishing. A Los Angeles artist with

an interest in conceptual work, he soon became as influential in photography circles as he was in the art world. His book *Every Building on the Sunset Strip* (1966) was exactly what the title said: Ruscha cruised the Strip in a car taking snapshots of each building, then taped them side-by-side in an accordion-like foldout book.

By the end of the decade photography in California had progressed from the status of an unwelcome stepchild to that of a mature art form in its own right. The interpretive vision of the artist—which Robert Frank had publicly introduced in the late fifties—was now being emphasized, and one result was that there appeared to be no limits to the definition of the medium or to the materials that artists could use in their quest for expression. All that was lacking was the right amount of exposure through exhibitions and publications. Both the diverse concepts of photography set forth in the sixties and numerous opportunities for broader public viewing would become accepted and possible in the seventies.

Detail from Edward Ruscha's book *Every Building on the Sunset Strip*, 1966

## NOTES

1. Mary Beth Norton, et al. *A People and a Nation: A History of the United States* (Boston: Houghton Mifflin, 1982), p. 907.
2. Interview with the author.
3. Interview with the author.
4. Interview with the author.
5. Interview with the author.
6. Interview with the author.
7. Interview with the author.
8. Interview with the author.
9. Interview with the author.
10. Interview with the author.
11. Other teachers at CCAC have included Susan Ciriclio, Van Deren Coke, Harry Critchfield, Paul Diamond, Hal Fischer, Oliver Gagliani, Josepha Haveman, Chris Johnson, Vilem Kriz, and Louis Miljabak.
12. The faculty included such well-known California photographers as Ellen Brooks, Judy Dater, Jim Goldberg, Mike Mandel, Larry Sultan, and Henry Wessel, Jr.
13. David Bohn, *Studio 1968* (Carmel, Ca.: Carmel Photography Gallery, Sunset Cultural Center, 1968), n.p.
14. Among the many dedicated participants attracted to ASUC, one might mention Debra Bloomfield, Steve Fitch, Wanda Hammerbeck, Sam Samore, Gail Skoff, and Erica Uhlenbeck.
15. Interview with the author.

16. Other institutions offering classes in photography in the Bay Area included City College of San Francisco, Santa Rosa Junior College, Mills College in Oakland, and the College of Marin in Kentfield, where several graduates of San Francisco State taught at different times. Humboldt State University in Arcata, in the far north of the state, has had an active program since the mid-sixties. History classes and alternative processes are taught in addition to basic subjects. The small staff, which includes Tom Knight, William Thonson, and Ellen Land-Weber, has been augmented with many guest lecturers.

17. Prior to this, photography had been taught under design. An important aspect of the three-year MFA program is that graduate students come in as members of the art department and study with painters, sculptors, and printmakers. Photography is therefore seen within a fine-arts context.

18. Interview with the author.

19. Quoted by John Upton in *Minor White, Robert Heinecken, Robert Cumming* (Long Beach: California State University Fine Arts Gallery, 1973), n.p.

20. Interview with Irene Borger.

21. Interview with Irene Borger.

22. Interview with Irene Borger.

23. Interview with Irene Borger.

24. Among those who have taught at UCLA Extension are Ellen Brooks, Darryl Curran, Robert Heinecken, Jerry McMillan, Leland Rice, Edmund Teske, and Todd Walker.

25. Private schools such as the Art Center and the Chouinard Art Institute have also been among the most valuable in fostering an interest in photography and encouraging experimentation.

26. Interview with Irene Borger.

27. Other teachers have included Lewis Baltz, Lawrie Brown, Robert Cumming, Victor Landweber, Leland Rice, and Arthur Taussig, who currently runs the gallery.

28. Interview with Irene Borger.

29. Interview with Irene Borger.

30. Interview with Irene Borger.

31. Ibid.

32. Interview with Irene Borger.

33. Interview with the author.

34. Interview with Irene Borger.

35. Interview with the author. The Pasedena Art Museum became the Norton Simon Museum in 1974.

36. In 1969 the Oakland Art Museum, the Oakland Historical Society, and the Snow Museum were moved to a new building and became the Oakland Museum.

37. Nathan Lyons, *The Persistence of Vision* (Rochester, N.Y.: George Eastman House, 1967), n.p.

38. The Californians included in *Vision and Expression* were: Michael Bishop, Robert Brown, Carl Cheng, Larry Colwell, Linda Connor, Darryl Curran, Judy Dater, Clyde Dilley, Oliver Gagliani, Chauncey Hare, Robert Heinecken, Joanne Leonard, Jacqueline Livingston, Phil Palmer, Bart Parker, Fred Parker, Leland Rice, and John Spence Weir.

39. Lee Witkin opened his Witkin Gallery in New York City in 1969—the first profitable gallery devoted solely to photography. In 1968 Simon Lowinsky opened his Phoenix Gallery in San Francisco, which frequently showed photographs. (This gallery became the Simon Lowinsky Gallery in 1976.) Some gallery ventures in the Bay Area, among them the Toren and Aardvark, were short-lived.

40. Margery Mann and Sam Ehrlich, "The Exhibition of Photographs: Northern California," *Aperture*, 13 (1968), p. 13.

238 Don Worth, *Aspens,
Colorado,* 1957

Ping Yuen #1

171 Jerry McMillan,
*Untitled,* 1975

Hong Kong                    Jerry Burchard 78

27 Jerry Burchard,
*5 Minutes in Agadir,* 1977

RWt          "Beast, Landscape and Stamps."          1969.

72 Robert Fichter, *Beast, Landscape and Stamps,* 1969

73 Robert Fichter, *Dogs and Rhino,* 1970

51 Darryl Curran, *Edward and Robert*, 1972

LOCK   DIN  WALL

cleverosity caused it to chase something

and it was Poe-attically caught.

Nine lives meowed themselves to infinity.

Many years later the wall was opened.

This is a window to the passed past.

ART
NO VIEW

CACTI are the

latent moderne
took ~~nostalgia~~ no stallion

from the race.
↑
it's accouterments
are of craft; items
of which survive
by nostalgia

SCULPTURE of WESTERN NATURE

129 Robert Heinecken,
*How Does Posing for a Drawing Differ from a Photograph?*,
1977

He: How does posing for a drawing differ from
    a photograph?
She: For a drawing you have to hold your body
    in a given position - often for a long time.
He: And for a photograph?
She: Well, it's only a flash.
                    Heinecken June 77  #3 of 3

131 Robert Heinecken,
*Lessons in Posing Subjects/*
*Simulated Animal Skin Gar-*
*ments*, 1982

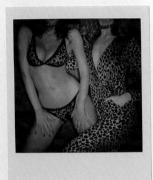 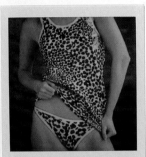 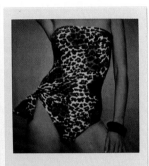  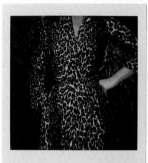

Posing subjects in garments designed to represent African animal skins achieves the sense of a wild and untamed predator. At the same time, the choice of these garments can conote a committed social and/or political conscience.

First, it proclaims a sympathy for the recent social taboo against wearing *actual* animal pelts. Secondly, it demonstrates understanding and support for the customs and interests of emerging 3rd World Nations. However, Terms such as "Jungle Beats", "a Tarzan Tan" and "Safari Chic" should not come to mind.

The leopard spot pattern predominates as is revealed in the top row and can be effectively adapted to garments ranging from lingerie, sports wear, business clothes to sophisticated evening wear.

The bottom row illustrates problems in the socio/politcal area. The simulated tiger skin print in the first two fail because they transgress the zoologic fact that on the actual animal the stripes run transversely, not horizontally.

The 3rd example attempts to personify the Zebra skin but is too easily confused with ordinary Anglo stripes. Number 4 typifies political misguidance as it relates to the 3rd World. i.e. A Tiger pattern is embarrasingly misidentified as having the colors of a Zebra. Finally, the snake skin garment is deficient because that reptile is not easily identified with any 3rd World Nation.

Lesson in Posing Subjects/Simulated Animal Skin Garments

 4/10

Heinecken 1982

75

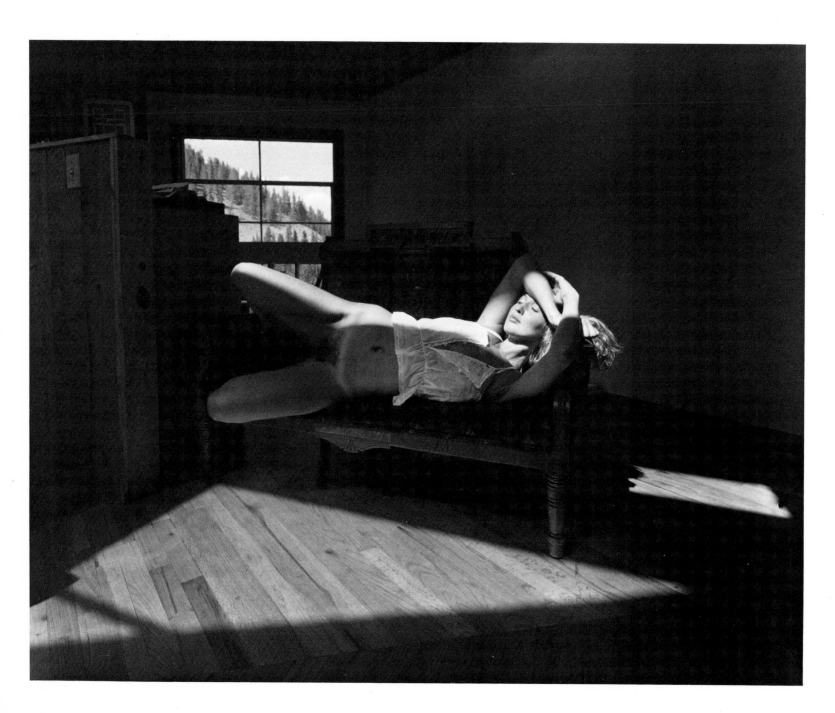

224 Jack Welpott, *Sabine,*
1973

58. Judy Dater, *Eating*, 1982/1983

59 Judy Dater, *Ms. Cling-free*, 1982/1983

In the seventies Americans experienced yet another major shift in attitudes about their country and its future. A number of events at the outset of the decade played a role in the rise of pessimism: the Kent State deaths (1970), the Watergate break-in (1972), the Arab oil embargo (1973), the retreat from Vietnam (1973), the scandals surrounding the Nixon administration and the eventual resignation of the president (1974), and the threatened economic collapse of several major cities (1975). With the oil embargo we became very much aware of our dependence on other countries and of the limitations of the earth's resources as well. The decline of the dollar abroad and the increasing rate of inflation at home signaled the end of the economic boom. America approached its bicentennial celebration with fears about the future and a lack of confidence in the system's ability to cure its ills.

As Americans came to doubt the individual's ability to effect changes in society, many began to reject the idealism of the sixties and turned inward in pursuit of self-improvement. Organizations and activities such as Esalen, est, transactional analysis, and Transcendental Meditation arose to minister to their psychological needs. In their spiritual searches, many joined quasi-religious groups like the Hare Krishna, Reverend Moon's Unification Church, and Jim Jones's People's Temple in Guyana. Yet others sought physical fitness, participating in activities like jogging and tennis, and eating health foods.

Writer Tom Wolfe dubbed the seventies the "Me Decade" because of this widespread self-indulgence and apoliticism. Some historians related the egotistical interests of trying to reach one's fullest potential to living "in a decade of exhausted public passions" in which "private passions reigned supreme."[1]

Other examples of personal expression could be seen in the women's movement, which began to lose its fervor as the eighties approached; in the gay liberation movement, which gained considerable voting power in cities like San Francisco; and in the interest in tracing family trees after the highly popular miniseries *Roots* was shown on television in 1977.

In 1979 fears of powerlessness became a sad reality when fifty-two Americans were held hostage in Iran, and their fellow citizens were forced to recognize that the prestige and power of the United States were no longer what they had been. The decade ended with the social liberalism of Jimmy Carter being replaced by Ronald Reagan's promises of economic conservatism and withdrawal of support for social programs.

Experimentation and pluralism were even more characteristic of photography in California in the seventies than they had been in the previous decade. Photographers themselves, however, would remember it as a time of artistic and economic opportunity. The boom began with the decade, and by 1975 art photographers were beginning to enjoy a considerable reputation. It even appeared that they would soon be able to support themselves in other ways than teaching: selling prints, getting book contracts, and in such related areas as curating, writing, or running galleries.

Several factors contributed to the boom. For one thing, the art world and its followers had expended too much enthusiasm on the movements and superstars of the sixties, and prices of fine art had risen dramatically. A number of dealers observed that photography might make a valuable sideline for clients with less to spend, and accordingly added a number of the better-known names to their rosters. Others appreciated the relatively low expenses of showing, storing, and shipping photographs, and began to open galleries that specialized in the medium. Photographs began to command interesting prices at auction. Dealers suggested increasing print values by limiting editions. The boom was on.

The most important contributors to this heightened visibility during the seventies were the schools. They had created a new and appreciative audience with the multitude of educational programs in photography that they had offered in the previous decades. Their importance cannot be understated, for as Arthur Ollman has observed: "good art needs a good audience."[2] Equally important, the schools had contributed to the development of the medium itself by training photographers who had begun to generate a tremendous volume of diverse and experimental work. Moreover, by inviting outside photographers to be visiting artists, teachers, and lecturers, the schools had also encouraged the expansion of the network of opportunities and the breakdown of regional trends.

Once the students had been introduced to new ideas, they came to demand a greater diversity in programming, which led to changes in the kind and number of photography classes offered. The San Francisco Art Institute is a good example of a school that changed significantly during the seventies. Larry Sultan has observed:[3]

It is a much more vital place now than when I went to school there. . . . The experience that led to . . . my collaboration [with Mike Mandel] was this frustration with what we both saw as academic tradition: resistance to new ideas, to redefining photography, and a resistance to any kind of interdisciplinary approach.

By the second half of the decade, however, several people who work in less traditional styles—such as Ellen Brooks, Steve Josephsberg, and Harry Bowers—were hired to expand the directions of the teaching at the school.[4] Not only was the faculty opened up to include more viewpoints, the school made an effort to increase the number of workshops, lectures, and exhibitions that offered photographers a greater public exposure.[5] Sultan says that when he returned to the Art Institute as a teacher in 1978:[6]

It was very exciting because . . . the questions being asked were: What does photography have to do with life? What is the significance of the photograph to one's experience? That was really becoming a large part of the dialogue . . . between formalism and postmodernism. . . . So I feel SFAI was a vital core for the questioning going on now.

San Francisco State greatly increased the number of photography courses it offered, and people like Van Deren Coke, Henry Holmes Smith, Melanie Walker, and Neal White were invited to teach or lecture there.

A number of State's graduates of the sixties began to make names for themselves during the seventies. Judy Dater, who was married to Jack Welpott for a time, collaborated with him on a project of portraits of women that was published in 1975 as *Women and Other Visions*. She has continued to concentrate on portraiture, trying, as Anne Tucker has pointed out, to make her subjects "express something about themselves which definitely exists, though it may be hidden—perhaps even from themselves."[7] Her recent self-portraits are setup situations photographed in color or black-and-white, which comment on role-playing and facades.

Michael Bishop, who has taught at SFAI, UCLA, and schools in the East, is interested in investigating the camera's viewpoint. He does this by depicting familiar objects, such as a tree and a lawnmower, from unusual angles and in uncommon relationships to each other, showing them to us in ways that we might not perceive simply by looking at them.

Leland Rice went on to teach at a number of California schools, to curate exhibitions, and to write about the medium, but he is nevertheless best known for his photographs. The large color images that he has produced in recent years appear painterly because of their expansive forms and linear splashes of color. He tends to work indoors, often in the studios of other artists, selecting spaces that appear almost abstract, but always including some element (a paint can, a wall socket) that reminds us that these are pictures of real places.[8]

Other educational centers in the Bay Area continued to introduce or expand photography programs during the seventies. The ASUC Studio in Berkeley offered guidance to students, particularly in the area of publishing, under the direction of Roger Minick. Students Richard Misrach and Steve Fitch were among those who published their own books. Fitch highlighted symbols of American highways in *Diesels and Dinosaurs*, which was about signs from roadside eateries and truckstops. In later work, he concentrated on color studies using light from electronic flash, car headlights, and streetlamps. Misrach produced

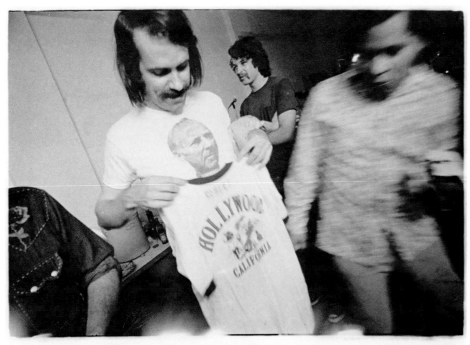

ROBERT FICHTER'S GOING AWAY PARTY, JUNE 1972, CULVER CITY, CA
ROBERT FICHTER WEARING AN EDWARD WESTON T-SHIRT

Robert Fichter's going-away party, June 1972, Culver City, California

*Telegraph* 3 A.M., a book on streetlife in Berkeley. He then worked on several series on the Western landscape which were completely devoid of the human figure. Making nighttime exposures, with electronic flash for additional illumination, he created scenes with an almost magical presence in which desert plant forms appear to make human-like gestures. Misrach's work reflected one of the changes in photography in the seventies, moving from social statements to giving pictorial information about the world.[9]

Of all the new programs to open in the north in the seventies, perhaps none was as ambitious as the one at Lone Mountain College in San Francisco. From 1970, when photography courses began, until 1978, when financial difficulties forced the college to shut down, they offered a considerable alternative to the well-established and academically grounded courses at the two major schools of the Bay Area. The permanent faculty was tiny—consisting of Gregory MacGregor, Larry Sultan, and Jane Wattenberg—but energetic, and the students proved to be very serious about their work.

Although MacGregor was busy as the administrator as well as being a teacher, he became known for his own work. In his on-going series, he often assigns or invents new associations for familiar objects by hand-coloring the surroundings or placing them in unexpected contexts. In his Explosions series he creates situations that are reminiscent of scientific experiments.

Among the best known of Lone Mountain's students is Arthur Ollman, whose work had been internationally exhibited by the late seventies. Until recently, these were mostly of urban environments at night, using existing light and strobes, long exposures, intense color, and unusual perspectives to alter the experience. Ollman has also made a series of videotaped interviews with major photographers as part of a history project, and has been active in San Francisco Camerawork, a professional organization for photographers. In 1983 Ollman became the director of the newly formed Museum of Photographic Arts in San Diego.[10]

The program at the University of California at Davis began in 1970, when Harvey Himelfarb, a graduate of San Francisco State and a member of the Visual Dialogue Foundation, started teaching there. While Himelfarb is the only full-time staff member, many important guest and short-term lecturers—including Lewis Baltz, Robert Frank, and John Spence Weir—have rounded out the program. Davis, which confers a master's degree in photography, continues to have an open attitude toward the arts as a result of faculty members like Robert Arneson, Himelfarb, Wayne Thiebaud, and William T. Wiley. Himelfarb's work has a formalistic and fine-print quality in which geometric forms predominate, and each work is honed down to the smallest number of elements.

Downstate, UCLA continued to play the major role among the universities. In addition to Heinecken and Fichter, there has been an extensive guest faculty made up of photographers from all over the country, including such people as Michael Bishop, Judith Golden, Mark McFadden, Bart Parker, Keith Smith, and Karen Truax.[11]

The unusual thing about UCLA, as John Brumfield has observed, is that:[12]

> The range and the diversity of the kinds of work that come out of that school is pretty remarkable in the fact that it's a small program to begin with, limited in some years to two new graduate students.

That is a strength too . . . a built-in guarantee of a kind of intensity.

The California Institute of the Arts (Cal Arts) moved to its new home in Valencia in 1970. A private art school, it evolved from Walt Disney's dream of merging the Chouinard Art Institute with the Los Angeles Conservatory of Music. The first director was Ben Lifson, whose own work concentrated on street photography from a formalist point of view. Under John Brumfield, who became the director in 1975, photography became part of the art-school curriculum, so that students must take courses in contemporary art history and in criticism. The highly motivated and liberal faculty, which includes photography-oriented artists like John Baldessari and Douglas Huebler, has furthered the breakdown of barriers between mediums.[13] Brumfield has broadened ideas on the medium with his essays and criticism, as well as with his own work, which treats photography as a channel for ideas.

The University of Southern California also offers photography as part of the curriculum of the school of fine arts. Philip Melnick started the program there and was succeeded by Robbert Flick in 1976. While the selection of courses is still small, Flick helps compensate by maintaining a close association with the rest of the photography community and directing a lot of his energy into teaching. His own work comprises several different series that examine the physical environment. He has created unusual views of Los Angeles with grid-like structures of one hundred different images. Each tiny image is one view; together they read like an unfinished puzzle that the viewer must complete.[14]

Other noteworthy institutions that taught photography in Southern California in the seventies include the University of California branches at Riverside, San Diego, and Santa Barbara; California State University, Fullerton; Brooks Institute, Santa Barbara; Loyola Marymount University, Otis Art Institute of the Parsons School of Design, and Mount Saint Mary's College in Los Angeles; Pasadena City College; and Pomona College in Claremont.[15]

One of the changes that the boom effected was a marked increase in publishing. Reproductions in books and magazines have long been of sufficient quality to encourage the creation of publications dedicated to fine-art photography, but the small audience

and the expense of printing kept these works to a minimum. The growing demand was met first with monographs on the work of individual artists, but critics and curators soon began to write on a greater variety of subjects, and a number of important books were released. These ranged from selections of the work of particular groups, as with Anne Tucker's *The Woman's Eye* (1973), to the treatment of certain styles of photography, such as Jonathan Green's *The Snapshot* (1974), to scholarly studies that opened up new territories, which was the case with Van Deren Coke's *The Painter and the Photograph* (1972).[16] At the same time, a number of critics began to recognize the wealth of material to be mined from an examination of the nature of photography. Susan Sontag's *On Photography* (1977) and A. D. Coleman's *Light Readings* (1979) initiated serious discussions of the medium as art, examining its uses, meanings, and practitioners.

Museums and universities played an increasingly important role in making the public aware of photography, first by expanding the number and kinds of exhibitions, and second simply by serving as a "seal of approval." Significant changes took place at the M. H. de Young Memorial Museum under the direction of curator Thomas Garver, and at the San Francisco Museum of Modern Art, where director Henry

John Baldessari, *Untitled*, 1976, from the portfolio *Raw Prints*, lithograph with Ektacolor print, 14¾ × 20½" (37.3 × 52.0). San Francisco Museum of Modern Art, Purchase, 76.131.6

Jerry McMillan at opening of the exhibition *Jerry McMillan: Recent Work*, held September 23–November 1, 1981, at the Baxter Art Gallery, California Institute of Technology, Pasadena

Hopkins hired Van Deren Coke to replace the ailing John Humphrey in 1979. Coke, who established the museum's Department of Photography a year later, was a former director of George Eastman House and of the Art Museum of the University of New Mexico, Albuquerque.[17]

As critic Thomas Albright has pointed out, less attention was given during this period to "individual distinction, and more and more emphasis was placed on originating shows that would bring news of collective developments in art to the public."[18] The range of subjects for investigation quickly multiplied, and the number of exhibitions soon grew too large to list. A few of the more important ones should, however, be cited here.

The most influential show at the beginning of the decade was *Photography into Sculpture* (1970), which Peter Bunnell organized for the Museum of Modern Art in New York. Dedicated to three-dimensional works that made use of photographs, the show was well represented with artists from the West. This national exposure was valuable to California artists, and it was also influential in fomenting radical experimentation in other parts of the country.

In 1974, an exhibition at the M. H. de Young Memorial Museum, *New Photography: San Francisco*

*and the Bay Area*, summarized the latest trends in the north. Thomas Garver's catalog essay acknowledged the shift that was taking place toward ideational art. More and more, he observed, the photograph was being used to serve as a way of representing ideas rather than objects that exist in the real world. Two major gallery shows not long after that exhibition confirmed the trend. *West Coast Conceptual Photographers*, at La Mamelle, Inc., and *Photography and Language*, at La Mamelle and San Francisco Camerawork (both organized in 1976), presented photographers who used the medium to explore logic and ideas—a clear departure from those who had earlier experimented with using light and tone to express symbolic thoughts.[19]

One area of photography that was explored in some detail in shows during this period was of more than casual interest to Californians: the landscape. But unlike the days of Adams and Weston, the new landscape was often as much *in* the camera as in front of it. *The Extended Document* and *New Topographics*, both organized by George Eastman House in 1975, questioned the camera's veracity and its traditional role as a neutral observer; *The Invented Landscape*, at the Museum of Modern Art in 1979, displayed the work of photographers who create their landscapes with their cameras.

Near the decade's end, two exhibitions marked opposing viewpoints. *Mirrors and Windows: American Photography since 1960*, organized by John Szarkowski of New York's Museum of Modern Art (1978), presented a distinctly formalist approach to the medium. Although it included work by people like Heinecken and McMillan, it favored photographs of images that exist in the world and offered only a limited selection of works that employed subject manipulation or alteration of the finished print. The following year, Van Deren Coke organized an exhibition for the San Francisco Museum of Modern Art that represented a different direction. *Fabricated to Be Photographed* showed the work of artists who literally construct their subject matter or alter existing spaces in order to express their concepts. In supporting a multitude of theories and techniques, Coke's view suggested that photography has a closer relationship to mainstream art.

More commercial galleries dedicated to photography began to appear during the decade. In San Francisco, Sean Thackrey and Sally Robertson were

the first to open, in 1970. In 1974 the Grapestake Gallery was launched under the direction of Ursula Gropper and Tom Meyer, with a program that provides for approximately five shows of contemporary California and national photographers each year. The Stephen Wirtz Gallery, opened in 1976, was at first exclusively devoted to photography but eventually expanded to show other mediums as well. Jeffrey Fraenkel, who started his gallery in 1979 after working at the Grapestake, has brought in the work of many Eastern photographers, and in the process has helped forge stronger links between the local community and a national network. Douglas Elliot and Joseph Folberg began the Douglas Elliot Gallery the same year.[20]

Further downstate, the Friends of Photography continued its regular schedule of exhibitions at the Sunset Cultural Center in Carmel, and Margaret Weston opened the Weston Gallery in the same city in 1973. Other galleries in the city include the Josephus Daniels Gallery (1977) and Photography West (1980). The Collector's Gallery in Pacific Grove opened in 1979.

Galleries developed more slowly in the southern part of the state. Ohio Silver of Los Angeles was opened in 1971 by Randolph Laub, who was later joined by his wife Claudia. The Laubs tried to show as much work as possible, and generated a great deal of excitement—but, unable to turn the gallery into a profit-making venture, had to close down in 1975. That same year, however, the G. Ray Hawkins Gallery was launched with the intention of showing the "classics" of photography. When David Fahey was hired, he convinced Hawkins to add contemporary work to the roster and to include nationally as well as regionally known younger photographers. Hawkins publishes the *Photo-Bulletin* to provide background information on each exhibition and artist. Stephen White turned his bookstore into the Photo Album Gallery (it later became the Stephen White Gallery, and finally closed in 1982) four months after Hawkins started up. At that time he exhibited a full range of photographs, from nineteenth-century to contemporary work. He published catalogs on individual artists, put together several lecture series, and was a motivating force behind the idea of a photography museum in Los Angeles. Susan Spiritus in Newport Beach, which is over an hour's drive from Los Angeles, has shown only photography since 1976, and many

of her exhibitions have been of East Coast artists.[21]

Alternative spaces, publicly funded galleries that are not commercial but cannot be considered museums, began to appear in the seventies. For the most part these organizations have favored the newer and less traditional art forms, such as video and performances. One of the most influential in San Francisco has been La Mamelle, Inc., which began as a book and evolved into an exhibition space. It was started in 1976 by Carl Loeffler, under whose direction several exhibitions of experimental photography were sponsored.[22]

The other major organization in the north that has functioned as an alternative to the commercial and institutional spaces is San Francisco Camerawork. It was started as the Camerawork Gallery in Costa Mesa in 1968 by John Patrick Lamkin, whose original idea for it had been inspired by a talk given by Minor White. It was still a commercial gallery when he moved it to Fairfax in 1973 and then to San Francisco in 1975, at which time he expanded it to include other activities. In time, however, Lamkin decided to give it up and pursue alternative lifestyles. He sold the gallery for the sum of one dollar to a group of twenty-nine people from the photographic community, who renamed it San Francisco Camerawork and turned it into a nonprofit organization. Former president of the board of directors, Arthur Ollman, has described it as "a clearinghouse for ideas, a place to experiment."[23] Exhibitions are offered to emerging photographers or curators whose ideas may not yet be accepted in the usual channels, and all proposals are considered by a committee that is constantly rotated in order to represent a variety of viewpoints. Shows are changed every month, and lectures, seminars, and workshops are offered regularly. A bookstore and an archive are maintained, and a newsletter published.

There are also a number of alternative spaces in Southern California. BC Space, a custom photography lab run by Jerry Burchfield and Mark Chamberlain, offers exhibition space and other assistance to photographers. Cameravision is a cooperative that generally shows the work of younger photographers, and SoHo/Cameraworks provides exposure for lesser-known artists.

Funded by the city of Los Angeles, the Los Angeles Municipal Art Gallery in Barnsdall Park cannot be considered as either a commercial gallery or

an alternative space. However, it has hosted several major exhibitions, particularly during the latter part of the decade. Its location has also made it a central showplace for the photography community.

The Los Angeles Institute of Contemporary Art has provided frequent opportunities for photographic exhibitions. Through the seventies it often shared its space with the Los Angeles Center for Photographic Studies (LACPS), a nonprofit organization founded by a group of photographers in 1973. In a permanent home since 1980, LACPS has evolved from a group whose main goal was making photography more visible to a major alternative to commercial exhibition spaces. It was been an extremely important meeting ground for photographers who wish to share and implement ideas, and it has also offered support for photography as a fine art. The board of trustees comprises many of the leading artists and teachers in the photography community. LACPS usually organizes shows of contemporary work, some of which have traveled. The organization publishes extensive catalogs, a calendar announcing exhibitions and related activities, and *Obscura*, a bimonthly journal of critical articles on the medium. LACPS also sponsors a lecture series, maintains a slide registry, and publishes portfolios of artists' work.

One of the most important attempts to gain institutional support for photography in California was the organization of the Founders Committee of the Photography Museum. This group of collectors, dealers, and others interested in photography assembled in Los Angeles in 1980 to discuss ways to create a photography center. They prepared an exhibition, *Southern California Photography 1900–65: An Historical Survey*, which was shown as the Los Angeles County Museum of Art in 1980. Many other activities were planned in addition to the establishment of a permanent site for the center, but the group eventually disbanded when it seemed that they would be unable to obtain sufficient backing.

An increase in grants for photography was another major factor in the development of the medium in the seventies. The National Endowment for the Arts (NEA), which had been founded in 1965, extended its aid in 1973 to exhibitions of photography.[24] Although the NEA provided grass-roots funding for nonprofit organizations that show work and provide services for photographers, their policy with

museums was often to fund shows that would be seen by the largest possible audience, and this stimulated exhibition ideas with broader appeal and extensive travel schedules. Such shows helped extend the network of informed viewers, break down regional boundaries, and disseminate ideas. As Lewis Baltz succinctly put it:[25]

The only really strong decentralizing force in the art world in the 1970s was the NEA, which went out of its way to encourage work to be made and seen in various places throughout the country. . . . NEA funding gave regional institutions the first really solid financial base they had to pursue ambitious exhibitions. Museums that had been importers of New York shows a few years earlier began, with NEA help, to organize their own major exhibitions and put them on the road.

The NEA fellowship program, which began in 1971, offers financial assistance to individuals in the form of grants, so that they will have time to do their own work. Approximately thirty to fifty photographers receive these grants each year.

The California Arts Council, funded by the state government, offers grants to specific projects, exhibitions, individuals, and nonprofit organizations. Local governments have also participated—as, for example, has San Francisco through its Hotel Tax fund, which provides contributions to art institutions. Private funding from corporations and foundations has also become important.

The mass media played a part in increasing the visibility of the medium. Articles on trends, collecting, and specific photographers turned up in national periodicals such as *Time*, *The New Yorker*, and the *Wall Street Journal*. Major art magazines like *Artforum*—which provided California coverage first through Margery Mann's and then Hal Fischer's articles and reviews—and *Arts Magazine* began to examine the medium more closely in the seventies, reflecting the increase in gallery and museum shows. By the end of the decade, serious critical attention and evaluation of the medium was evident not only in magazines but in photography publications, journals, exhibition catalogs, and books.

In California, Joan Murray began reviewing photography in *Artweek*, a biweekly, now weekly, tabloid

on art-related activities in the state that was launched in 1970. Other important California periodicals included *The Dumb Ox*, edited by James Hugunin, *Picture Magazine* and *Photo Show*, originally edited by Don Owens, and *Bombay Duck*, edited by Ev Thomas.[26]

Not all of the effects of the boom were positive. The simple fact that people had begun to buy photographs was not enough. Insufficient attention was paid to quality. As Lewis Baltz has pointed out:[27]

> Once photographs became collectible, and once an affluent audience materialized that would only buy what it could grasp immediately, one began to see some of the lunacy that marked the high points of photography's go-go years. Magazine pictures by every hack that ever worked at Magnum —or dreamed of working at Magnum—were in galleries; commercial work by slick illustrators like Avedon was given museum retrospectives; Adams was rehabilitated and repackaged in the most skillful marketing venture of all. The audience probably got exactly what it deserved, but photography, as a medium of thought, got less of a hearing than it was entitled to. Photography became the junk food of the art market.

While photography was experiencing its economic boom, California was contributing to its rapid growth by producing many innovative and influential photographers whose diverse styles expanded approaches to the medium. Major stylistic developments included a more widespread use of color; the fabrication of subject matter; the creation of large-scale prints; and the combining of words and photographs in symbiotic relationships, so that neither element is complete without the other. More and more, the photograph was used to explore visual ideas, mainly by exploiting the camera's unique perceptual qualities. Particularly appealing were those that played on the differences and ambiguities that exist between camera illusion and subjective reality, drawing attention to how the camera can alter the ways that we see things. Staged situations that examine human interactions and relationships also became more popular— and these too were often intended to make the viewer aware that the information is transmitted, limited, and shaped by the camera.

Photographers may use several of these stylistic

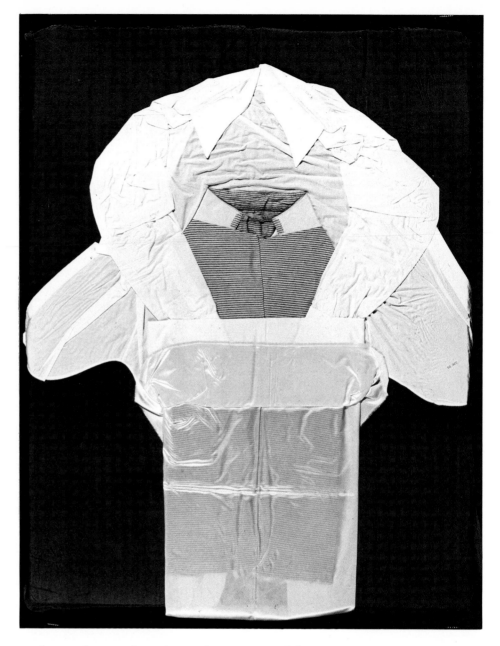

modes simultaneously in the implementation of their ideas. For example, color and increased scale have become major trends, but they are only employed by an artist when they are necessary to the expression of his or her ideas. Since a technique is applied to serve the purpose of the artist, common methods may often yield different results. For example, one photographer may depict interactions to express a linguistic concept while another may produce very similar images for the purpose of commenting on social roleplaying. Therefore, the following discussion should

Harry Bowers, *Untitled* (HB-24-80), 1979/1980, Ektacolor print, 4/10, 49⁷⁄₁₆ × 39½" (125.6 × 100.4). San Francisco Museum of Modern Art, Gift of Dorothy Goldeen, 82.490

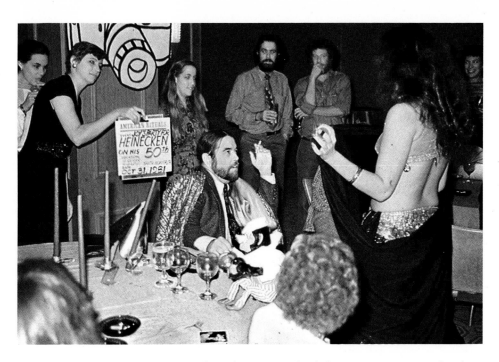

Party for Robert Hein-
ecken's fiftieth birthday,
October 31, 1981

*Eros & Photography* (1977) by Donna-Lee Phillips, *Gay Semiotics* (1977) by Hal Fischer, and *Structural(ism) and Photography* (1978) by Lew Thomas.[28] Among the other artists who share this outlook are Meyer Hirsch, Fred Lonidier, Ilene Segalove, and Phil Steinmetz.[29]

Since context plays a critical role in communicating ideas, all of these photographers are careful to control the ways in which they present material. Frequently the artist will use words, phrases, or sentences to fix our connotative associations of the images. Scale and the ordering of images (which are often in sequence) are also very important.

Conceptual photographers sometimes create the subject they are depicting. This is almost always the case with a number of other people who might be gathered under a style that could be characterized as fabricated photography.

In most cases, those who work in this fashion are exploring the perplexities of camera illusion as compared with real situations. These manipulations of subject matter offer a particularly rich area, and photographers have managed to develop completely different styles within this tendency.

Jo Ann Callis is a master at creating strange scenes. From the early black-and-white Morphe series to her more recent color work of animals and inanimate objects, Callis has placed her subjects in mysterious and ambiguous situations. We are usually given only a few clues to what is happening: in one photograph a young child lies on a bed with a light casting an eerie pink glow on her naked body; in another, a parrot peers at a sailboat floating in a bathtub.

Robert Cumming, who came to California in 1970, invents his own subjects. His pictures begin as creations of his imagination, which he renders as sculptures that are often strong in wit and irony. By using the camera to verify the existence of these unlikely situations, he plays with our ready acceptance of the camera's "truth," questioning our perceptions and commenting on our attitudes toward life. Cumming uses black-and-white film to exploit the association with newspaper pictures and make his works resemble documents of real events.

Phillip Galgiani's approach is more abstract. He works in his studio, placing objects such as hats, glasses, chairs, and lights in odd relationships. His own hands often appear in the picture interacting

not be taken to imply definitive categories of styles, but only general approaches.

Lew Thomas has been a key person in supporting and propagating the concept of the photograph as a tunnel through which information travels. Having become disenchanted with the pretensions he found in the formalistic approach, Thomas decided to pursue his interest in the photograph as idea, using it to examine the systems around us and to question our relationships to those systems. To Thomas, the principal concern of the photograph should not be aesthetics or the reflection of the world, but the giving of information.

In the early seventies, Thomas observed contemporary art movements—such as Pop, Minimalism, and particularly Conceptual Art—in which many artists were using photography as a secondary means of communicating theories. He began to work in this fashion in 1971, but received little encouragement until 1976, when Carl Loeffler at La Mamelle, Inc., invited him to co-curate *West Coast Conceptual Photographers*. Shortly afterward, John Patrick Lamkin asked Thomas and Loeffler to curate *Photography and Language* for the Camerawork gallery.

One result of these activities was the development of a loose association of artists with shared aims. Other important examples of the new trend were soon forthcoming, notably in the form of several books:

with the objects—creating often puzzling juxtapositions that sometimes suggest a magician practicing tricks.

John Divola alters spaces before he photographs them, and it is often difficult to distinguish what he has added. He employs spray paint and other methods of marking, using intense colors to manipulate the perceptual space and heighten the conflict between illusion and reality.

Steven Cortright creates an interplay of illusion and reality by adding objects to the surface of the print. He photographs compositions of broken glass and other debris, then enlarges the image to lifesize, hand-colors it, and attaches some of the original bits of glass.

In contrast to Cortright, Harry Bowers's fabrications are not only concerned with illusion. In his early work Bowers arranged pieces of clothing to imitate human gestures, adding captions that helped establish the frame of reference. In his more recent work, however, the clothing often serves as a backdrop for other elements, and the stylized situations suggested are often sexual in nature. Color and large-scale printing, often 40 x 50", are essential elements of his style.

Other photographers interested in camera illusion have chosen to base their photographs on existing subjects. Among them is Richard Ross, who has made much use of ready-made tableaux, photographing wild animals in lifelike settings that are in fact exhibits in natural-history museums. (In some recent work he has given this an interesting twist by photographing stuffed replicas of wild animals that have been gathering dust in the storage areas of museums.) In a different vein, a recent series on dogs combined fabricated scenes with factual photographs to produce witty commentaries on camera illusion. In one example, an old picture of a dalmatian, taken by someone else, was juxtaposed with one taken by Ross of another kind of dog with paper circles taped on its body.

Robert Heinecken has continued his exploration of what is and isn't real in a unique way in one of his recent series. Using advertisements from fashion magazines and other sources, he invents a storyline to describe the sequences he has created. Thus reconstituted, the ads take on new meanings, and Heinecken questions the manipulation of reality not only by the media but by the camera as well.

For many photographers, the real world is sufficiently suggestive and surprising without manipulation of any sort. They find their sources in the urban landscape itself, and photograph it in ways that make their commentaries quite clear.

Lewis Baltz, Joe Deal, and Henry Wessel, Jr., use the camera to transmit information about the vacancy of modern life. Their images offer a detached look at the world—not in the documentary manner of the thirties and forties nor the casual, off-hand manner of someone like Robert Frank, but in a studied and formalistic way. Baltz has created several series in which housing developments and industrial sites appear—at first glance—to be simple and emotionless presentations. But they are not free of judgment. Baltz has deliberately sought out compositions that reveal blandness. For example, the unrelenting repetition of forms serves as a statement on the loss of individuality in mass society. Joe Deal works in a similar vein, photographing such subjects as suburban houses, city homes, and apartments from a set distance and perspective, so that the viewer only sees a segment of the chosen subject, forcing the eye to look at details in the images—such as the dweller's material possessions—that reveal our fascination with and need for physical comforts. Wessel, who is more likely to include people in his pictures, presents them as part of the urban landscape. His images reflect the incongruous relationship today between people and their environment.

Toward the end of the decade, more and more artists began to use photography in socially referential ways, signaling the need for more substantial meaning in both life and art. Although their styles vary greatly, they are all attempting to relate their personal concerns to the world at large. In the past, such work might have been aimed at evoking sympathy for the subject or rallying people against an unjust act. Today's images, however, are connected to a postmodernist view of art-making which relates it to the problems one faces in a fast-moving, often chaotic, and psychologically trying existence. John Brumfield, for one, deals with behavioral patterns in his sequenced images of people posing; each descriptive title provides an appropriate frame of reference. In *Robert Posing as a Hollywood Star*, for example, the character awkwardly imitates the role, revealing the falseness of both the original pose and his attempt to assume it.

Hal Fischer takes another approach. In one series he presents what appear to be candid portraits of gay men juxtaposed with well-composed dialogue that describes each individual's thoughts on his relationship with someone else. Reading the statement makes the viewer feel like an eavesdropper on an intimate conversation.

Victor Landweber expresses his social and political cynicism in several series by using consumer items such as candy, cameras, or paint samples. Sometimes he combines other mediums with his photographs to produce collages, creating works that play on the visual attraction of popular industrial products and reveal something of the attachment the public feels for them.

Some photographers reveal their feelings by involving their subjects in more than posing. Jim Goldberg, for example, concentrates on portraits, his subjects ranging from transient hotel dwellers to the urban rich. In order to avoid misrepresenting his subjects, Goldberg involves them in the creative process. Together they select a photograph, on which the subject is invited to write his or her own comments. The often startling intensity of the commentaries, their revelations, and the immediacy of the handwriting, help break down the distance between subject and viewer.

Chauncey Hare and Fred Lonidier have developed new approaches to an old concern: the exploitation of workers by big business. Hare goes into people's homes to interview them as well as photograph them, and uses the materials to create verbal/visual statements about their lives. Lonidier, in one series, photographed the injuries of people who had been hurt in job-related accidents, and exhibited the photographs with statements by the workers about the irresponsibility of the employer.

The collaborative ventures of Mike Mandel and Larry Sultan embrace a number of notions and styles to make comments on cultural and political influences in our lives. Often they blur the distinction between the camera's reality and our own in order to force us to be more aware of the manipulative nature of the world. In *Evidence*, which was both a book and an exhibition, they explored the effects of context on the camera's vision. Photographs were selected from governmental and industrial files and shown without any indication of their original purpose. The images are puzzling and even bizarre, making us question our acceptance of them as evidence of actual events. In another on-going series, Sultan and Mandel draw attention to the ways in which we process information from billboards. Situations are set up, photographed in color, and produced on the scale of billboards. By placing these in actual billboard locations, they negate the preciousness of the photographic object—and share their work with the community at large.

Staged situations that express an idea or concern are by far the most popular method of expressing social concerns. These can take an appealing variety of forms.

Women photographers in particular have used this technique to examine or reveal personal concerns about male/female relationships and role expectations. Ellen Brooks has been using miniature plastic figures to create situations that often resemble domestic interplay. Eileen Cowin's photographs deal with relationships between people, words and images, and reality and fiction. She appears as director/narrator/actor in sequences that resemble movies; color and large scale intensify the dramatic quality of each scene. Ilene Segalove is another photographer who acts in her own scenes, juxtaposing them with stills from real motion pictures.

Others explore similar themes with more direct self-portraiture. Judith Golden does this to make tongue-in-cheek comments on the roles and facial facades assigned by America's mass culture. She often uses her own face, altering her natural appearance with a variety of hand-applied mediums, so that each image becomes a unique assemblage. Recently she has explored the idea of role-playing through life-sized color portraits of women. Joanne Leonard deals in a less direct species of self-portraiture when she uses photographs of her neighbors, collages that make reference to her marriage, or, more recently, kitchen countertops to comment on women's roles in American life. She adds color by hand, but uses it to convert the mundane into magical landscapes and scenes from the infinite night sky.

The impact on photography by California photographers in the seventies was manifold. Their pluralistic approach in ideology and stylistic mode often encouraged multimedia experimentation and subject or print manipulation. This gave a visually exciting and, at times, even exotic look to photography in

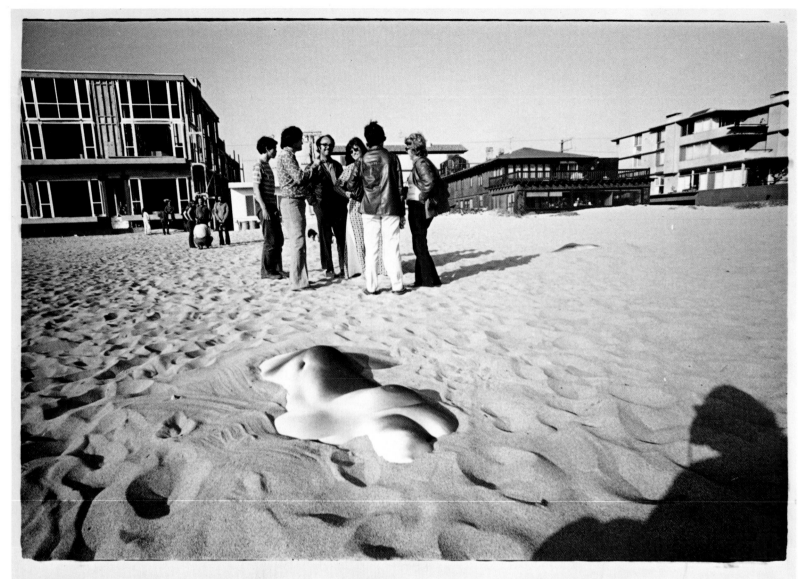

ELLEN BROOKS' M.F.A. SHOW, VENICE, CA

PHOTO: DARRYL CURRAN    ELLEN IN LONG DRESS AND SUNGLASSES , N.D.

California. The use of various mediums and new approaches has also served to unlock the doors that previously kept photography separate from the other arts. This in turn has led to intelligent discussions that looked beyond the photograph as simply an aesthetic or experimental object. Ways were found for photography to relate to reality in a nondocumentary manner, so that instead of merely serving as a record, the photograph was used to reveal different ways of looking at the world and to communicate things about how the world functions and how it affects us. In the process, photography became socially referential in an unemotional manner, contributing to the postmodernist discourse on the relationship of art to the world in which it exists.

By the end of the decade the decline of the boom had begun; it would continue into the eighties, bring-

Ellen Brooks's Master of Fine Arts show, Venice, California, 1971

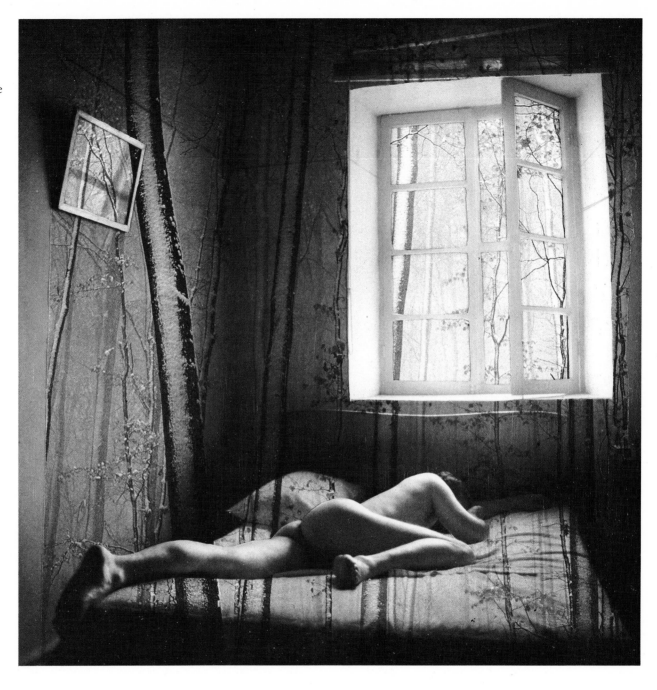

Joanne Leonard, *Sad Dreams on Cold Mornings*, 1971, from the series *Dreams and Nightmares*, 1971–1972, collage: positive transparency, selectively opaqued, over color magazine reproduction, 9½ × 9⅜″ (24.2 × 23.8). San Francisco Museum of Modern Art, Purchased with the aid of funds from the National Endowment for the Arts, 1975 Soap Box Derby Fund, and the New Future Fund Drive, 77.85

ing with it many changes. The first of these, of course, was the effect it had on the photographers' lives. Although for a while it seemed that many of the better art photographers would be able to make a living from their work, few were able to sustain themselves for any length of time. As Arthur Ollman has observed:[30]

It looked as if the rewards being garnered . . . were greater than they actually were. The number of people in California making more than $10,000 a year selling photographs is a very small number.

And as the recession set in, fewer grants were given by both the public and private sectors. At the same time, the galleries retrenched, leaving photography for more secure and profitable sales. Tax-cutting ini-

tiatives like California's Proposition 13 hit the museums' budgets, reducing the number of exhibits and purchases. Looking back, John Spence Weir has concluded:[31]

> I don't think it was ever a limitless growth . . . but there were opportunities. If you worked hard and you made an effort to be successful . . . you could be recognized. . . . Right now there is a depression in the gallery scene. . . . You have to take a job as a postman or . . . any kind of job that supports your habit, so to speak.

Those who have stayed in the field are clearly aware of the difficulties, and most accept the fact that they are unlikely to show a profit at it. Perhaps this will ultimately prove a benefit to photography, since only the true devotees will continue, as Judy Dater suggests:[32]

> You have to be so dedicated to your art that you will be willing to spend the kind of money it costs to keep doing it. . . . It's going to be harder and harder for someone who is not seriously involved to even finance it. Probably half my income goes right back into my work. . . . The other half goes for living.

The boom also weakened the links of the photographic community. No longer was there a small enclave of mutually supportive artists. The community had grown too large to maintain social contacts and the stakes were too high. Robert Fichter recalls that in the sixties:[33]

> It was almost like a Greek fishing village, when someone would say, "Great, come in and sit down." Now it's like everyone is broken into camps and galleries; it's a very different thing.

The network itself had changed during this period, its center shifting from the educational institutions to the gallery and museum circle, with its greater potential for exposure. And even if a photographer were recommended for a job or an exhibition, there were now so many people competing for each opportunity that chances of getting it were greatly reduced. The very network that had created a broad system of support for individuals now contributed to the breakdown of that support as they received less attention and encouragement.

There were other, less tangible effects that became obvious in the postboom period, as Lewis Baltz has noted:[34]

> I'd be very sorry to see a repeat of the late fifties and early sixties, when photography was more of a cult than an art. That was such a demeaning time—photography was so closed and had such an undercurrent of servility and defensiveness. . . . The boom brought a lot of opportunism into photography, but at least it blew open the doors and the windows and cleaned out some of the mustiness.

The postboom decline appears to have had a sobering effect on the work of photographers as well as on their aspirations to riches and fame. By and large, it has become less experimental. New and more serious themes have appeared, particularly observations on the nature of life in this new era. It is a striking contrast to the vibrant exploration in photography and lifestyles that Americans had previously pursued as they searched for new values to replace the worn-out dreams of the sixties. Where the medium had been democratized in the sixties—with all ideas deemed acceptable—and privatized in the seventies —as experimentation reflected the search for individual satisfaction—the eighties promised that photography and its importance as an art form would have a more clearly articulated and sophisticated relationship to the milieu in which it exists.

# CONCLUSION

Since the end of World War II, photography has achieved a major presence as a creative art medium. People working in photography evolved from small groups in separate regions with distinct styles to a large number of practitioners and appreciators in many geographic areas who shared ideas. Along with the acceptance of photography as an art form came the artist's ability to use any idea or manner of execution to carry out his or her aims. Thus, the philosophy behind the imagery and its character became increasingly exciting, discerning, and complex.

California has always been an important center of activity, but during this time it produced the right set of circumstances to bring about changes in ways of thinking about photography. An open-minded attitude was nurtured, and with it came the adoption of a variety of ideas and styles which made the work here provocative in new ways, sometimes even flashy. From the experimentation initiated by Southern California artists to the rational concepts of the photography and language movement in Northern California, photographers here have championed different ways of using the medium. The constant consideration of new methods and ideas served to speed up their acceptance throughout America, especially when regional boundaries became less distinct.

There are many reasons why California offered a conducive environment for diversity. For one thing, there was the long tradition of creative photography. Perhaps more important, however, was the growing number of educational institutions offering courses and degrees in photography. This produced a tremendous increase in the number of photographers and a public that became the mainstay of the economic boom. Besides producing work, members of this group became teachers, collectors, curators, book buyers, and backers. The schools also served to validate the medium as a fine art by teaching it in art departments and sponsoring photography exhibits. Moreover, a nationwide network was established as teachers shared ideas and provided support by exchanging information about jobs and exhibition opportunities.

Very often the students taking classes in photography were those in tune with and even initiators of the cultural, social, and political shifts taking place in the country. In fact, it is easy to draw a connection between photography and its milieu. The increase in enrollment in photography classes can be linked to the increase in leisure time and the greater prosperity enjoyed by Americans after the Second World War. The increase in experimentation in photography—led by Southern California photographers in the sixties—appears to correspond to the interest shown by many Americans in the pursuit of alternative lifestyles and the shaping of political affairs.

During the first part of the seventies, a pessimistic cloud hung over many Americans. Realizing that social and political change would not come quickly, they turned to an endless variety of therapeutic means for self-improvement. California was usually at the forefront in these explorations. Similarly, photographers embraced a wide-ranging variety of new concepts to carry out their artistic intents. The economic boom at mid-decade forced photography out of the academic realm into a wider arena of exposure and criticism. The extended network produced by the boom provided many pathways to interchange current trends. It no longer mattered where the work was done; what was important was the possibility of different ways of using the medium.

By the end of the decade, economic decline had set in and artists had to rethink their hopes of reaping financial rewards from their art. Americans took a sober look at the country's ability to handle its internal problems, and the temper of the people became more conservative. Less experimentation took place in photography and the work became more serious. Particularly in California, evaluations of the art went beyond pure aesthetics to consider the work in relation to its environment.

The directions taken by photographers since 1945 have kept California in the vanguard of changes in thinking about photography. It has gone from a symbolic art object having meaning as a visual experience to an open-ended form for experimentation and communication. The photographer's aim, too, has shifted from depicting outer reality and private concerns to sharing personal observations about the external world. Today photography is no longer struggling to be accepted as art. It is frequently in the public eye, and there is a sophistication about the audience as well as the ideas of the artists. It is through such dynamic centers as California that photography has arrived and made its presence known in a visually stimulating and thought-provoking way.

# NOTES

1. Mary Beth Norton, et al. *A People & A Nation: A History of the United States* (Boston: Houghton Mifflin, 1982), p. 977.

2. Interview with the author.

3. Interview with the author.

4. Regan Louie, Larry Sultan, and Henry Wessel, Jr., also began teaching there in the seventies.

5. A number of the Institute's former students gained recognition during this period for their unique uses of photography. Among them were Stephen Collins, Phillip Galgiani, Ingeborg Gerdes, Jim Goldberg, Wanda Hammerbeck, Mike Mandel, Danuta Otfinkowski, Gail Skoff, and Larry Sultan.

6. Interview with the author.

7. *The Woman's Eye* (New York: Knopf, 1973), pp. 142–43.

8. Other former State students —among them Lawrie Brown, Hal Fischer, Gregory MacGregor, Catherine Wagner, and John Spence Weir —also went on to teach at California schools.

9. Mills College in Oakland, a private school for women, introduced a small but serious program that led to both a bachelor's and a master's degree in photography. Teachers have included Jim Crawford, Vilem Kriz, Joanne Leonard, and Catherine Wagner.

The University of California Extension remained extremely active under Thomas Baird's directorship, with as many as twenty to twenty-five classes offered at one time. After Stephen Collins took over in 1975, a commercial-photography component was added.

Other institutions in Northern California that offered photography programs that were well attended were California State College, Sonoma; California State University, Hayward; Chabot College, Hayward; Diablo Valley College, Pleasant Hill; Foothill College, Los Altos; Holy Names College, Oakland; Laney College, Oakland; San Jose City College; San Jose State University; Sonoma State University, Rohnert Park; Stanford University, Stanford; and the University of California at Santa Cruz.

10. The California College of Arts and Crafts, Oakland, began their graduate program in 1975.

11. Among the former students from UCLA who have become important in the field of photography are Ellen Brooks, Jack Butler, Jo Ann Callis, John Divola, Robbert Flick, Graham Howe, James Hugunin, Victor Landweber, Patrick Nagatani, Sheila Pinkel, and Sherie Scheer.

12. Interview with Irene Borger.

13. Other teachers have included Lewis Baltz, Jo Ann Callis, Robert Cumming, John Divola, Judy Fiskin, Anthony Friedkin, Steve Kahn, and Robert Ketchum.

14. Susan Rankaitis received her MFA degree in painting from USC, and then began using photographic paper as her canvas and the photographic process to achieve abstracted linear forms shimmering with silver-and-gold-toned fragments of shapes.

15. The University of California at Riverside began a program in photography in 1973 under Ed Beardsley's guidance. It is possible to get an MFA in photography. History of photography is taught in the art department. Teachers have included Jack Butler, Joe Deal, Kenda North, Herb Quick, and Gordon Thorpe. The California Museum of Photography, located on this campus, was founded in 1978.

Photography has been part of the curriculum at the University of California at San Diego since 1969. There are no degrees in photography, only a BA and MFA in art. Teachers have included Becky Cohen, Connie Hatch, Jean Kennedy, Fred Lonidier, Allan Sekula, and Phil Steinmetz.

Photography was taught on and off at the University of California at Santa Barbara for fifteen years, and regularly for the past five. The school has had an unusual variety of teachers, many of whom incorporate other mediums in their photography (such as Steven Cortright, Richard Ross, and Ilene Segalove). Other teachers have included Anthony Hernandez and Mike Mandel.

The California State University at Fullerton has had a number of influential students and teachers. Eileen Cowin and Robert Cumming both taught there, as did former student Jerry Burchfield.

16. *The Painter and the Photograph* was originally published as a catalog in 1964.

17. Other museums in the north that included photography in their programming during this decade were the Downtown Center of the Fine Arts Museums of San Francisco; Monterey Peninsula Museum of Art, Monterey; San Jose Museum of Art; the Stanford University Museum and Art Gallery, Stanford; and the University Art Museum, Berkeley. In the southern part of the state, exhibitions were seen at the California Museum of Science and Industry, Los Angeles; Downey Art Museum, Downey; Laguna Beach Museum of Art; La Jolla Museum of Contemporary Art; California State University at Long Beach Art Museum and Galleries; Los Angeles County Museum of Art; Newport Harbor Art Museum, Newport Beach; Pasadena Art Museum; Santa Barbara Museum of Art; and the California Museum of Photography at the University of California, Riverside.

18. "The Contemporary Art Museum: Irresponsibility Has Become Most Widespread," *Art News*, 79 (January 1980), p. 44.

19. Other key shows organized in California during the decade were *California Photography 1970*, 1970, University of California at Davis; *24 from L.A.*, 1973, San Francisco Museum of Modern Art; *Emerging Los Angeles Photographers*, 1977, Friends of Photography, Carmel; *Contemporary California Photography*, 1978, San Francisco

Camerawork; *Photography as Artifice*, 1978, California State University, Long Beach; and *Attitudes: Photography in the 1970s*, 1979, California State University, Fullerton.

20. Other galleries in San Francisco that began to show photography in addition to their regular programming include the John Berggruen Gallery; Foster Goldstrom Fine Arts; Fuller Goldeen Gallery (formerly the Hansen Fuller Gallery); Grosvenor Towers Gallery; Jehu Gallery; Lawson Galleries; Northpoint Gallery; and Smith Andersen Gallery (in Palo Alto). Focus Gallery and the Simon Lowinsky Gallery (formerly the Phoenix Gallery) continued to hold many exhibitions of artists from across the nation, as they had in the sixties. The Bank of America intermittently scheduled shows in its Concourse Gallery, located in its corporate headquarters, as did the Standard Oil Company of California in its Chevron Gallery.

21. Galleries in the south that currently show photography along with other work include the Cityscape Gallery in Pasadena and the Janus, Meghan Williams, Margo Leavin, Rosamund Felsen, and Tortue galleries in Venice. The ARCO Center for Visual Art in Los Angeles, supported by corporate funding, hosts many photography exhibitions. Galleries that showed photography in the seventies but have since closed include the Broxton Gallery, Los Angeles; Jack Glenn Gallery, Corona del Mar; Light Gallery, Los Angeles (a branch of the New York gallery); Nuage Gallery, Century City; Ross-Freeman, in the San Fernando Valley; and Thomas-Lewallen, Santa Monica.

22. Photography was also seen in San Francisco in alternative-space shows at the Exploratorium; AIR Gallery; Capricorn-Asunder Gallery (funded by the San Francisco Arts Commission); 80 Langton Street; Galería de la Raza; Nanny Goat Hill Gallery; Project Artaud; 63 Bluxome Street; and at Darkroom Workshop in Berkeley.

23. Interview with the author.

24. This continued until 1981, when photography grants were placed under the same heading as the other visual arts.

25. Interview with the author.

26. In addition to Mann, Fischer, and Murray, other important California writers and critics include Robert Atkins, Irene Borger, John Brumfield, Van Deren Coke, Cathy Colman, Ted Hedgpeth, James Hugunin, Deborah Irmus, Mark Johnstone, Donna-Lee Phillips, Dinah Portner (Berland), Martha Rosler, Allan Sekula, and John Upton.

27. Interview with the author.

28. Related articles and essays by such authors as John Brumfield, James Hugunin, Robert Leverant, Martha Rosler, Sam Samore, and Allan Sekula appeared in many national magazines and exhibition catalogs.

29. John Baldessari, Peter D'Agostino, and William Wegman also use photography in their art-making, but they are considered to be conceptualists rather than photographers.

30. Interview with the author.

31. Interview with the author.

32. Interview with the author.

33. Interview with Irene Borger.

34. Interview with the author.

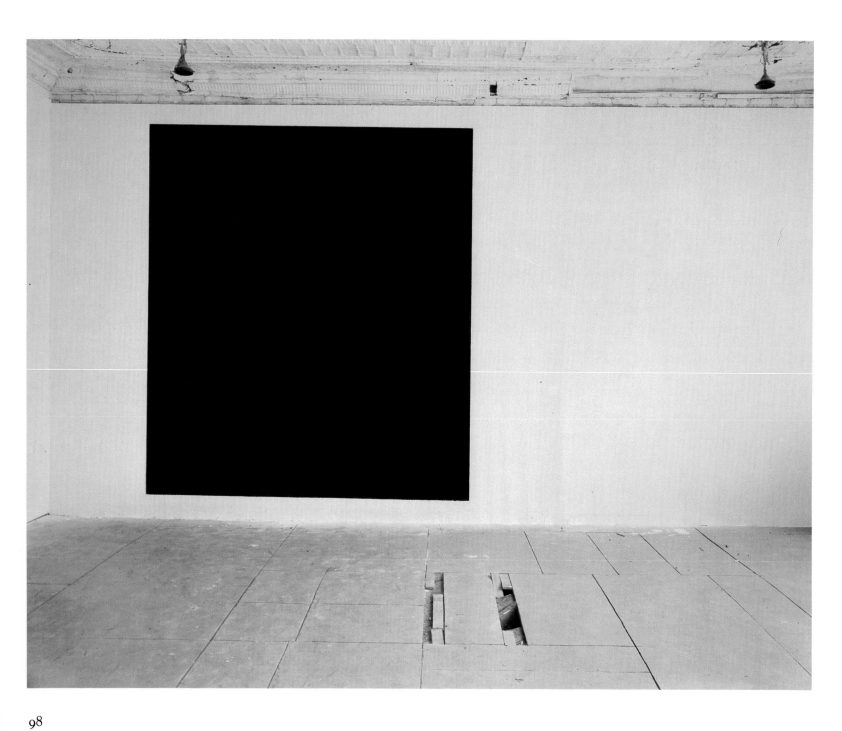

204 Leland Rice, *Untitled,*
1978

135  Harvey Himelfarb,
*Untitled,* 1980

70 John Divola, *Untitled,*
1977/1982

67  John Divola, V3, 1974

142  Barbara Kasten,
*Untitled*, 1977

146 Barbara Kasten,
*Construct LB/6,* 1982

106

145 Barbara Kasten,
*Construct LB/4*, 1982

174 Jerry McMillan,
*Untitled*, 1982

13 Michael Bishop,
*Untitled,* 1974

229 Henry Wessel, Jr.,
*Mission Beach, California,*
1973

227 Henry Wessel, Jr., *San Francisco, California,* 1972

61 Joe Deal, *Corona Del Mar, California,* 1978

62  Joe Deal, *Laguna Beach, California,* 1978

2 Lewis Baltz, *Northwest Wall, Unoccupied Industrial Spaces, 17875 C and D Skypark Circle, Irvine*, 1974

1 Lewis Baltz, *Tract House #22*, 1971

85 Robbert Flick, *Along Ocean Park, Looking West, Summer, 1980,* 1980

87 Robbert Flick, *Saguaro National Monument I*, 1982

184. Richard Misrach, *The Sante Fe*, 1982/1983

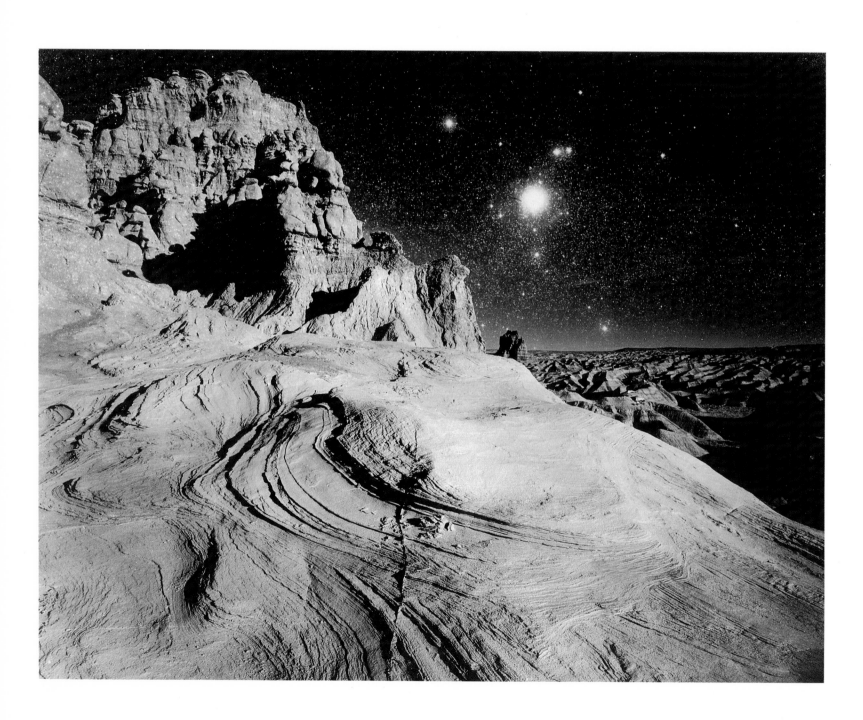

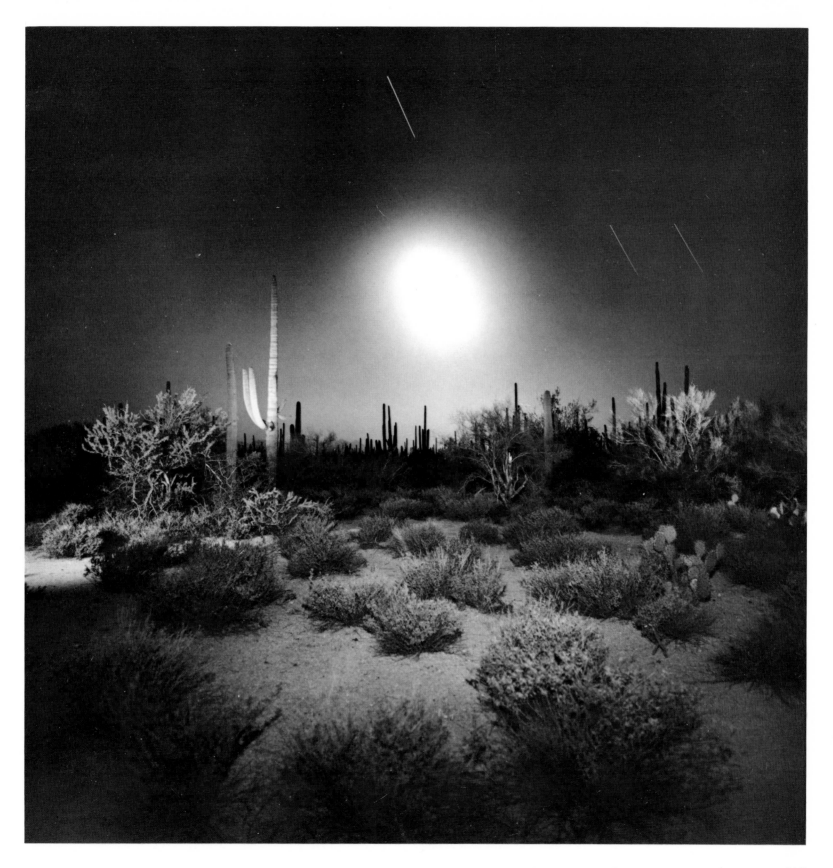

CHINA RANCH, 1979
DEATH VALLEY SERIES

## CHINA RANCH

Chinese labor was cheap and fairly reliable in the early days of Death Valley mining. In the borax mines the Chinese were hired to collect the borax, build the roads and generally do a lot of the hard, unpleasant tasks. Quon Sing was a cook at the Old Harmony Borax Works. As the story goes, he left Harmony to work for a Mr. Osborn, a wealthy mining man with interests near Tecopa. He served him long and well and for that he was given a parcel of land in Rainbow Canyon south of Tecopa. The land was not considered to be worth much but it did have water.

Quon Sing was an industrious, hard worker. He planted shade trees, dates, figs, vegetables, and grapes. He raised hogs and chickens. He transformed his parcel of barren land into a beautiful, restful and quite profitable ranch. People came from all over the area to buy his produce and enjoy the cool shade of his ranch.

A white man came by and decided that he would like to own such a ranch. So he simply took his shotgun and ran the Chinaman off the ranch and took it as his own. He knew that no one cared enough about a Chinaman to do anything about it. Quon Sing was never seen again!

The ranch has gone through several owners since then. It is still a green oasis, however, it has become overgrown and neglected. But things are changing . . . a local school teacher and his family have recently moved onto the ranch. Slowly, patiently and lovingly they are clearing the land and preparing for planting. They are determined to make China Ranch productive once again.

*GEOLOGICAL AGE OF MOUNTAINS AROUND CHINA RANCH - 2-5 MILLION YEARS*

FURNACE CREEK RANCH 1979
DEATH VALLEY SERIES

## FURNACE CREEK RANCH

"All this belongs to me!" bellowed Death Valley's first non-Indian resident as he gazed out from the green oasis across the barren valley. It was 1870 and the man was Teck Bennett, better known as Bellerin' Teck. As the story goes, he was a bad-tempered, argumentative sort who shouted rather than talked. Thus he loudly claimed the valley in general and Furnace Creek in particular to be his own. No one was there to contest his claim so he settled down and began to grow alfalfa and raise quail. In time a traveler came by . . . he had two oxen. Teck thought that he could sure use a couple of oxen and the traveler thought it would be nice to own part of this fertile ranch. So they became partners. The partnership was short-lived, however, for one day Teck lost his temper, picked up his shotgun and ran his partner off the ranch. Teck then had all the land again and the oxen too!

So in the midst of the desolate whiteness of Death Valley there is a green spot where good water is plentiful and grass and trees will grow easily. It is for this reason that people have been, and will continue to be, drawn to Furnace Creek. This land has served as a home for the Indians, a welcome camp for the weary '49ers, a ranch for Bellerin' Teck, a range for cattle, the home base for the Borax workers, a stopping off place for prospectors, and finally today a luxury tourist resort complete with golf course and swimming pool.

GEOLOGICAL AGE OF FURNACE CREEK AREA -
RECENT QUARTERNARY DEPOSITS

192 Arthur Ollman,
*Untitled*, 1978

177 Roger Minick, *Mother and Daughter at K-Mart,* 1977

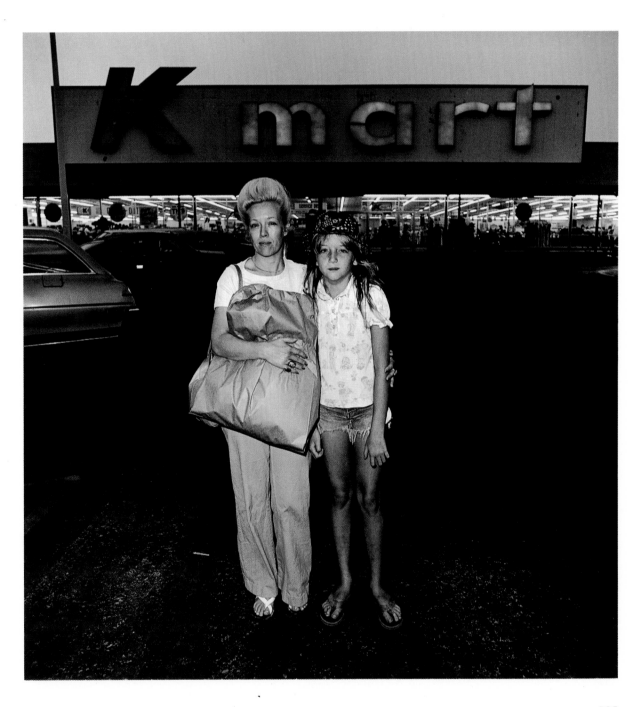

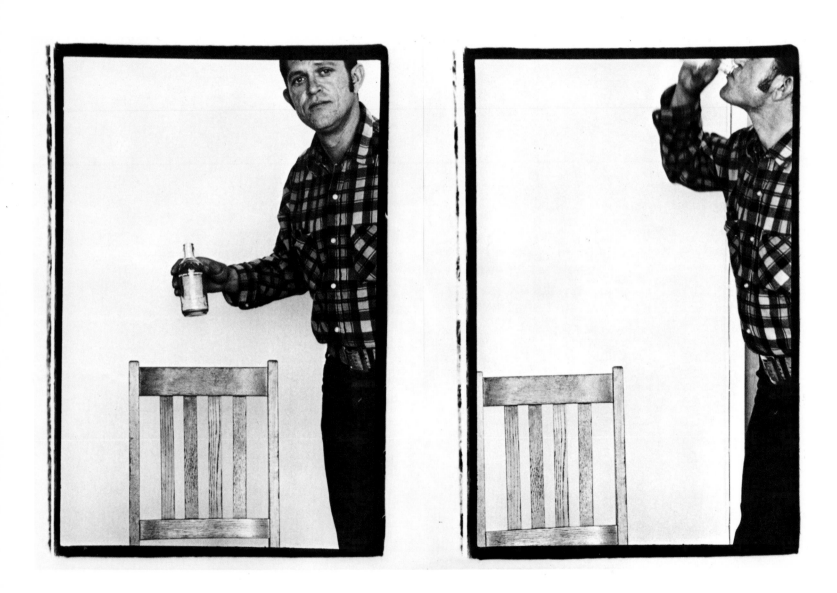

20 John Brumfield, *Robert
Posing as a Hollywood Star,*
1979–81

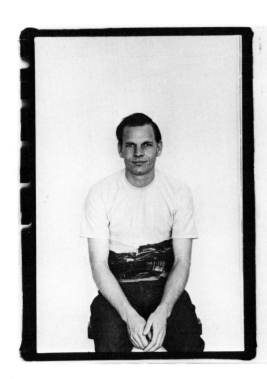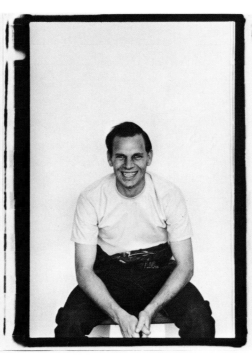

169 Kenneth McGowan,
*Wall of Masks*, 1979

168 Kenneth McGowan,
*Studio Commissary,* 1979

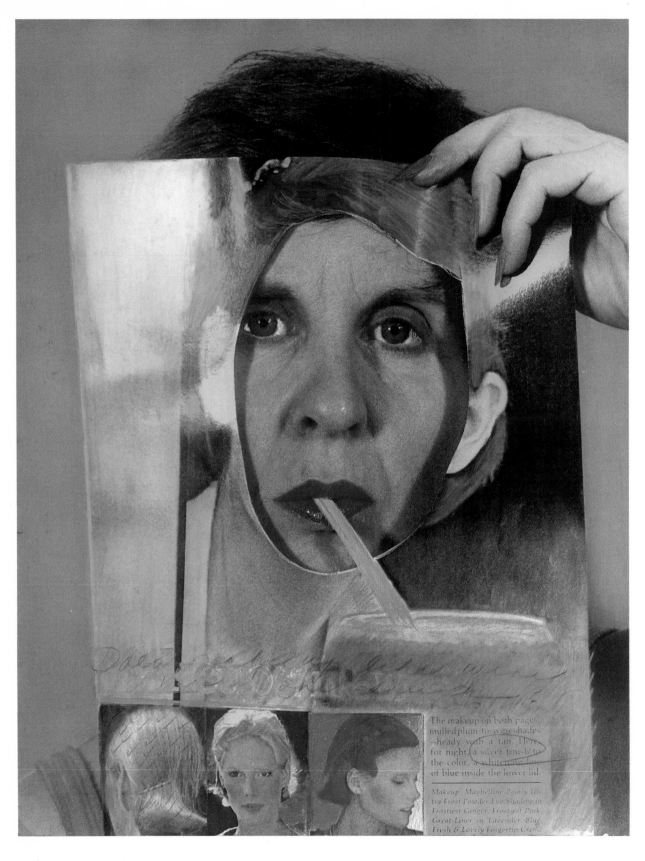

121 Judith Golden, *Make-up Like Wine*, 1977

117 Judith Golden, *The Redhead Fantasy*, 1974

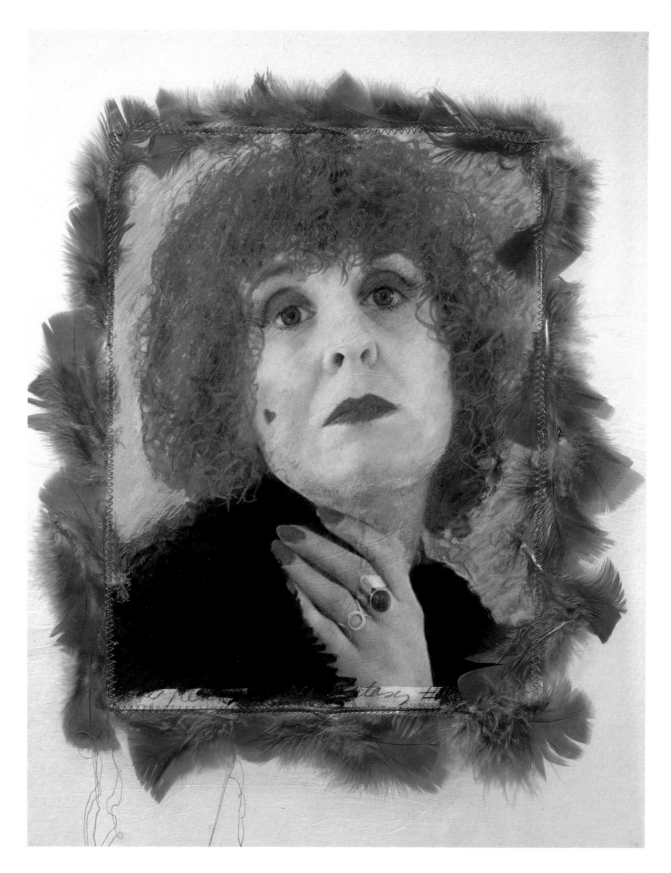

97 Anthony Friedkin,
*Beverly Hills Hotel*, 1975

112 Jim Goldberg,
*Untitled*, 1978/1979

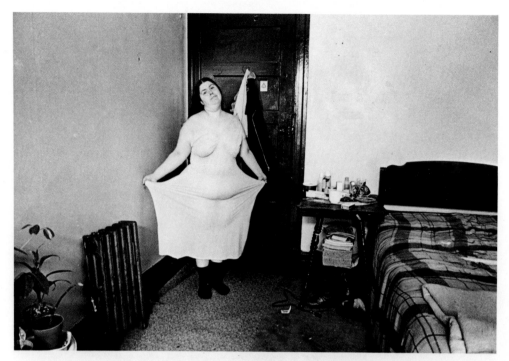

I AM A 29 YEAR old female who Loves
plants and ANIAMAls who came to SAN FRANCISCO
from a quiet town IN Oregon 3½ YEARS ago. I
DON'T LIKE IT HERE!

THE CITY has made me DISliKe myself
now I get depressed easily, which makes me
sleep alot and watch a lot of HORROR MOVIES.
I guess the picture shows me in A SO-SO
mood and in A simple way of living.
NO MONEY MEANS LIVING IN THE PITS.

anne williams

My wife is Acceptable.
Our relationship is satisfactory.
Edgar G.

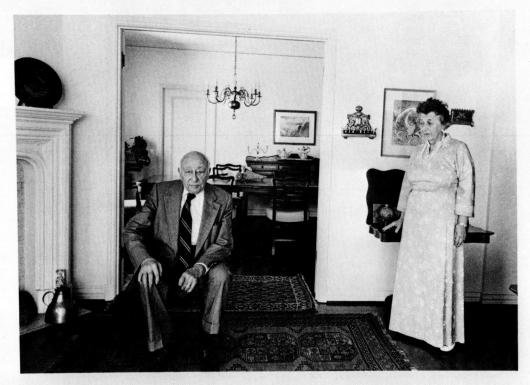

Edgar looks splendid here. His power and
strength of character come through. He is a
very private person who is not demonstrative
of his affection; that has never made me
unhappy. I accept him as he is.
        We are totally devoted to each other.
                    Regina Goldstine
Dear Jim:
        May you be as lucky in marriage!

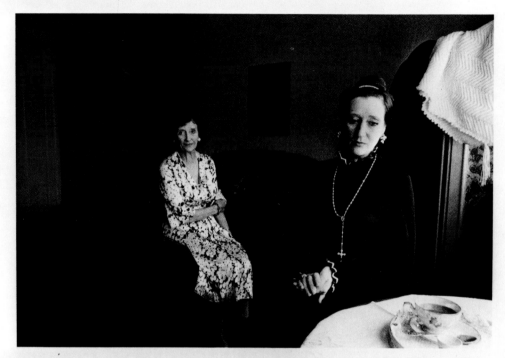

I Keep thinking where we went wrong.
We have no one to talk to now,
however, I will not allow this loneliness to
destroy me,— I STILL HAVE MY DREAMS.
I would like an elegant home, a loving husband
and the wealth I am used to.

Countess Vivianna de Blonville.

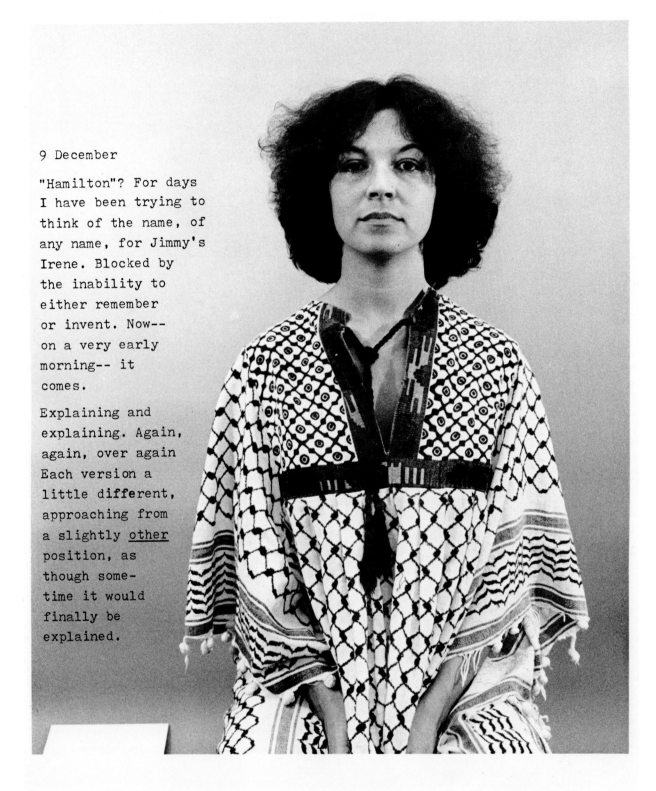

9 December

"Hamilton"? For days
I have been trying to
think of the name, of
any name, for Jimmy's
Irene. Blocked by
the inability to
either remember
or invent. Now--
on a very early
morning-- it
comes.

Explaining and
explaining. Again,
again, over again
Each version a
little different,
approaching from
a slightly other
position, as
though some-
time it would
finally be
explained.

201 Donna-Lee Phillips,
*10 December*, 1977–78/
1983

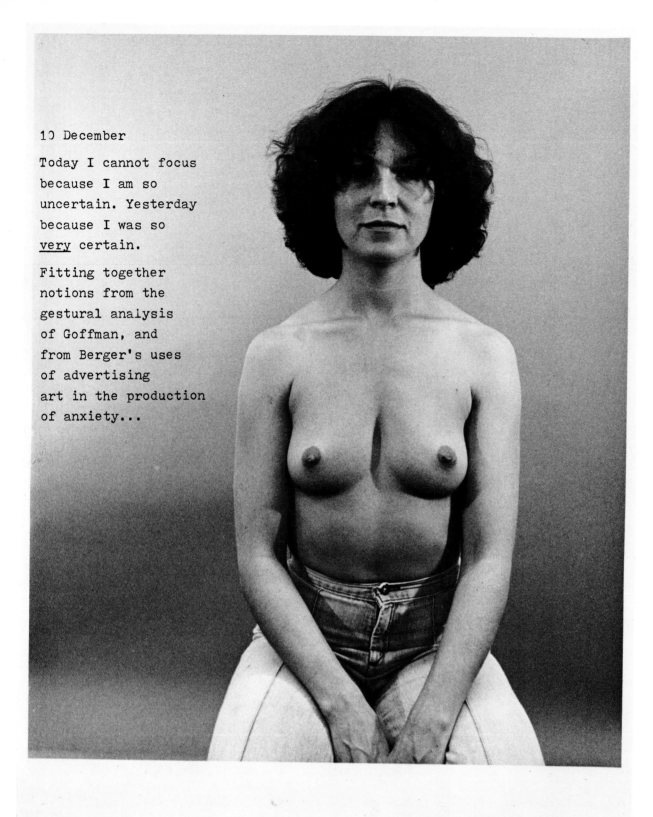

10 December

Today I cannot focus
because I am so
uncertain. Yesterday
because I was so
<u>very</u> certain.

Fitting together
notions from the
gestural analysis
of Goffman, and
from Berger's uses
of advertising
art in the production
of anxiety...

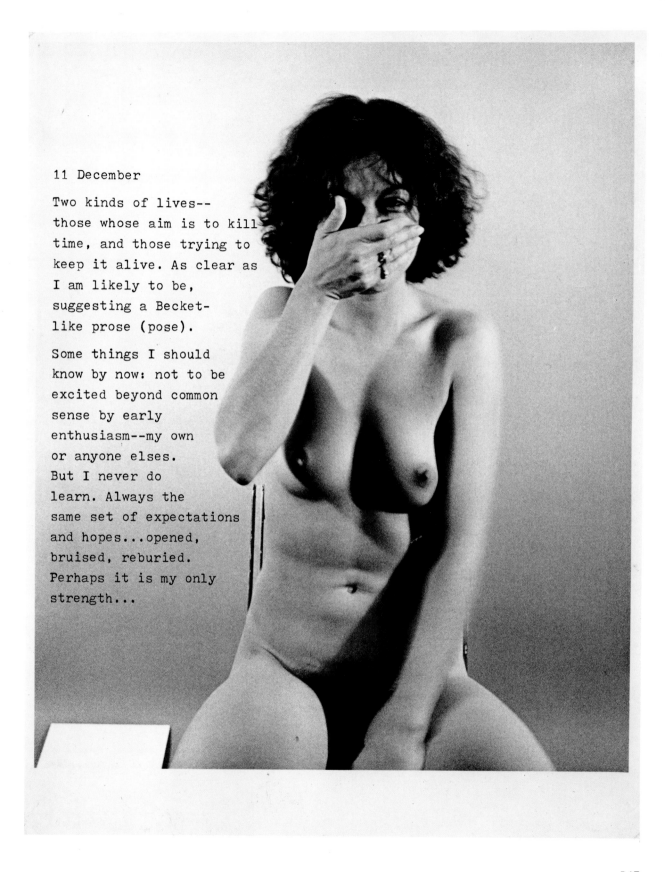

11 December

Two kinds of lives--
those whose aim is to kill
time, and those trying to
keep it alive. As clear as
I am likely to be,
suggesting a Becket-
like prose (pose).

Some things I should
know by now: not to be
excited beyond common
sense by early
enthusiasm--my own
or anyone elses.
But I never do
learn. Always the
same set of expectations
and hopes...opened,
bruised, reburied.
Perhaps it is my only
strength...

195 Bill Owens, *"I don't feel that Richie...,"* 1971

197 Bill Owens, *"We're really happy...,"* 1971

I don't feel that Richie playing with guns will have a negative effect on his personality. (He already wants to be a policeman.) His childhood gun-playing won't make him into a cop-shooter. By playing with guns he learns to socialize with other children. I find the neighbors who are offended by Richie's gun, either the father hunts or their kids are the first to take Richie's gun and go off and play with it.

We're really happy. Our kids are healthy, we eat good food and we have a really nice home.

200 Bill Owens, *"I've been a chiropractor for thirty-three years...,"* 1976

199 Bill Owens, *"I'm a table worker inspecting birth control pills...,"* 1976

I've been a chiropractor for thirty-three years, working directly and indirectly with nerves through the spinal column. I'm thinking of retiring in a couple more years and going into worm farming. Worms are an asset to society.

I'm a table worker inspecting birth control pills. After working here for two years, I can't believe there are any babies being born anywhere. My husband is a minister. When your kids go to college you need the money, so here I am.

**B75SF-46  A Hippie.**  Shoulder length hair and black leather jacket;
he's a Haight-Ashbury hybrid. Eye contact, he gestures me over.
I hesitate, he moves towards me. We leave Gus' together, almost a
zipless pick-up. Whenever I return to the bar, the hippie is there.
Sometimes we depart together, once to his apartment — a bedroom
littered with ferns and posters (nouveau Haight-Ashbury). He strikes
my fantasy, the flower child / space cadet I was five years too late for.
However, familiarity breeds discontent, he leaves cigarette burns on
the bedsheets and crabs under the covers. I stop seeing him; friends
tell me he drifted over to Polk Street.

83  Hal Fischer, *The Punk Poet*, 1979

**B76SF-89  The Punk Poet.**  At our big Halloween party, the one for which 150 people showed, and Susie fell out the window and down the airshaft, we met. Ernie had described him often, but I was still seduced by his good looks. At the end of the party, after taking his girlfriend home, he returned for me. During the next three months, we tormented one another, opposites fighting each other's strengths. He held the sexual trump card: my desire. But I could undermine his art, subverting his romantic excesses with criticism. We enjoyed the intensity of it all, a Rimbaud/Verlaine rapport. But the night he hit me and then cried, both of us realized that we had done enough to one another.

# BIBLIOGRAPHY₃

~~Arakawa. FOR EXAMPLE. Milano: Alessandro Press, 1974.~~

Anonymous. ART & LANGUAGE. New York: Fox 4, Vol. 3, No. 4. October 1976.

Armstrong, Duke. 100 FAMOUS PAINTINGS. San Francisco: Toltec Press, 1970.

AYER, Alfred. LANGUAGE, TRUTH & LOGIC. New York: Dover, 1952.

Bachelard, Gaston. THE POETICS OF SPACE. Boston: Beacon Press, 1969.

Bann, Stephen. LANGUAGE IN AND ABOUT THE WORK OF ART. London: Studio International April 1971. THE TRADITION OF CONSTRUCTIVISM. New York: Viking Press, 1974.

Barthes, Roland. WRITING DEGREE ZERO —ELEMENTS OF SEMIOLOGY. Boston: Beacon Press, 1970. ~~MYTHOLOGIES. New York: Hill & Wang, 1974.~~ THE PLEASURES OF THE TEXT. New York: Hill & Wang. 1975. SADE, FOURIER, LOYOLA. New York: Hill & Wang, 1976.

~~Batcock, Gregory. THE NEW ART. New York: Dutton, 1966. MINIMAL ART. New York: Dutton, 1969. WHY ART. New York: Dutton, 1976.~~

Baudelaire, Charles. THE MIRROR OF ART. New York: Doubleday, 1956.

Benjamin, Walter. ILLUMINATIONS. New York: Schocken, 1976.

Berger, John. A PAINTER OF OUR TIME. Baltimore, Md.: Penguin Books, 1965. ART AND REVOLUTION. New York: Random House, 1969. THE LOOK OF THINGS. Middlesex, England: Penguin, 1972. ~~WAYS OF SEEING. New York: Viking Press, 1973.~~ A SEVENTH MAN. New York: Viking Press, 1975.

Bochner, Mel. SERIAL ART (SYSTEMS: SOLIPSISM). New York: Arts Magazine, Summer 1967. ~~THE SERIAL ATTITUDE. New York: Artforum, December 1967.~~ TEN MISUNDERSTANDINGS (A THEORY OF PHOTOGRAPHY(. New York: Multiples. 1970.

Bresson, Robert. NOTES ON CINEMATOGRAPHY. New York: Urizen Books, 1977.

Brecht, Bertolt. BRECHT ON THEATRE. New York: Hill and Wang.

~~Burgin, Victor. PHOTOGRAPHIC PRACTICES & ART THEORY. London: Studio International, 1976.~~

Burnham, Jack. THE STRUCTURE OF ART. New York: George Braziller, 1971. ~~THE GREAT WESTERN SALT WORKS. New York: George Braziller, 1976.~~

~~Butterfield, Jan. ROBERT IRWIN: ON THE PERIPHERY OF KNOWING. New York: Arts Magazine, February 1976.~~

Cage, John. NOTATIONS. New York: Something Else Press, 1969.

~~Calas, Nicholas & Elena. ICONS & IMAGES OF THE SIXTIES. New York: Dutton, 1971.~~

Cardew, Cornelius. STOCKHAUSEN SERVES IMPERIALISM. London: Latimer, 1974.

Cendrars, Blaise. COMPLETE POSTCARDS FROM THE AMERICAS. Berkeley, Calif.: University of California Press, 1976.

Clark, Martin. ANTONIO GRAMSCI AND THE REVOLUTION THAT FAILED. New Haven, Conn.: Yale University Press, 1977.

Clark, T.J. IMAGE OF THE PEOPLE. Greenwich, Conn.: New York Graphic Society, 1973. THE ABSOLUTE BOURGEOIS. Greenwich, Conn.: New York Graphic Society, 1973.

Collier, John. VISUAL ANTHROPOLOGY: PHOTOGRAPHY AS A RESEARCH METHOD. New York: Holt, Rinehart & Winston, 1976.

Coplans, John. ~~SERIAL IMAGERY. Pasadena, Calif.: Pasadena Art Museum, 1968.~~ MEL BOCHNER ON MALEVICH. New York: Artforum, June 1974.

Cumming, Robert. PICTURE FICTIONS. Orange, Calif.: 1971. A TRAINING IN THE ARTS. Toronto, Canada: Coach House Press, 1973.

Dorner, Alexander. THE WAY BEYOND ART. New York: New York University Press, 1958.

Ehrenzweig. Anton. THE HIDDEN ORDER OF ART. Berkeley, Calif.: U C Press.

Eisenman. P. & Frampton, K. & Gandelsonas, M., editors. OPPOSITIONS 5. Cambridge, Mass.: M.I.T. Press, 1976.

Enzensberger, Hans Magnus. THE CONSCIOUSNESS INDUSTRY. New York. Seabury Press, 1974.

Fischer, Ernst. THE NECESSITY OF ART. Baltimore, Md.: Penguin Books.

Fischer, Hal. BRACKETING. Oakland, Calif.: Artweek, Spetember 1975.

Fixel, Lawrence. TIME TO DESTROY / TO DISCOVER. San Francisco: Panjandrum Press, 1972.

Flaubert, Gustave. BOUVARD & PECUCHET. New York: New Directions, 1971.

Foley, Suzanne. JIM MELCHERT: POINTS OF VIEW. San Francisco: S F Museum of Modern Art, 1975.

Foucault, Michael. THE ORDER OF THINGS. New York: Vintage, 1974. MENTAL ILLNESS & PSYCHOLOGY.

Fox, William. EXTENSIONS OF THE WORD. Reno, Nevada: West Coast Poetry Review, 1974.

~~Gablik, Suzi. PROGRESS IN ART. New York: Rizzoli, 1977.~~

Garver, Thomas. NEW PHOTOGRAPHY: SAN FRANCISCO & BAY AREA. San Francisco: Fine Arts Museums of San Francisco, 1974.

Gerstner, Karl. COMPENDIUM FOR LITERATES. Cambridge, Mass.: M.I.T. Press, 1974.

~~Gottlieb, Carla. BEYOND MODERN ART. New York: Dutton, 1976.~~

Green, Christopher. LEGER AND THE AVANT-GARDE. New Haven, Conn.: Yale University Press, 1976.

~~Haacke, Hans. FRAMING AND BEING FRAMED: 7 WORKS 1970-75. Halifax, N.S. Canada: Press of the Nova Scotia College of Art & Design, 1975.~~

Hanson, Anne Coffin. MANET AND THE MODERN TRADITION. New Haven, Conn.: Yale University Press, 1977.

Hartley, Anthony, ed. & trans. MALLARME. Baltimore, Md.: Penguin Books, 1965.

Hess, John & Kleinhans, editors. JUMP CUT. No. 12/13. Berkeley, Calif.: 1977.

Higgins, Dick. FOEW&OMBWHNW. New York: Something Else Press, 1969.

Hofstadter, Albert & Kuhns, Richard, editors. PHILOSOPHIES OF ART & BEAUTY. Chicago. University of Chicago Press, 1964.

Hugunin, James & Kelley, Theron, editors, DUMB OX Nos. 1, 2, 3, & 4. Northridge, California.

Husserl, Edmund. PHENOMENOLOGY & THE CRISIS OF PHILOSOPHY. New York: Harper, 1965.

Jacobs, Jessica, ed. WORDS WORK TWO. San Jose, Calif.: San Jose State University Art Gallery, 1975.

~~Johnson, Ellen H. MODERN ART AND THE OBJECT. New York: Harper & Row, 1976.~~

Judd, Donald. COMPLETE WRITINGS 1959-1975. Halifax, Canada: The Press of N.S. College of Art & Design, 1975.

~~Karshaw, Donald. CONCEPTUAL ART & CONCEPTUAL ASPECTS. New York: New York Cultural Center, 1970.~~

Klonsky, Milton, ed. SPEAKING PICTURES. New York: Crown, 1975.

~~Kostelanets, Richard, ed. ART & LANGUAGE IN NORTH AMERICA. Toronto: 1975.~~

~~Kozloff, Max. CUBISM & FUTURISM. New York: Charterhouse, 1973.~~

Kubler, George. SHAPE OF TIME. New Haven, Conn.: Yale University Press, 1962.

Lang, Berel & Williams, editors. MARXISM AND ART: WRITINGS IN AESTHETICS AND CRITICISM. New York: David McKay Co., 1972.

Levaco, Ronald, ed. KULESHOV ON FILM. Berkeley, Calif.: U of C Press, 1974.

Leverant, Robert. PHOTOGRAPHIC NOTATIONS. Berkeley, Calif.: Images Press, 1977.

~~LeWitt, Sol. ARCS, CIRCLES & GRIDS. Bern, Switzerland: Kunsthalle Bern & Paul Bianchini, 1972.~~

Lifshitz, Mikhail. THE PHILOSOPHY OF ART OF KARL MARX. New York: Urizen Press, 1976.

~~Lippard, Lucy. SIX YEARS: THE DEMATERIALIZATION OF THE ART OBJECT. New York: Praeger, 1973.~~

Livingston & Tucker. BRUCE NAUMAN (WORK FROM 1965-72). Los Angeles, Calif.: LACMA, 1973.

Loach, Roberta, ed. VISUAL DIALOG. Los Altos, California.

Lond, Harley, ed. INTERMEDIA (vols. I, II, III, IV.). Los Angeles.

Lukács, Georg. HISTORY & CLASS CONSCIOUSNESS. Cambridge, Mass.: M.I.T. Press, 1971. THE THEORY OF THE NOVEL. Cambridge, Mass.: M.I.T. Press, 1971.

Malevich, Kasimir. THE NON-OBJECTIVE WORLD. Chicago: Paul Theobald, 1959.

Marioni, Tom, editor. THE ANNUAL. San Francisco: San Francisco Art Institute, 1977.

Matejka, Ladislaw & Tetanik, Irwin R. editors. SEMIOTICS OF ART: PRAGUE SCHOOL CONTRIBUTIONS. Cambridge, Mass.: M.I.T. Press, 1976.

Matsumoto, Masashi. QUOTABLES. San Francisco: N.F.S. Press, 1977.

~~McShine, Kneston, ed. INFORMATION. New York: MOMA, 1970.~~

Metz, Christian. FILM LANGUAGE. New York: Oxford University Press, 1974.

~~Meyer, Ursula. CONCEPTUAL ART. New York: Dutton, 1972.~~

Moore, Stephan. 8-1/2 x 11. San Jose, California. 1977.

Morris, Robert. SOME NOTES ON PHENOMENOLOGY OF MAKING. New York: Artforum.

Mukařovský, Jan. THE WORK AND VERBAL ART. New Haven, Conn.: Yale University Press, 1977.

~~Muller, Gregoire. THE NEW AVANT-GARDE. New York: Praeger, 1972.~~

Nuschamp, Herbert. FILE UNDER ARCHITECTURE. Cambridge, Mass.: M.I.T. Press, 1974.

Mycue, Edward. DAMAGE WITHIN THE COMMUNITY. San Francisco: Panjandrum Press, 1975.

Nichols, Bill, ed. MOVIES AND METHODS. Berkeley, Calif.: U C Press, 1976.

O'Connor, James. THE CORPORATIONS AND THE STATE. New York: Harper & Row, 1974

~~O'Doherty, Brian. INSIDE THE WHITE CUBE. New York: Artforum, March 1976.~~

Peckham, Morse. MAN'S RAGE FOR CHAOS. New York: Schocken, 1967.

Phillips, Donna-Lee, ed. EROS AND PHOTOGRAPHY. San Francisco: Camerawork Press, 1977.

Pincus, Theo. CONVERSATIONS WITH LUKACS. Cambridge, Mass.: M.I.T. Press, 1975.

~~Pincus Witten, Robert. OCCULT SYMBOLISM IN FRANCE. New York: Garland, 1976.~~

Ponge, Francis. THE VOICE OF THINGS. New York: McGraw Hill. 1974.

Poster, Mark. EXISTENTIAL MARXISM IN POST-WAR FRANCE. Princeton, New Jersey: Princeton University Press, 1975.

Richardson, Brenda. TERRY FOX. Berkeley, Calif.: U C Art Museum, 1973.

Rickaby, Tony. AN UNKNOWN ART HISTORY. London: 1975.

Robbe-Grillet, Alain. FOR A NEW NOVEL: ESSAYS ON FICTION. New York: Grove Press, 1965.

Rose, Barbara. ART AS ART: SELECTED WRITINGS OF AD REINHARDT. New York: Viking Press, 1975.

Rosenblum, Robert. CUBISM AND TWENTIETH CENTURY. New York: Harry N. Abrams, 1976.

Samore, Sam & Loeffler, Carl, editors. WEST COAST CONCEPTUAL PHOTOGRAPHERS. San Francisco: La Mamelle, 1976.

Silliman, Ron. DISAPPEARANCE OF THE WORD, APPEARANCE OF THE WORLD. San Francisco: Arts Contemporary, Vol. 2, No. 3, 1977.

Sitney, P. Adams, ed. THE ESSENTIAL CINEMA. New York: New York University Press, 1975. VISIONARY FILM: THE AMERICAN AVANT-GARDE. New York: Oxford U. Press, 1974.

Snow, Michael. MICHAEL SNOW: A SURVEY. Toronto, Canada: Art Gallery of Ontario, 1970. ~~COVER TO COVER. Halifax, Canada: The Press of M.S. School of Design & Art, 1976.~~

Sontag, Susan. ANTONIN ARTAUD: SELECTED WRITINGS. New York: Farrar, Straus & Giroux, 1976.

Stein, Gertrude. THE MAKING OF AMERICANS. New York: Something Else Press, 1966.

Thomas, Kesa. PERFORMANCES & INSTALLATIONS. San Francisco: N.F.S. Press, 1977.

Thomas, Lew, ed. PHOTOGRAPHY AND LANGUAGE. San Francisco: Camerawork Press, 1976.

Valery, Paul. LEONARDO, POE, MALLARME. Princeton, New Jersey: Princeton University Press, 1972.

Van Deren Coke. THE PAINTER and the PHOTOGRAPH. Albuquerque, New Mexico: University of New Mexico Press, 1972

Villa, Carlos, ed. OTHER SOURCES: AN AMERICAN ESSAY. San Francisco: San Francisco Art Institute, 1976.

Vogel, Amos. FILM AS A SUBVERSIVE ART. New York: Random House. 1974.

~~Waldman, Dianne, CARL ANDRE. New York: Solomon F. Guggenheim Museum, 1970.~~

Whorf, Benjamin Lee. LANGUAGE, THOUGHT & REALITY. Cambridge, Mass.: M.I.T. Press, 1956.

Winner, Langdon. AUTONOMOUS TECHNOLOGY: Technics Out-of-Control as Theme in Political Thought. Cambridge, Mass.: M.I.T. Press, 1977.

Wittgenstein, Ludwig. TRACTATUS LOGICO PHILOSOPHICUS. Atlantic Highlands, New Jersey: Humanities Press, 1974.

Worringer, Wilhelm. ABSTRACTION AND EMPATHY. New York: International University Press, 1967.

Worth, Sol, and Adair, John. THROUGH NAVAJO EYES. Bloomington, Indiana: Indiana University Press, 1972.

215 Lew Thomas, *Bibliography,* 1977

212 Lew Thomas, *Sink,* 1972

49 Robert Cumming,
*Theatre for Two—Easy Anal-*
*ogies*, 1978

48 Robert Cumming, *Saws
through at Right Angles . . .
Rip and Cross-cut,* 1978

105 Phillip Galgiani,
*Hand Supports*, 1978

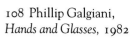
108 Phillip Galgiani,
*Hands and Glasses*, 1982

109 Phillip Galgiani,
*Hands and Hat*, 1982

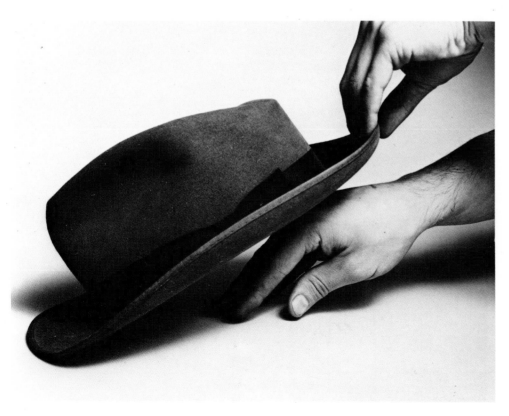

107 Phillip Galgiani, *Sight Line*, 1978

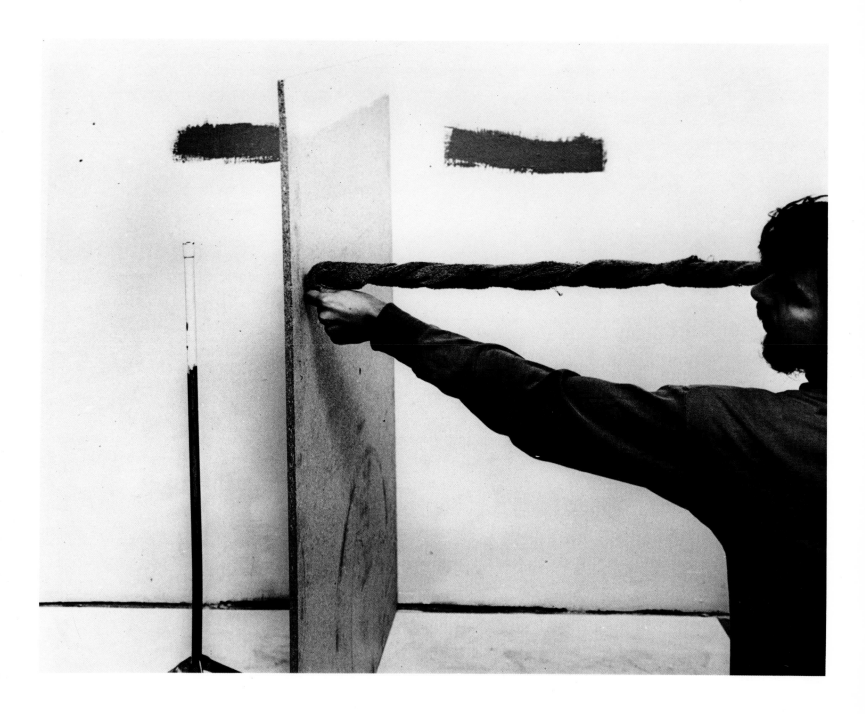

REMOVING A FENDER FROM
1950 STUDEBAKER

CROCKET CA.

156 Gregory MacGregor,
*Poodle Shaped Explosion in*
*Vicinity of Cumulus Clouds,*
*U.S. Route 80, Utah,* 1979

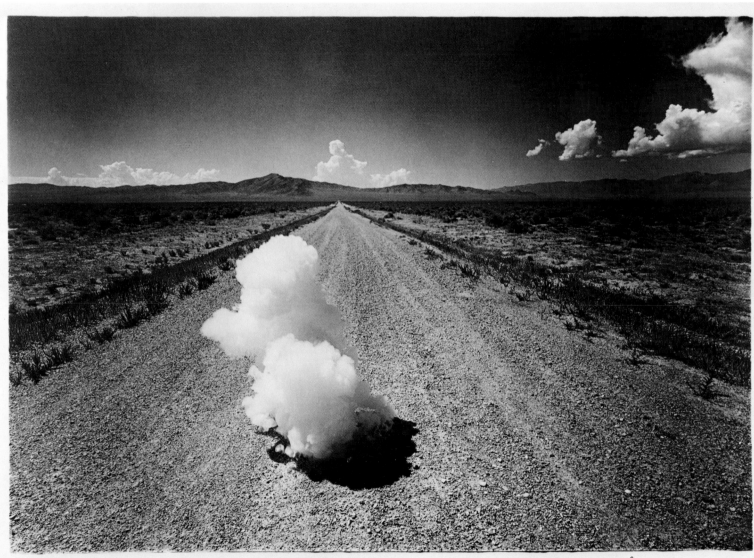

Poodle Shaped Explosion in
Vicinity of Cumulus Clouds U.S. Route 80, Utah

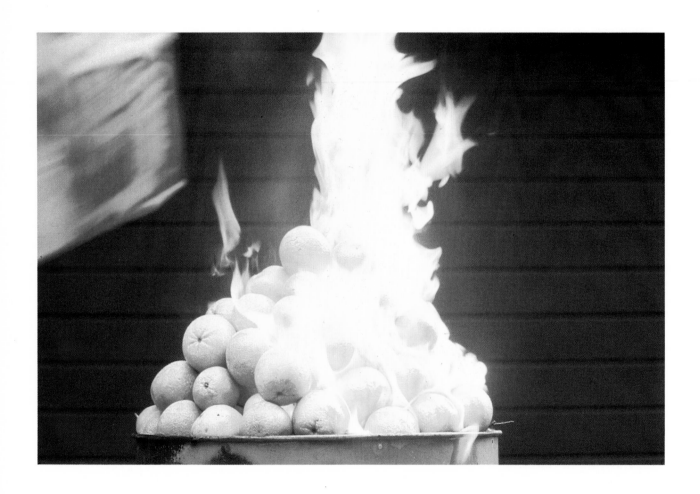

162

157 Mike Mandel and
Larry Sultan, *Oranges on
Fire*, 1975

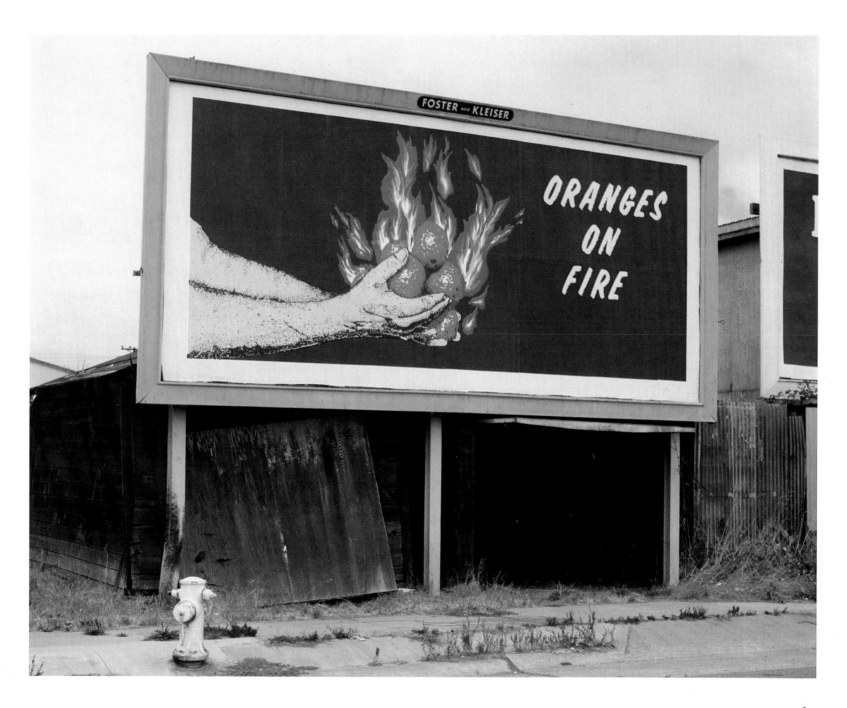

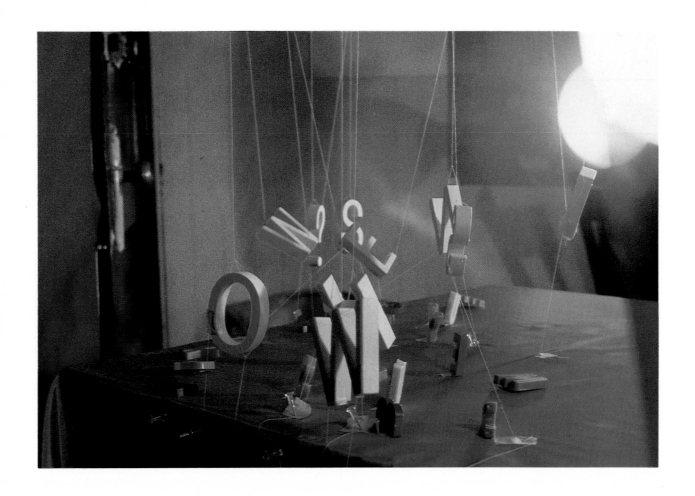

163 Mike Mandel and
Larry Sultan, *Whose News*
*(Abuses You)*, 1980

VICKS VICTORS: A PSEUDONYM FOR ME. IT'S SAYING THAT VICTOR IS VIC'S OWN VICTOR – A STATEMENT AROUND SELF POSSESSION; ABOUT TAKING RESPONSIBILITY FOR MY OWN LIFE AND THE WAY I ASSESS MY CIRCUMSTANCES; ABOUT LOCATING THE SOURCE OF MY SUCCESSES AND FAILURES AS BEING SQUARELY WITHIN MYSELF; AND ABOUT FINDING THAT I AM INDEED TOTALLY ALL RIGHT WITH ME. IT'S A STATEMENT EXPRESSING AN ATTITUDE WHICH CONTAINS APPROPRIATE ACTION, SELF-CERTAINTY AROUND DECISIONS, AND ACCEPTANCE OF A VARIETY OF PERSONAL FRAILTIES.

LIFE MAY NOT LOOK LIKE THE IMAGES I HAVE IN MY MIND OF HOW IT SHOULD BE. STILL I HAVE THE ABILITY TO EXPAND MY OUTLOOK TO EMBRACE THE WAY THAT IT IS. THERE WILL BE ONLY AS MUCH DISAPPOINTMENT AND UPSET IN MY LIFE AS I, MYSELF, CREATE, WHILE I KNOW THAT AT ONE AND THE SAME TIME I ALWAYS HAVE AN INFINITE ABILITY TO CREATE PERSONAL SATISFACTION OUT OF THE DAY-TO-DAY CIRCUMSTANCES OF MY BEING.

AS VIC'S VICTOR, I ACKNOWLEDGE MYSELF AS CREATOR OF THE SPACE IN WHICH I EXIST AND OF THIS SPACE AS THE CONTEXT FOR MY EXPERIENCE OF THE WORLD. AS THE BEING WHO OCCUPIES THIS SPACE I RECOGNIZE MYSELF AS THE SINGLE SOURCE OF MYSELF AS VICTOR.

Vicks Victors Cough Drops      V.L. '78

Wax Lips                    V.L. '78

151 Victor Landweber,
*Wax Lips,* 1978

189 Patrick Nagatani,
*Reims, France #4,* 1982

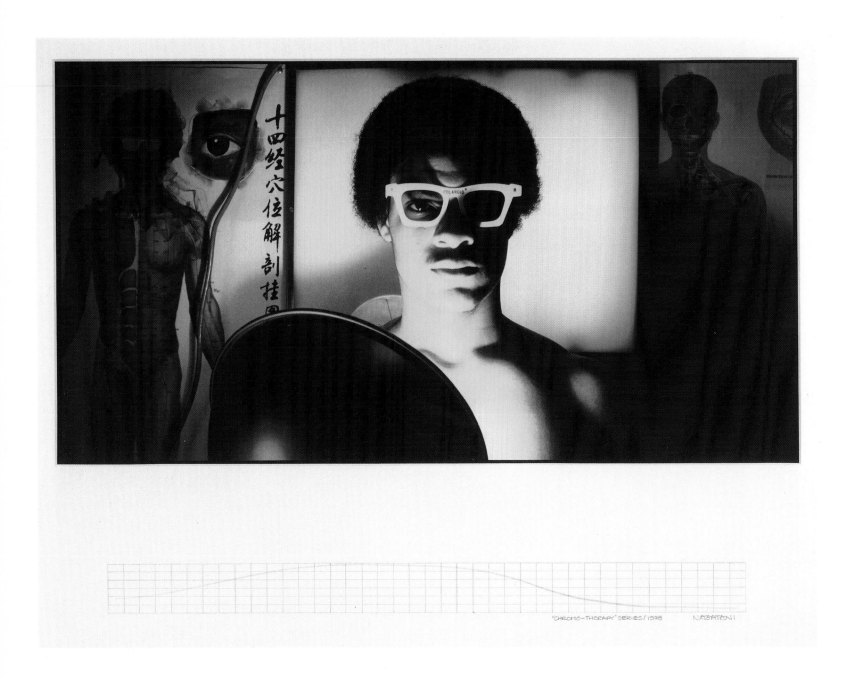

187 Patrick Nagatani,
*Untitled,* 1979

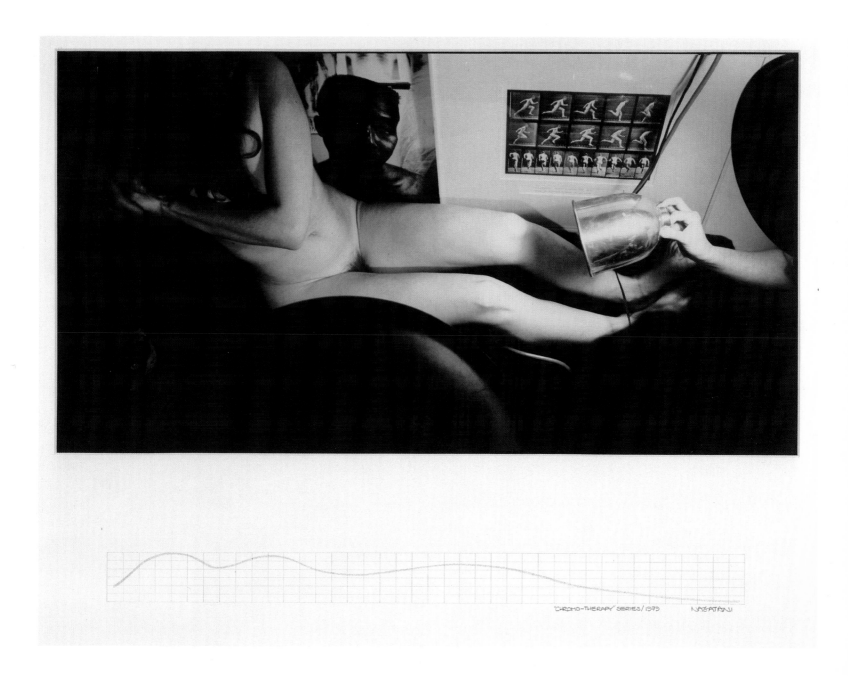

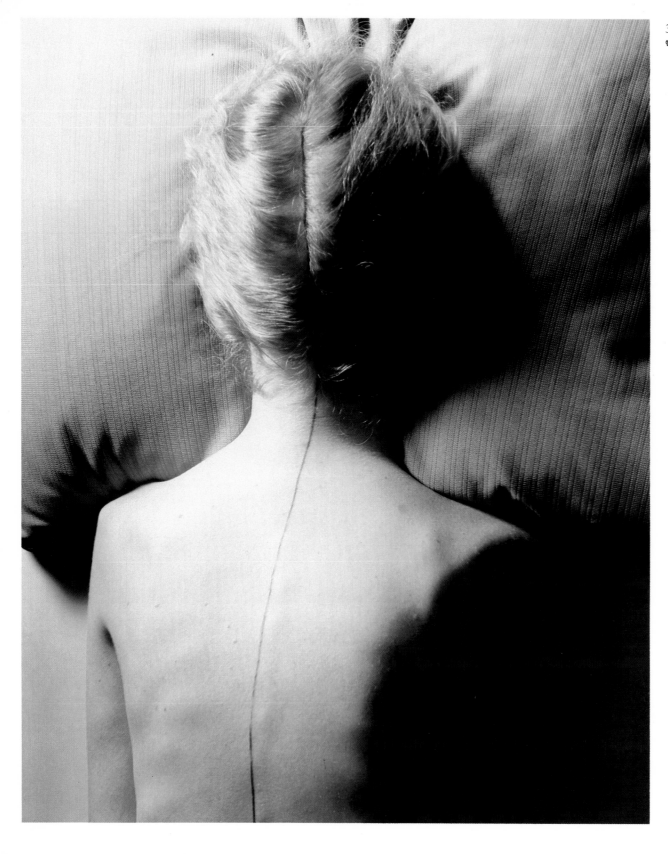

35 Jo Ann Callis, *Woman with Wet Hair*, 1978

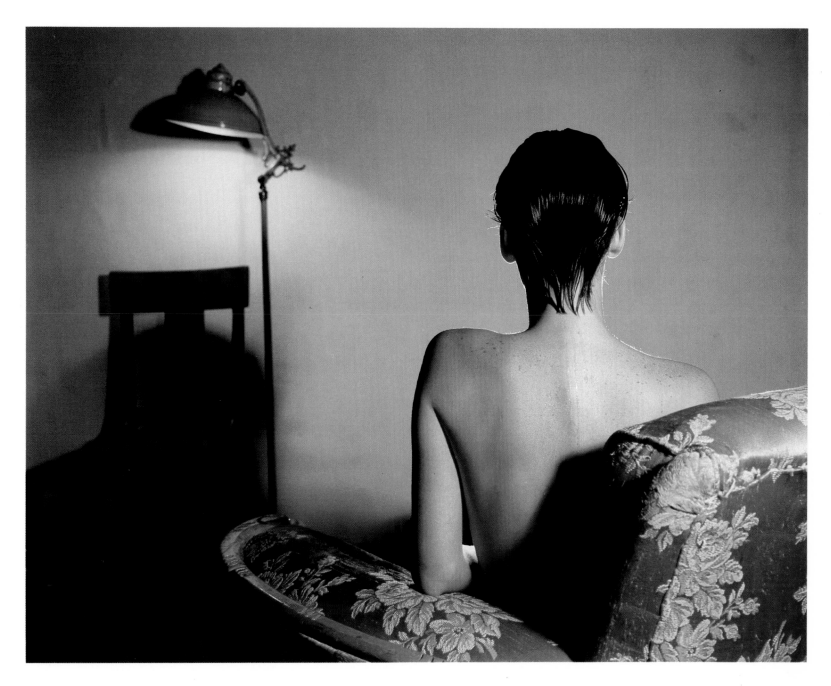

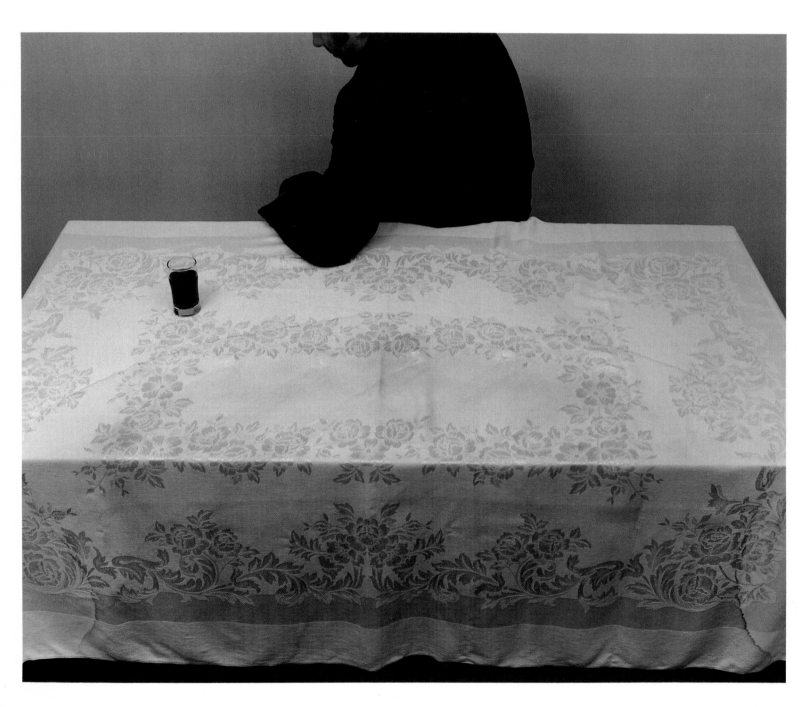

42 Eileen Cowin, *Untitled,* 1981

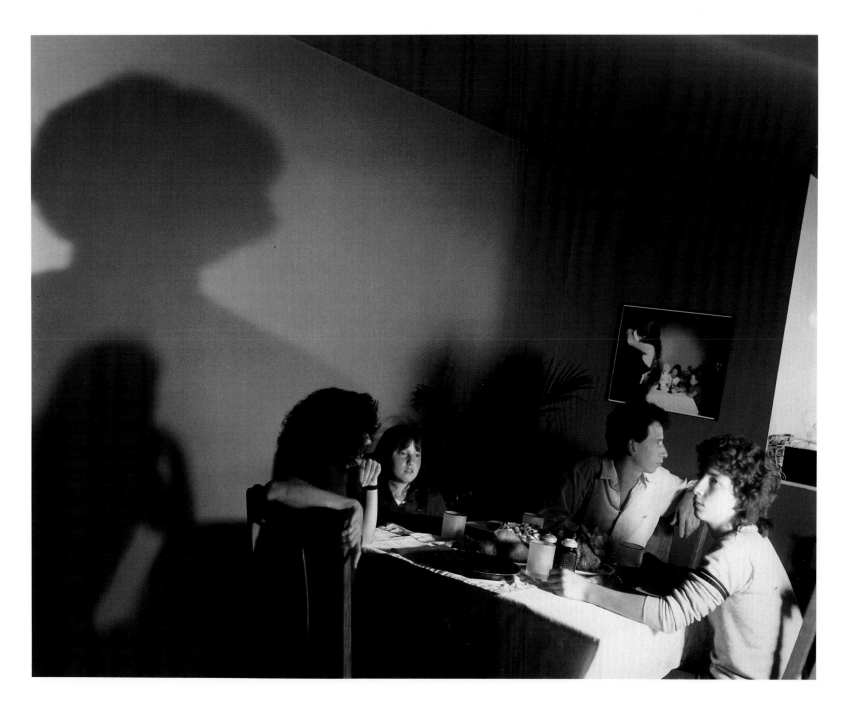

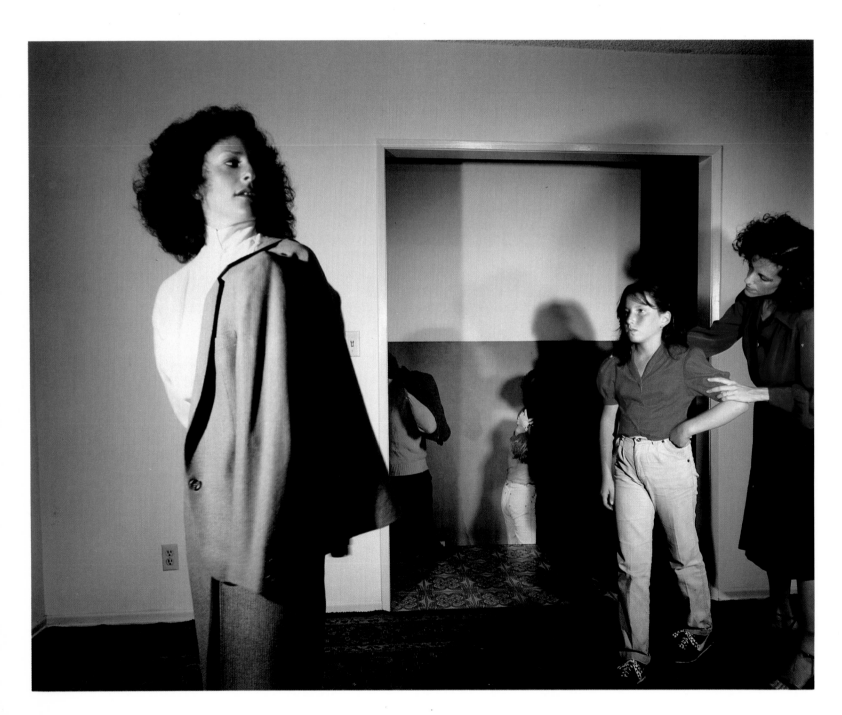

46 Eileen Cowin, *Untitled,*
1982

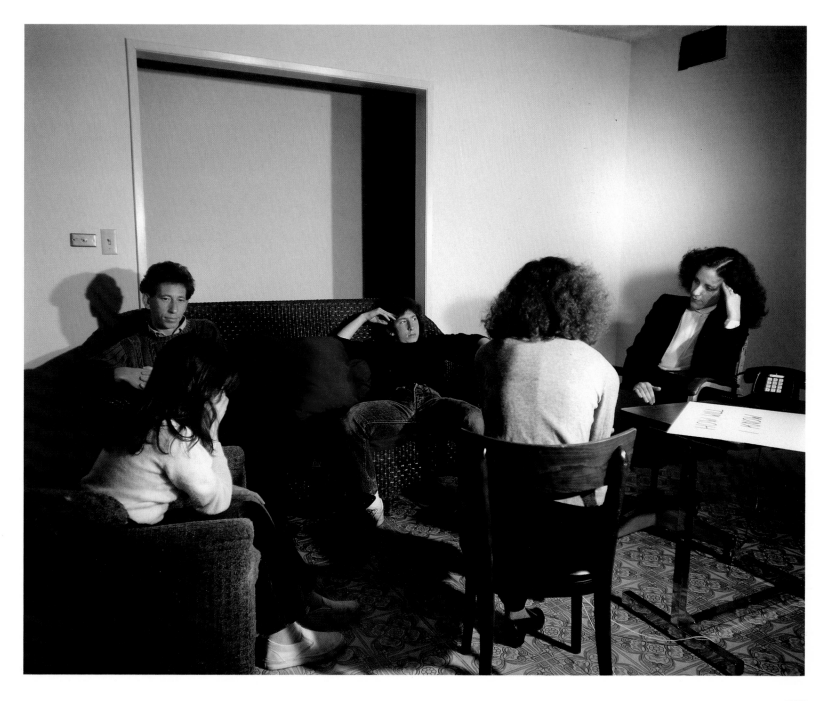

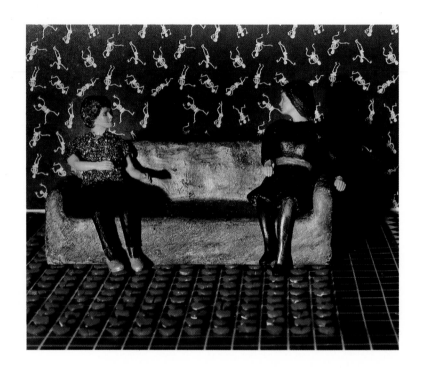

18 Ellen Brooks,
*Navigating A & B,* 1982

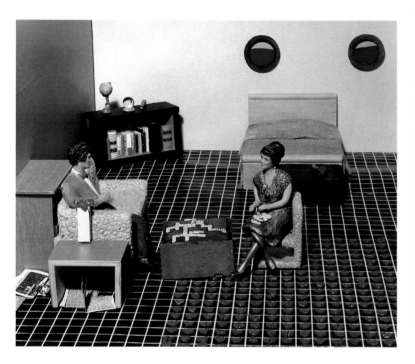 

In the listing of dimensions, height precedes width precedes depth. Measurements indicate image size; centimeter measurements are in parentheses. Date refers to date of negative; when two are listed and separated by a slash, the second date is the date of the print. When known, print edition number follows medium; portfolio edition number follows portfolio title.

Many of the prints are from portfolios. Unless a second date follows the portfolio title, the publication date of the portfolio is the same as the date of the print. Parenthetical phrases not in italics are descriptive information. San Francisco Museum of Modern Art accession numbers appear after works in the permanent collection.

## LEWIS BALTZ

All works are gelatin silver prints, collection of the San Francisco Museum of Modern Art. Numbers 2, 3, and 4 are from the portfolio *The New Industrial Parks Near Irvine, California,* 15/21.

1 *Tract House #22,* 1971, from the portfolio *Tract Houses,* 12/12, 5⁷⁄₁₆ × 8⁷⁄₁₆″ (13.8 × 21.5) Gift of the artist and Mrs. Leo Castelli in honor of John Humphrey, 80.466

2 *Northwest Wall, Unoccupied Industrial Spaces, 17875 C and D Skypark Circle, Irvine,* 1974, 6¹⁄₁₆ × 9″ (15.4 × 22.9) Gift of Carol Campbell Wenaas, 80.472.48

3 *South Wall, PlastX, 350 Lear, Costa Mesa,* 1974, 6 × 9″ (15.3 × 22.9) Gift of Carol Campbell Wenaas, 80.472.6

4 *Southwest Wall, Ware, Malcolm, and Garner, 16722 Hale, Irvine,* 1974, 6¹⁄₁₆ × 9″ (15.4 × 22.9) Gift of Carol Campbell Wenaas, 80.472.43

Numbers 5 and 6 are from the portfolio *Park City,* 5/21.

5 *Park City, interior, 30,* 1979, 6⁷⁄₁₆ × 9½″ (16.3 × 24.1) Extended loan of Jack Moore, Los Altos, California

6 *Park City, interior, 38,* 1979, 6⁷⁄₁₆ × 9⁹⁄₁₆″ (16.2 × 24.2) Extended loan of Jack Moore, Los Altos, California

## RUTH BERNHARD

All works are gelatin silver prints, collection of the San Francisco Museum of Modern Art.

7 *At the Pool (profile with hair),* 1950/ 1980, 7½ × 9⅝″ (19.1 × 24.5) Theo Jung Collection, Gift of Theo Jung, courtesy Ruth Bernhard, 80.359

8 *Classic Torso,* 1952/1980, 13⁹⁄₁₆ × 10¹⁄₁₆″ (34.5 × 25.5) Theo Jung Collection, Gift of Theo Jung, courtesy Ruth Bernhard, 80.358

9 *Two Leaves,* 1952/c. 1976, 10⁵⁄₁₆ × 7¹³⁄₁₆″ (26.1 × 19.9) Margery Mann Memorial Collection, Gift of Tom Vasey, 78.84

10 *Seated Figure–Joan Folding,* 1962/ 1980, 10⁷⁄₁₆ × 13¾″ (26.5 × 35.0) Theo Jung Collection, Gift of Theo Jung, courtesy Ruth Bernhard, 80.356

## MICHAEL BISHOP

All works are lent by the artist.

11 *Untitled* (#1008, phone book), 1974, gelatin silver print with toning, 14¹³⁄₁₆ × 22″ (37.7 × 55.9)

12 *Untitled* (#2284, tree trunks), 1974, gelatin silver print with toning, 14¹³⁄₁₆ × 22″ (37.7 × 55.9)

13 *Untitled* (#1523, yellow object), 1974, Ektacolor print, 12³⁄₁₆ × 18¹⁄₁₆″ (32.5 × 45.9)

14 *Untitled* (#529, crane), 1979, Ektacolor print, 21⅛ × 14⅛″ (53.7 × 35.8)

15 *Untitled* (#1029, red building), 1979, Ektacolor print, 21¹⁄₁₆ × 14⅛″ (53.4 × 35.9)

## ELLEN BROOKS

All works are Ektacolor prints, lent by the artist.

16 *New Year's,* 1980, 20 × 24″ (50.8 × 61.0)

17 *Untitled* (two women on a couch), 1981, 20 × 24″ (50.8 × 61.0)

18 *Navigating A & B,* 1982, diptych, each 20 × 24″ (50.8 × 61.0)

## JOHN BRUMFIELD

All works are 1979–81, gelatin silver prints, courtesy G. Ray Hawkins Gallery, Los Angeles.

19 *Max Showing How a Real Man Is Supposed to Drink a Bottle of Whiskey*, diptych, each 18⁵/₁₆ × 12¼″ (46.5 × 31.1)

20 *Robert Posing as a Hollywood Star*, triptych, each 18¹¹/₁₆ × 12⁵/₈″ (47.5 × 32.1)

## WYNN BULLOCK

All works are gelatin silver prints, collection of the San Francisco Museum of Modern Art.

21 *The Logs* (847A), 1957, 5¹³/₁₆ × 9¼″ (14.8 × 23.5)
Anonymous gift, 69.58.20

22 *Navigation without Numbers* (1307A), 1957, 7⅛ × 9″ (18.1 × 22.9)
Purchase, 69.59.7

23 *Sea Palms* (R3211), 1968, 7¹¹/₁₆ × 9⁹/₁₆″ (19.6 × 24.3)
Purchase, 69.59.9

24 *The Lamp* (H3390), 1969, 7⅜ × 7⅜″ (18.8 × 18.8)
Purchase, 69.59.14

25 *Unmarked Graves* (R3465), 1969, 7⅛ × 7⁵/₁₆″ (18.1 × 18.6)
Purchase, 69.59.20

## JERRY BURCHARD

All works are gelatin silver prints with selenium toning and lent by the artist unless otherwise indicated.

26 *Rochester at Christmas*, 1972, 18 × 19⁵/₁₆″ (45.7 × 49.0)

27 *5 Minutes in Agadir*, 1977, 13⅛ × 19¼″ (33.4 × 48.9)

San Francisco Museum of Modern Art, Gift of Win Ng, 81.364

28 *Ping Yuen #1*, 1977, 13¹/₁₆ × 19³/₁₆″ (33.2 × 48.7)

29 *Hong Kong*, 1978, 12⁹/₁₆ × 18¹³/₁₆″ (31.9 × 47.8)
San Francisco Museum of Modern Art, Mrs. Ferdinand C. Smith Fund Purchase, 79.117

30 *Washington Square Trees*, c. 1970, 13⅛ × 19¼″ (33.4 × 48.9)

## JO ANN CALLIS

All works are Ektacolor prints.

31 *Girl on Bed*, 1977, 13⅞ × 17⁵/₁₆″ (35.3 × 43.9)
Collection of Richard Lorenz, San Francisco

32 *Man at Table*, 1977, 2/15, 13¹⁵/₁₆ × 17⅛″ (35.4 × 43.5)
San Francisco Museum of Modern Art, Byron Meyer Fund Purchase, 79.98

33 *Woman on Metal Chair*, 1977, 1/15, 17¹¹/₁₆ × 14⁵/₁₆″ (45.0 × 36.4)
San Francisco Museum of Modern Art, Mrs. Ferdinand C. Smith Fund Purchase, 79.99

34 *Woman with Black Line*, 1977, 17¼ × 13¹⁵/₁₆″ (43.8 × 35.4)
Lent by the artist

35 *Woman with Wet Hair*, 1978, 13⅞ × 17⅜″ (35.3 × 44.2)
Lent by the artist

## LINDA CONNOR

All works are lent by the artist.

36 *Sea Creatures*, 1971, gelatin silver print with selenium toning, 6⅛ × 4¹³/₁₆″ (15.6 × 12.3)

37 *Unrequited Love*, 1971, from the series *Indian Miniature Fantasies*, gelatin silver print with selenium toning, 6⅝ × 4½″ (16.9 × 11.5)

38 *Marion*, 1972, gelatin silver print with selenium toning, 6⅜ × 5³/₁₆″ (16.7 × 13.2)

39 *Religious Effigies, Benares, India*, 1979, gelatin silver printing-out-paper print with gold toning, 7⅞ × 9¾″ (20.0 × 24.8)

40 *Temple, Khahuraho, India*, 1979, gelatin silver print with gold toning, 11¾ × 9¾″ (29.9 × 24.8)

41 *Temple Wall, Kathmandu, Nepal*, 1980, gelatin silver print with gold toning, 7¹³/₁₆ × 9¾″ (19.9 × 24.7)

## EILEEN COWIN

All works are Ektacolor prints from the series *Family Docudrama*, begun 1980, and lent by the artist, courtesy G. Ray Hawkins Gallery, Los Angeles.

42 *Untitled* (family dinner), 1981, 19 × 24″ (48.3 × 61.0)

43 *Untitled* (me looking at R), 1981, 19 × 24″ (48.3 × 61.0)

44 *Untitled* (R leaving), 1981, 19 × 24″ (48.3 × 61.0)

45 *Untitled* (couple with flowers, woman undressing), 1982, 24 × 19⅛″ (61.0 × 48.6)

46 *Untitled* (therapy), 1982, 19¼ × 24″ (48.3 × 61.0)

## ROBERT CUMMING

All works are gelatin silver prints, collection of the San Francisco Museum of Modern Art unless otherwise indicated.

47  *8 Balls Dropped off the Peak of the Roof, 2 Fell on the North Side, 6 Favored the East*, 1974, diptych, each 8 × 10″ (20.3 × 25.4) Anonymous loan

48  *Saws through at Right Angles . . . Rip and Cross-Cut*, 1978, 7¹³⁄₁₆ × 9¹³⁄₁₆″ (19.9 × 25.0) Purchase, 81.138

49  *Theatre for Two—Easy Analogies*, 1978, 7¹¹⁄₁₆ × 9¹¹⁄₁₆″ (19.6 × 24.6) Purchase, 81.139

50  *Two Objects of Oppression and a Gift for Christmas*, 1978, 7¹¹⁄₁₆ × 9¹¹⁄₁₆″ (19.6 × 24.6) Purchase, 81.137

## DARRYL CURRAN

51  *Edward and Robert*, 1972, two-color gum print and transfer rubbing, 25¾ × 20″ (62.9 × 50.8) Collection of Robert Fichter, Tallahassee, Florida

52  *#2 X-Ray/Heart Patty*, 1973, cyanotype variation, transfer rubbing, and pencil on Rives BFK paper, 26⅛ × 19⅞″ (66.3 × 50.5) Lent by the artist

53  *Brassaï and Friend*, 1978, cyanotype and gum pigment on Rives BFK paper, 14⅞ × 21⅞″ (37.8 × 55.6) Lent by the artist, courtesy G. Ray Hawkins Gallery, Los Angeles

54  *Hollywood Tease Shirt*, 1978, fourcolor Kwik Print on Kwik Print vinyl, 18⅛ × 22″ (46.1 × 55.9) Lent by the artist, courtesy G. Ray Hawkins Gallery, Los Angeles

55  *#10/Forecast*, 1980, cyanotype on Rives BFK paper, 22 × 14¹⁵⁄₁₆″ (55.9 × 38.0) Lent by the artist

## JUDY DATER

All works are lent by the artist, courtesy Grapestake Gallery, San Francisco, unless otherwise indicated.

56  *Twinka (in the window)*, 1970/1982, gelatin silver print, 13⅜ × 10½″ (34.0 × 26.7) San Francisco Museum of Modern Art, Gift of the artist and Rena Bransten (by exchange), 73.30.6

57  *Cheri*, 1972/1982, gelatin silver print, 10⅜ × 13⅜″ (26.4 × 34.0) San Francisco Museum of Modern Art, Gift of the artist and Rena Bransten (by exchange), 73.30.1

58  *Eating*, 1982/1983, Cibachrome print, 20 × 24″ (50.8 × 60.9)

59  *Ms. Clingfree*, 1982/1983, Cibachrome print, 20 × 24″ (50.8 × 60.9)

60  *Woman in Leopard Suit*, 1982/1983, Cibachrome print, 20 × 24″ (50.8 × 60.9)

## JOE DEAL

All works are gelatin silver prints lent by the artist. Numbers 61, 62, and 66 are from the series *Beach Cities*.

61  *Corona Del Mar, California*, 1978, 11⁵⁄₁₆ × 11⁷⁄₁₆″ (28.7 × 29.1)

62  *Laguna Beach, California*, 1978, 11¼ × 11⅜″ (28.6 × 28.9)

Numbers 63, 64, and 65 are from the series *Long Beach Survey*.

63  *Blvd. Trailer Court, Long Beach, California*, 1979, 11⁵⁄₁₆ × 11⅜″ (28.7 × 28.9)

64  *International Tower*, 1980, 11⅜ × 11⅜″ (28.9 × 28.9)

65  *Long Beach, California*, 1980, 11⅜ × 11⅜″ (28.9 × 28.9)

66  *Synchronized Swimming*, 1982, 11⁵⁄₁₆ × 11⅜″ (28.7 × 28.9)

## JOHN DIVOLA

67  *V3*, 1974, from the *Vandalism* series, gelatin silver print, 7¹⁄₁₆ × 7¹⁄₁₆″ (18.0 × 18.0)

San Francisco Museum of Modern Art, Mrs. Ferdinand C. Smith Fund Purchase, 79.226

Numbers 68 through 71 are from the *Zuma* series, 1977–1978.

68  *Untitled (ocean view through broken glass window with brown curtain)*, 1977, Ektacolor print, 9¹³⁄₁₆ × 12¹⁄₁₆″ (25.0 × 30.7) San Francisco Museum of Modern Art, Byron Meyer Fund Purchase, 79.103

69  *Untitled (#5, light reflected from window on black wall, red spray paint)*, 1977/1982, dye-transfer color print, 2/30, 14½ × 18″ (36.9 × 45.6) Lent by the artist

70  *Untitled (#12, ocean view through white interior spray-painted silver and red, dark orange rug)*, 1977/1982, dye-transfer color print, 2/30, 14⅝ × 18″ (37.2 × 45.7) Lent by the artist

71  *Untitled (#38, ocean view through spray-painted blue and red interior, boarded window frame)*, 1978/1982, dye-transfer color print, 2/30, 14⁹⁄₁₆ × 17¹⁵⁄₁₆″ (37.0 × 45.6) Lent by the artist

## ROBERT FICHTER

All works are lent by the artist unless otherwise indicated.

72  *Beast, Landscape and Stamps*, 1969, cyanotype with stamping, 14½ × 11¹⁄₁₆″ (36.9 × 28.1) Collection of Doris and Darryl Curran, Los Angeles

73  *Dogs and Rhino*, 1970, cyanotype/gum-bichromate print with graphite, 19⅝ × 12¹⁵⁄₁₆″ (49.9 × 32.9)

74  *A New Photograph of a Successful Weapon of War*, 1970, cyanotype/gum-bichromate print with ink, 19⅞ × 12¹³⁄₁₆″ (50.5 × 32.6)

75  *Astro View*, 1971, cyanotype/gum-bichromate print, 25¹¹⁄₁₆ × 19⁹⁄₁₆″ (65.2 × 49.7)

76 *Untitled* (Goodyear blimp), 1972, cyanotype/gum bichromate print, 24 × 20″ (60.9 × 50.8) Collection of Carolyn and Virgil Mirano, Venice, California

## HAL FISCHER

All works are RC prints lent by the artist, unless otherwise indicated. Numbers 77, 78, and 79 are from the series *Gay Semiotics*.

77 *Bondage Device: Open End Table Rack*, 1977, 18⁹/₁₆ × 12⁷/₁₆″ (47.2 × 31.6)

78 *Signifiers for a Male Response*, 1977, 18⁹/₁₆ × 12¹/₂″ (47.2 × 31.8) San Francisco Museum of Modern Art, Gift of Richard Lorenz

79 *Street Fashion Basic Gay*, 1977, 18⁵/₈ × 12⁷/₁₆″ (47.3 × 31.6)

Numbers 80 through 83 are from the series *The Boyfriend*, two prints per title.

80 *The European Visitor*, 1979, 8 × 10″ (20.3 × 25.4)

81 *A Hippie*, 1979, 8 × 10″ (20.3 × 25.4)

82 *The Merchant down the Street*, 1979, 8 × 10″ (20.3 × 25.4)

83 *The Punk Poet*, 1979, 8 × 10″ (20.3 × 25.4)

## ROBBERT FLICK

All works are gelatin silver prints from the series *Sequential Views*, courtesy Tortue Gallery, Santa Monica, California.

84 *Along Florence Avenue Looking North, Inglewood Centinella Park* (SV003/80), 1980, 15⁵/₈ × 21⁵/₈″ (39.7 × 55.0)

85 *Along Ocean Park, Looking West, Summer, 1980* (SV013/80), 1980, 15⁹/₁₆ × 21⁵/₈″ (39.6 × 55.0)

86 *N.E. of Backus Road, Kern County, California* (SV037/81), 1981, 17⁵/₈ × 22³/₄″ (44.8 × 57.8)

87 *Saguaro National Monument I* (SV055/82), 1982, 17⁵/₈ × 22³/₄″ (44.8 × 57.8)

## VIDA FREEMAN

All works lent by the artist. Numbers 88 through 90 are from the series *Death Valley*.

88 *China Ranch*, 1979, palladium print with text, overall 15 × 20¹/₁₆″ (38.1 × 51.0)

89 *Cottonball Marsh*, 1979, palladium print with text, overall 15 × 20¹/₁₆″ (38.1 × 51.0)

90 *Furnace Creek Ranch*, 1979, palladium print with text, overall 15 × 20¹/₁₆″ (38.1 × 50.0)

Numbers 91 through 94 are from the series *Sacred Stones*.

91 *Clava Cairns, Inverness-shire, Scotland*, 1982, platinum palladium print, 4¹/₈ × 4¹/₁₆″ (10.5 × 10.3)

92 *Glenquickan, Kirkcudbright, Scotland*, 1982, platinum palladium print, 4¹/₈ × 4¹/₁₆″ (10.5 × 10.3)

93 *Nether Largie So., Kilmartin Valley, Scotland*, 1982, platinum palladium print, 4¹/₈ × 4¹/₁₆″ (10.5 × 10.3)

94 *Ring of Brodgar, Orkney Island, Scotland*, 1982, platinum palladium print, 4¹/₈ × 4¹/₁₆″ (10.5 × 10.3)

## ANTHONY FRIEDKIN

All works are gelatin silver prints lent by the artist. Numbers 95 and 98 are from the series *Gay Essay*. Numbers 96, 97, and 99 are from the series *Beverly Hills Essay*.

95 *Jim and Mundo*, 1970, 12¹/₂ × 18⁷/₈″ (31.8 × 48.0)

96 *Beverly Hills High School*, 1975, 12¹/₂ × 18⁷/₈″ (31.8 × 48.0)

97 *Beverly Hills Hotel*, 1975, 12¹/₂ × 18⁷/₈″ (31.8 × 48.0)

98 *Jim Aquilar*, 1975, 12¹/₂ × 18⁷/₈″ (31.8 × 48.0)

99 *Jag*, 1978, 12¹/₂ × 18⁷/₈″ (31.8 × 48.0)

## JACK FULTON

All works are lent by the artist unless otherwise indicated.

100 *Lock Din Wall*, 1973, gelatin silver print with ink, 13¹⁵/₁₆ × 11″ (35.4 × 28.0)

101 *Peas on Urth*, 1974, Ektacolor print with hand-coloring and lacquer, 10 × 8″ (25.4 × 20.3) San Francisco Museum of Modern Art, Soap Box Derby Fund Purchase, 81.62

102 *Cacti Are the Sculpture of Western Nature: Art—No View*, 1975, gelatin silver print with rub-on letters and black and colored ink, 10¹⁵/₁₆ × 13¹⁵/₁₆″ (27.8 × 35.4) San Francisco Museum of Modern Art, Gift of Jean Gardner, 82.507

103 *At Fat Jimmy's*, 1979, reversed Ektacolor print with special process color and ink, 14 × 11″ (35.6 × 28.0)

104 *Site Unscene*, 1979, reversed Ektacolor print with special process color and ink, 14 × 11″ (35.6 × 28.0)

## PHILLIP GALGIANI

All works are gelatin silver prints lent by the artist.

105 *Hand Supports*, 1978, 16 × 20″ (40.7 × 50.8)

106 *Paper Held Two Ways*, 1978, 16 × 20″ (40.7 × 50.8)

107 *Sight Line*, 1978, 16 × 20″ (40.7 × 50.8)

108 *Hands and Glasses*, 1982, 16 × 20″ (40.7 × 50.8)

109 *Hands and Hat*, 1982, 16 × 20″ (40.7 × 50.8)

110 *Hands and Picture Frame*, 1982, 16 × 20″ (40.7 × 50.8)

## JIM GOLDBERG

All works are gelatin silver prints. Numbers 111 through 113 are from the series *San Francisco Hotel*, collection of the San Francisco Museum of Modern Art, Theo Jung Collection, Theo Jung Fund Purchase.

111 *Untitled* (Dorothy and T.J.), 1977/1978, 14 × 10⅞" (35.6 × 27.7), 80.90

112 *Untitled* (Anne Williams), 1978/1979, 13¹⁵/₁₆ × 10¹⁵/₁₆" (35.5 × 27.8), 80.88

113 *Untitled* (Larry J. Benko and son, David), 1979, 13¹⁵/₁₆ × 10⅞" (35.4 × 27.7), 80.89

Numbers 114, 115, and 116 are from the series *The Privileged of San Francisco*, lent by the artist.

114 *Untitled* (Regina Goldstine), 1981, 11 × 14" (27.9 × 35.6)

115 *Untitled* (Countess Vivanna de Blanville), 1982, 11 × 14" (27.9 × 35.6)

116 *Untitled* (Michael Mindel), 1982, 11 × 14" (27.9 × 35.6)

## JUDITH GOLDEN

All works are lent by the artist unless otherwise indicated. Numbers 117 and 118 are from the series *Chameleon*, 1974–1976.

117 *The Redhead Fantasy*, 1974, gelatin silver print with oil pastel, thread, and feathers in plastic, overall 20³/₁₆ × 15¹³/₁₆" (51.3 × 40.2) San Francisco Museum of Modern Art, Gift of the artist, 82.286

118 *Inspector X/Paris*, 1975, gelatin silver print with pastel, thread, fabric, stitched in vinyl, 15½ × 12⁷/₁₆" (39.4 × 31.6)

Numbers 119, 120, and 121 are from the series *Magazine Make Over*.

119 *Body*, 1976, gelatin silver print with oil and colored pencil, 13¹⁵/₁₆ × 11" (35.4 × 28.0)

120 *Now New Long Lasting Eye*, 1976, gelatin silver print with oil and colored pencil, 14 × 11" (35.6 × 28.0)

121 *Makeup like Wine*, 1977, gelatin silver print with oil and colored pencil, 14 × 11" (35.6 × 28.0)

## JOHN GUTMANN

All works are gelatin silver prints lent by the artist, courtesy Castelli Graphics, New York, and Fraenkel Gallery, San Francisco.

122 *Ben's Barber Shop Window, "Streamlined Hair Cut,"* 1946/1978, from the series *Documents of the Street*, 10¹³/₁₆ × 10⁷/₁₆" (27.5 × 26.5)

123 *The Cigaret*, 1949/1981, 12¹³/₁₆ × 10⅜" (32.6 × 26.4)

124 *The Oracle*, 1949/1981, 12⅞ × 10⅛" (32.7 × 25.7)

125 *"Gold–Silver Coins Bought Here," 47th Street, New York City*, 1981, from the series *Documents of the Street*, 10¼ × 10⁹/₁₆" (26.1 × 26.9)

## ROBERT HEINECKEN

All works are lent by the artist unless otherwise indicated.

126 *14 or 15 Buffalo Ladies #1*, 1969, offset photo-lithograph with pastel and pencil, Ed. 9, 17 × 12¹/₁₆" (43.2 × 30.7) San Francisco Museum of Modern Art, Purchase, 82.53

127 *TV Dinner/Before and After*, 1970, formed emulsion on canvas, chalk, and resin, two parts, each 12 × 15 × 1" (30.5 × 38.1 × 2.6)

128 *Daytime Color TV Fantasy/Arm and Hammer*, 1976, photographic lithograph, 13⁹/₁₆ × 17½" (34.4 × 44.5)

129 *How Does Posing for a Drawing Differ from a Photograph?*, 1977, four Polaroid SX-70 prints and lithographic text, overall 11 × 14" (28.0 × 35.6)

130 *Lessons in Posing Subjects, Fantasy Narrative #1*, 1981, five Polaroid SX-70 prints and lithographic text, 4/10, overall 15⅜ × 20⅜" (39.1 × 51.7)

131 *Lessons in Posing Subjects/Simulated Animal Skin Garments*, 1982, ten Polaroid SX-70 prints and lithographic text, 4/10, 15 × 20" (38.1 × 50.8)

## HARVEY HIMELFARB

All works are gelatin silver prints and lent by the artist, unless otherwise indicated.

132 *Untitled* (woman standing in partially filled swimming pool), 1970, from the *Visual Dialogue Foundation Founders Portfolio*, 5/15, 7¼ × 7¹/₁₆" (18.4 × 18.0) San Francisco Museum of Modern Art, William L. Gerstle Collection, William L. Gerstle Fund Purchase, 70.28.5

133 *Untitled* (fence posts in snow), 1971, 7½ × 7⅜" (19.1 × 18.8)

Numbers 134, 135, and 136 are from the series *Tiling the Plane*, 1976–1980.

134 *Untitled* (rectangular table), 1977, 7½ × 7½" (19.1 × 19.1)

135 *Untitled* (brick wall with wires), 1980, 7⅝ × 7½" (19.4 × 19.1) San Francisco Museum of Modern Art, Soap Box Derby Fund Purchase, 80.398

136 *Untitled* (trees, road, and sign post), 1980, 7⅝ × 7½" (19.4 × 19.1)

## PIRKLE JONES

All works are gelatin silver prints with selenium toning lent by the artist. Numbers 137 and 139 are from the series *Tidewater Oil Refinery, Avon, California*. Numbers 140 and 141 are from the series *Black Panther Essay*.

137 *Untitled* (oil refinery), 1957, 13⁷⁄₁₆ × 9⁷⁄₁₆" (34.2 × 24.0).

138 *Untitled* (workers building Paul Masson winery, Saratoga, California), 1963, 12¹⁵⁄₁₆ × 10³⁄₁₆" (31.3 × 26.9)

139 *Untitled* (workers constructing oil refinery), 1957, 12¼ × 10⅛" (31.1 × 25.7)

140 *Untitled* (group shot), 1968, 13⅜ × 10⁷⁄₁₆" (34.0 × 26.5)

141 *Untitled* (three Black Panthers), 1968, 13⅜ × 10⁷⁄₁₆" (34.0 × 26.5)

## BARBARA KASTEN

142 *Untitled* (77/2), 1977, photogenic painting, cyanotype with pastel, 29⁷⁄₁₆ × 41³⁄₁₆" (74.8 × 104.6)
Lent by the artist

143 *Untitled Photogenic Painting*, 1979, photogram on photomural paper with oil pastel, 31 × 42½" (78.7 × 107.9)
Lent by the artist.

Numbers 144 through 146 are lent courtesy John Weber Gallery, New York.

144 *Construct PC/4A*, 1981, Polacolor ER, 24½ × 20¾" (62.3 × 52.7)

145 *Construct LB/4*, 1982, Polacolor ER, 7½ × 9½" (19.1 × 24.2)

146 *Construct LB/6*, 1982, Polacolor ER, 9⁹⁄₁₆ × 7⁹⁄₁₆" (24.3 × 19.2)

## VICTOR LANDWEBER

All works are 1978, two Polaroid Polacolor II prints (pieced). Sizes given are overall. All are collection of the San Francisco Museum of Modern

Art, Gift of Louis Landweber, unless otherwise indicated.

147 *Garbage Candy*, 2¹³⁄₁₆ × 5⅞" (9.7 × 15.0)
Lent by the artist

148 *Red Hot Dollars*, 6⅜ × 4¼" (16.2 × 10.8), 81.212

149 *Vicks Victors Cough Drops*, 4¼ × 6⅝" (10.8 × 16.8), 81.215

150 *Wax Chewing Gum Tongues/Mr. Bones*, 6⁵⁄₁₆ × 4¼" (16.1 × 10.8), 81.216

151 *Wax Lips*, 6⅜ × 4¼" (16.2 × 10.8), 81.214

## GREGORY MacGREGOR

152 *Goblin Valley, Utah*, 1975, gelatin silver print with sepia toning and hand-coloring, 10¾ × 13¾" (27.3 × 35.0)
Courtesy Foster Goldstrom Fine Arts, San Francisco

153 *Pink Nebulus*, 1977, gelatin silver print with copper toning and hand-coloring, 10¹¹⁄₁₆ × 13¹³⁄₁₆" (27.2 × 35.1)
San Francisco Museum of Modern Art, Gift of Graham Nash, 79.401

154 *Anza Borrego Object*, 1978, from the portfolio *Out of State*, gelatin silver print with sepia toning, Ed. 29, 10⁷⁄₁₆ × 13⅝" (26.5 × 34.6)
San Francisco Museum of Modern Art, Mrs. Ferdinand C. Smith Fund Purchase, 78.140.16

155 *Removing a Fender from 1950 Studebaker*, 1978, gelatin silver print, 12⁹⁄₁₆ × 18¹⁄₁₆" (31.9 × 45.9)
Courtesy Foster Goldstrom Fine Arts, San Francisco

156 *Poodle Shaped Explosion in Vicinity of Cumulus Clouds, U.S. Route 80, Utah*, 1979, gelatin silver print, 12³⁄₁₆ × 17⁹⁄₁₆" (30.9 × 44.6)
San Francisco Museum of Modern Art, Anonymous gift, 80.254

## MIKE MANDEL and LARRY SULTAN

All works are Ektacolor prints lent by the artists.

157 *Oranges on Fire* (documentation of billboard), 1975, 19¾ × 34¼" (50.2 × 87.0)

158 *Oranges on Fire* (set-up for billboard), 1975, 8 × 10" (20.3 × 25.4)

159 *We Make You Us* (documentation of billboard), 1975, 19¾ × 34¼" (50.2 × 87.0)

160 *We Make You Us* (set-up for billboard), 1975, 8 × 10" (20.3 × 25.4)

161 *Ties* (documentation of billboard), 1978, 19½ × 30" (49.6 × 76.2)

162 *Ties* (set-up for billboard), 1978, 8 × 10" (20.3 × 25.4)

163 *Whose News (Abuses You)* (documentation of billboard), 1980, 19¾ × 34¼" (50.2 × 87.0)

164 *Whose News (Abuses You)* (set-up for billboard), 1980, 8 × 10" (20.3 × 25.4)

## KENNETH McGOWAN

All works are Cibachrome prints lent by the artist.

165 *Yoga*, 1976, 19½ × 19¼" (49.6 × 48.9)

166 *Pool Party*, 1977, 19¼ × 19⅛" (48.9 × 48.6)

167 *Lily Tomlin's Dresses*, 1979, 19⅜ × 19³⁄₁₆" (49.2 × 48.8)

168 *Studio Commissary*, 1979, 19½ × 19¼" (49.6 × 48.9)

169 *Wall of Masks*, 1979, 19³⁄₁₆ × 19⅛" (48.8 × 48.6)

## JERRY McMILLAN

170 *Untitled* (landscape bag), 1968, three-color photo-offset lithograph inside a paper bag construction, 9½ × 5½ × 4½" (24.2 × 14.0 × 11.5)

Collection of Jackie and Manny Silverman, Beverly Hills, California

171 *Untitled* (double oak coil), 1975, photo-etched half-hard brass coil, 12 × 27¾ × .025" (30.5 × 697.9 × .6)
Museum of Contemporary Art, Los Angeles

172 *Untitled* (square), 1977, from *Silver See: A Portfolio of Photography from Los Angeles*, gelatin silver print, Ed. 45, 19⅞ × 16⅛" (50.5 × 41.0)
San Francisco Museum of Modern Art, Mrs. Ferdinand C. Smith Fund Purchase, 78.171.12

173 *Untitled* (black stroke #302), 1982, sulfide duotone from a black-and-white photographic print, 1/25, 20 × 16" (50.8 × 40.7)
Lent by the artist

174 *Untitled* (black stroke #401), 1982, black-and-white photographic print, 1/25, 20 × 16" (50.8 × 40.7)
Lent by the artist

## ROGER MINICK

All works are lent by the artist. Numbers 175 through 177 are from the series *Southland*, and are gelatin silver prints with sepia toning.

175 *A & W and Palms*, 1974, 15½ × 19½" (39.4 × 49.6)

176 *Flying Wing Station*, 1975, 15½ × 19½" (39.4 × 49.6)

177 *Mother and Daughter at K-Mart*, 1977, 15¼ × 16" (38.8 × 40.7)

Numbers 178 and 179 are from the series *Sightseer*, and are gelatin silver prints.

178 *Family at Mt. Rushmore*, 1979, 18⅛ × 15½" (46.1 × 39.4)

179 *Winnebago at Mt. Rushmore*, 1979, 15⅜ × 18½" (39.1 × 47.0)

## RICHARD MISRACH

All works are lent by the artist, courtesy Grapestake Gallery, San Francisco, unless otherwise indicated.

180 *Boojum #2, Baja, California*, 1977, gelatin silver print with selenium toning, 15¼ × 15¼" (38.8 × 38.8)
San Francisco Museum of Modern Art, Mrs. Ferdinand C. Smith Fund Purchase, 79.225

181 *Ground/Sky Saguaro Transition*, 1977, gelatin silver print with selenium toning, 15 × 15" (38.1 × 38.1)

182 *San Gorgonio Pass*, Ektacolor print, 1981, 30 × 40" (76.2 × 101.6)

183 *San Jacinto*, 1982, Ektacolor print, 15¼ × 19" (38.8 × 48.3)

184 *The Santa Fe*, 1982/1983, Cibachrome print, 27⁷⁄₁₆ × 34¹⁄₁₆" (69.7 × 86.5)
San Francisco Museum of Modern Art, Members' Accessions Fund Purchase, 83.110

## PATRICK NAGATANI

All works are lent by the artist. Numbers 185 through 187 are from the series *Chromo-Therapy*, Cibachrome prints, graphite and transparent watercolor spray on mat.

185 *Untitled* (nude and dog), 1978, 9¼ × 17½" (23.5 × 44.5)

186 *Untitled* (man with glasses), 1978, 13¾ × 20" (32.4 × 50.8)

187 *Untitled* (nude reclining), 1979, 9⅛ × 17⅜" (23.2 × 44.2)

Numbers 188 and 189 are from the series *Colorful Cathedral*, nine Cibachrome prints with mixed media.

188 *La Basilique du Sacré-Coeur sur la Butte Montmartre #2, Paris, France*, 1982, 30½ × 33½" (77.5 × 85.1)

189 *Reims, France #4*, 1982, 33¹³⁄₁₆ × 30⅝" (85.9 × 77.8)

## ARTHUR OLLMAN

All works are Ektacolor prints lent by the artist, courtesy Grapestake Gallery, San Francisco, unless otherwise indicated.

190 *Untitled* (AM tunnel, San Francisco), 1977, 12⅝ × 19" (32.1 × 48.3)

191 *Untitled* (Divisadero mansion, San Francisco), 1977, 12⅝ × 19⅛" (32.1 × 48.6)

192 *Untitled* (conservatory, Golden Gate Park), 1978, 12¹³⁄₁₆ × 19⅛" (32.6 × 48.6)

193 *Untitled* (nighttime view of house overlooking ocean), 1978, 13¼ × 19¹⁄₁₆" (33.7 × 48.4)
San Francisco Museum of Modern Art, Mrs. Ferdinand C. Smith Fund Purchase, 78.177

194 *Untitled* (cactus house, Albany, California), 1980, 12¹³⁄₁₆ × 19¹⁄₁₆" (32.6 × 48.4)

## BILL OWENS

All works are gelatin silver prints. Numbers 195, 196, and 197 are 1971, from the series *Suburbia*, 1973.

195 *"I don't feel that Richie...,"* 8 × 10" (20.3 × 25.4)
Lent by the artist

196 *"People throw away a lot of good things...,"* 5¹³⁄₁₆ × 8⁹⁄₁₆" (14.8 × 21.8)
Lent by the artist

197 *"We're really happy...,"* from the *Bill Owens Portfolio*, 1977, 5/25, 6⁵⁄₁₆ × 8¹⁄₁₆" (16.1 × 20.4)
San Francisco Museum of Modern Art, Gift of John Berggruen, 77.275.1

Numbers 198, 199, and 200 are 1976, from the series *Working: (I Do It for the Money)*, 1977

198 *"At one time or another...,"* 6⅝ × 8⅝" (16.9 × 21.9)
Lent by the artist

199 *"I'm a table worker inspecting birth control pills...,"* 6⁷⁄₁₆ × 8³⁄₈″ (16.4 × 21.3)
Lent by the artist

200 *"I've been a chiropractor for thirty-three years...,"* from the *Bill Owens Portfolio*, 1977, 5/25, 6¼ × 8″ (15.8 × 20.3)
San Francisco Museum of Modern Art, Gift of John Berggruen, 77.275.1

## DONNA-LEE PHILLIPS

All works are lent by the artist.

201 *December 1 through December 6* and *December 8 through December 11*, 1977–78/1983, from the series *Fragments from a Visual Journal: November 16, 1977–January 9, 1978*, ten gelatin silver prints with typewritten texts, each 8 × 10″ (20.3 × 25.4)

202 *This Is Probably a Chair., This Is a Real Chair., This Signifies "Chair.", This Is Not a Chair., This Is a Photograph.*, 1981, from the series *100 Small Chairs, More or Less*, 1981, five RC prints with ink, each 15½ × 12⅛″ (39.4 × 30.8)

## LELAND RICE

All works are Ektacolor prints from the series *Wall Sites*, 1977–80. All are lent by the artist, courtesy Grapestake Gallery, San Francisco, unless otherwise indicated.

203 *Untitled* (spray-painted wall with electrical outlet, Fred Spratt's studio), 1977, from *Silver See: A Portfolio of Photography from Los Angeles*, Ed. 45, 9⁷⁄₁₆ × 12¹³⁄₁₆″ (24.0 × 32.6)
San Francisco Museum of Modern Art, Mrs. Ferdinand C. Smith Fund Purchase, 78.171.16

204 *Untitled* (painted wall and floor with tape, Andrew Spence's studio), 1978, 38 × 29⅝″ (96.5 × 75.3)

205 *Untitled* (paper with spray paint suspended on wall), 1978, from the portfolio *Out of State*, Ed. 29, 12½ × 9³⁄₁₆″ (31.8 × 23.4)
San Francisco Museum of Modern Art, Mrs. Ferdinand C. Smith Fund Purchase, 78.140.13

206 *Untitled* (black rectangle, Peter Lodato's studio), 1978/1979, 21½ × 16¾″ (54.7 × 42.5)

## EDMUND TESKE

All works are gelatin silver combination prints, collection of the San Francisco Museum of Modern Art, unless otherwise indicated.

207 *Untitled* (composite image of Jane Lawrence and reeds, Los Angeles), 1947, 4⅝ × 6⁹⁄₁₆″ (11.8 × 16.7)
Purchased with the aid of funds from Reese Palley, 68.50.6

208 *Untitled* (multiple image of Shirley Berman's face and Madison Grammar School demolition, Chicago), 1956, 4⅜ × 5⅝″ (11.1 × 14.3)
Purchased with the aid of funds from Reese Palley, 68.50.5

209 *Untitled* (torn poster, Tijuana, Mexico), c. 1962, gelatin silver print, 6¹¹⁄₁₆ × 4⅝″ (17.0 × 11.8)
Purchased with the aid of funds from Reese Palley, 68.50.1

210 *Untitled* (nude male torso), c. 1974, from *Silver See: A Portfolio of Photography from Los Angeles*, 1977, Ed. 45, 9¹⁵⁄₁₆ × 7⅞″ (25.3 × 20.0)
Mrs. Ferdinand C. Smith Fund Purchase, 78.171.19

211 *Untitled* (the three children of Mr. and Mrs. F. Montrose), 1976, 9½ × 6¹¹⁄₁₆″ (24.2 × 17.0)
Lent by the artist

## LEW THOMAS

All works are lent courtesy Fraenkel Gallery, San Francisco. All are gelatin silver prints, unless otherwise indicated.

212 *Sink*, 1972, 12 prints, overall 29¾ × 31¹¹⁄₁₆″ (75.6 × 80.5)

213 *Jumping with Nikomat*, 1973, three prints, overall 33 × 13½″ (83.8 × 34.3)

214 *Throwing Nikomat*, 1973, four prints, overall 27½ × 22″ (69.9 × 55.9)

215 *Bibliography*, 1977, photographic silkscreen, 28⅛ × 20⅛″ (71.5 × 53.7)

216 *Bookspine (Malevich)*, 1980, 23 × 19″ (58.4 × 48.3)

## TODD WALKER

All works are lent by the artist.

217 *Untitled* (nude in fetal position), 1969, unique Sabattier silver print, 9¾ × 7⅝″ (24.8 × 19.4)

218 *Untitled* (nude running), 1969, collotype, 8⅞ × 11⁹⁄₁₆″ (22.6 × 29.4)

219 *Untitled* (Pearl with black shadows), 1969, unique Sabattier silver print, 9¹³⁄₁₆ × 7⅝″ (25.0 × 19.4)

220 *Untitled* (Frances), 1970, offset lithograph, 11 × 8⅝″ (28.0 × 21.9)

221 *Untitled* (standing nude), 1970, gum-bichromate print, 10⅜ × 9¼″ (26.4 × 23.5)

## JACK WELPOTT

All works are gelatin silver prints. All are lent by the artist, unless otherwise indicated.

222 *Anna in Her Room*, 1964, 10¹¹⁄₁₆ × 13⅝″ (27.2 × 34.6)

223 *Laura Mae Dunlop*, 1973, 9½ × 9⁷⁄₁₆″ (24.2 × 24.0)
San Francisco Museum of Modern Art, Anonymous gift, 73.77.2

224 *Sabine* (Arles), 1973, from the portfolio *Out of State*, 1978, Ed. 29, 13 × 10″ (33.0 × 25.4) San Francisco Museum of Modern Art, Mrs. Ferdinand C. Smith Fund Purchase, 78.140.11

225 *Sherry*, 1980, 12¹/₁₆ × 15¾″ (30.7 × 40.0) San Francisco Museum of Modern Art, Gift of the artist in honor of John Humphrey, 80.491

226 *Toni Whiteman*, 1980, 9¹⁵/₁₆ × 7½″ (25.3 × 19.1)

## HENRY WESSEL, JR.

All works are gelatin silver prints.

227 *San Francisco, California*, 1972, 11¹⁵/₁₆ × 8″ (30.4 × 20.3) Lent by the artist, courtesy Fraenkel Gallery, San Francisco

228 *Untitled* (man with long hair and dog on beach), c. 1972, 10½ × 15¹¹/₁₆″ (26.7 × 39.9) Lent by the artist, courtesy Delahunty Gallery, Dallas

229 *Mission Beach, California*, 1973, 8 × 12″ (20.3 × 30.5) Lent by the artist, courtesy Charles Cowles Gallery, New York

230 *San Francisco, California*, 1973, 15¹¹/₁₆ × 10½″ (39.9 × 26.7) San Francisco Museum of Modern Art, Gift of Fraenkel Gallery, 81.134

231 *Richmond, California*, 1974, 8⅛ × 12⅛″ (20.7 × 30.8) Lent by the artist, courtesy Fraenkel Gallery, San Francisco

## MINOR WHITE

All works are gelatin silver prints, collection of the San Francisco Museum of Modern Art.

232 *Sandblaster* (San Francisco), 1949, 9⁵/₁₆ × 10⁵/₁₆″ (23.7 × 26.2) Gift of Mrs. Wellington S. Henderson, 73.29.4

233 *Bad Lands, South Dakota*, 1959, from *Sequence 15*, 7⁵/₁₆ × 9⁵/₁₆″ (18.6 × 23.7) Gift of the artist, 60.45.13

234 *Peeled Paint* (Rochester, New York), 1959, 10⁵/₁₆ × 8½″ (27.8 × 21.6) Gift of Mrs. Wellington S. Henderson, 73.29.3

235 *Shore Acres State Park, Oregon*, 1959, from *Sequence 15*, 7⁵/₁₆ × 9¼″ (18.6 × 23.5) Gift of the artist, 60.4505

236 *Untitled* (tide pool), n.d., 7 × 8¹⁵/₁₆″ (17.8 × 22.7) Gift of Virginia Hassel Ballinger in memory of Paul Hassel, 73.60.1

## DON WORTH

All works are gelatin silver prints, collection of the San Francisco Museum of Modern Art unless otherwise indicated.

237 *Kelp, Santa Cruz*, c. 1955, from the portfolio *Don Worth: Twelve Photographs*, 1957, Ed. 50, 7⅜ × 5¼″ (18.8 × 13.4) Gift of Don Worth in memory of Edward Weston, 58.1895

238 *Aspens, Colorado*, 1957, from the portfolio *Don Worth: Twelve Photographs*, 1957, Ed. 50, 9 × 7³/₁₆″ (22.9 × 18.3) Gift of Don Worth in memory of Edward Weston, 58.1893

239 *Rocks and Surf, San Francisco*, 1969, from the *Visual Dialogue Foundation Founders Portfolio*, 1970, 5/15, 11¹⁵/₁₆ × 9⁵/₁₆″ (30.4 × 23.7) William L. Gerstle Collection, William L. Gerstle Fund Purchase, 70.28.11

240 *Trees and Fog, San Francisco*, 1971, 16⁵/₁₆ × 21⅜″ (41.5 × 53.7) Lent by the artist

241 *Castor Bean* (*Ricinus communis occineus*), 1978, from the portfolio *Out of State*, Ed. 29, 6¹¹/₁₆ × 9¹⁵/₁₆″ (17.0 × 25.3) Mrs. Ferdinand C. Smith Fund Purchase, 78.140.8

## MAX YAVNO

All works are gelatin silver prints lent by the artist, courtesy G. Ray Hawkins Gallery, Los Angeles.

242 *Night View from Coit Tower*, 1947, 15³/₁₆ × 19½″ (40.2 × 49.6)

243 *Muscle Beach*, 1949, 11¹¹/₁₆ × 19⁹/₁₆″ (29.7 × 49.7)

244 *Santa Monica Beach*, 1949, 15⅝ × 19⁹/₁₆″ (39.7 × 49.7)

245 *Pinks*, 1977, 14⁹/₁₆ × 19¹³/₁₆″ (37.0 × 50.4)

246 *Kickoff*, 1978, 15¹¹/₁₆ × 19½″ (39.9 × 49.6)

## LEWIS BALTZ

*Born:* Newport Beach, California, 1945
*Studied:* San Francisco Art Institute, B.F.A., 1969; Claremont Graduate School, California, M.F.A., 1971
*Taught:* Pomona College, Claremont, California, 1970–1972; Claremont Graduate School, California, 1972; California Institute of the Arts, Valencia, 1972; University of California, Davis, 1981; University of California, Santa Cruz, 1982
*Resides:* Sausalito, California

## RUTH BERNHARD

*Born:* Berlin, Germany, 1905
*Studied:* University of Bremen, Germany, 1923–1925; Berlin Academy of Art, 1925–1927
*Taught:* University of California Extension, San Francisco, 1966–1975
*Resides:* San Francisco

## MICHAEL BISHOP

*Born:* Palo Alto, California, 1946
*Studied:* Foothill College, Los Altos Hills, California, 1965–1967; San Francisco Art Institute, B.A., 1967–1968; San Francisco State University, M.A., 1968–1970
*Taught:* University of California Extension, Berkeley, 1970–1972; San Francisco Art Institute, 1970–1972; University of California, Los Angeles, 1972–1975; Rochester Institute of Technology, New York, 1977–1978 and 1981; Massachusetts Institute of Technology, Cambridge, 1981–1983
*Resides:* Boston

## ELLEN BROOKS

*Born:* Los Angeles, 1946
*Studied:* University of Wisconsin, Madison, 1963–1965; University of California, Los Angeles, B.A., 1968; M.A., 1970; M.F.A., 1971
*Taught:* University of California Extension, Los Angeles, 1971; University of California Extension, Berkeley, 1971–1973; San Francisco Art Institute, 1973 to the present; Franconia College, New Hampshire, 1974; School of the Art Institute of Chicago, 1977; California Institute of the Arts, Valencia, 1982; University of California, Santa Cruz, 1982
*Resides:* San Francisco

## JOHN BRUMFIELD

*Born:* Los Angeles, 1934
*Studied:* California State University, Los Angeles, B.A., 1961; M.A., 1962; University of California, Berkeley, M.A., 1970; California Institute of the Arts, Valencia, M.F.A., 1974
*Taught:* University of Southern California, Los Angeles, 1962–1963; University of California, Berkeley, 1967–1970; California State University, San Jose, 1968–1970; California State University, Bakersfield, 1970–1975; California Institute of the Arts, Valencia, 1974 to the present
*Resides:* Frazier Park, California

## WYNN BULLOCK

*Born:* Chicago, 1902
*Studied:* Columbia University, New York, 1923; University of West Virginia, Morgantown, 1933–1936; Art Center

School of Design, Los Angeles (now in Pasadena, California), 1937–1939
*Taught:* San Francisco State College (now San Francisco State University), 1959; Illinois Institute of Technology, Institute of Design, Chicago, 1967
*Died:* Monterey, California, 1975

## JERRY BURCHARD

*Born:* Rochester, New York, 1931
*Studied:* California School of Fine Arts, San Francisco (now San Francisco Art Institute), B.F.A., 1960
*Taught:* San Francisco Art Institute, 1966 to the present
*Resides:* San Francisco

## JO ANN CALLIS

*Born:* Cincinnati, 1940
*Studied:* University of California, Los Angeles, B.A., 1974; University of California, Los Angeles, M.F.A., 1977
*Taught:* California Institute of the Arts, Valencia, 1976 to the present; California State University, Fullerton, 1977–1978; University of California Extension, Los Angeles, 1977 to the present
*Resides:* Culver City, California

## LINDA CONNOR

*Born:* New York, 1944
*Studied:* Rhode Island School of Design, B.F.A., 1967; Illinois Institute of Technology, Institute of Design, Chicago, M.S., 1969
*Taught:* San Francisco Art Institute, 1969 to the present; California College of Arts and Crafts, Oakland, 1970 and 1973; San Francisco State University, 1972; University of Califor-

nia Extension, Berkeley, 1973; School of the Museum of Fine Arts, Boston, 1978
*Resides:* San Anselmo, California

## EILEEN COWIN

*Born:* Brooklyn, 1947
*Studied:* State University College of New York, New Paltz, B.S., 1968; Illinois Institute of Technology, Institute of Design, Chicago, M.S., 1970
*Taught:* Franconia College, New Hampshire, 1971–1975; California State University, Fullerton, 1975 to the present
*Resides:* Venice, California

## ROBERT CUMMING

*Born:* Worcester, Massachusetts, 1943
*Studied:* Massachusetts College of Art, Boston, B.F.A., 1965; University of Illinois, Urbana-Champaign, M.F.A., 1967
*Taught:* University of Wisconsin, Milwaukee, 1967–1970; California State University, Fullerton, 1970–1972; University of California, Riverside, 1973; University of California Extension, Los Angeles, 1974–1977; Otis Art Institute, Los Angeles, 1974–1977; Orange Coast College, Costa Mesa, California, 1976; California Institute of the Arts, Valencia, 1976–1977; University of California, Irvine, 1977–1978; Hartford Art School, Connecticut, 1978 to the present
*Resides:* West Suffield, Connecticut

## DARRYL CURRAN

*Born:* Santa Barbara, California, 1935
*Studied:* Ventura College, California, A.A., 1958; University of California, Los Angeles, B.A., 1960; M.A., 1964
*Taught:* California State University, Fullerton, 1967 to the present; Los Angeles Harbor College, 1968–1969; University of California Extension, Los Angeles, 1971 to the present; University of California, Los Angeles, 1972
*Resides:* Los Angeles

## JUDY DATER

*Born:* Hollywood, California, 1941
*Studied:* University of California, Los Angeles, 1959–1962; San Francisco State University, B.A., 1963; M.A., 1966
*Taught:* University of California Extension, San Francisco, 1966–1974; San Francisco Art Institute, 1974–1978
*Resides:* San Anselmo, California

## JOE DEAL

*Born:* Topeka, Kansas, 1947
*Studied:* Kansas City Art Institute, Missouri, B.F.A., 1970; University of New Mexico, Albuquerque, M.A., 1974; M.F.A., 1978
*Taught:* University of California, Riverside, 1976 to the present
*Resides:* Riverside, California

## JOHN DIVOLA

*Born:* Santa Monica, California, 1949
*Studied:* California State University, Northridge, B.A., 1971; University of California, Los Angeles, M.A., 1973; M.F.A., 1974
*Taught:* University of California Extension, Los Angeles, 1974–1980; Immaculate Heart College, Los Angeles, 1975–1979; Loyola Marymount University, Los Angeles, 1976–1980; University of California, Los Angeles, 1977 and 1982–1983; California Institute of the Arts, Valencia, 1978–1982
*Resides:* Venice, California

## ROBERT FICHTER

*Born:* Fort Meyers, Florida, 1939
*Studied:* University of Florida, Gainesville, B.F.A., 1963; Indiana University, Bloomington, M.F.A., 1966
*Taught:* University of Florida, Gainesville, 1967; University of California, Los Angeles, 1968–1971 and 1976; Florida State University, Tallahassee, 1972 to the present; School of the Art Institute of Chicago, 1977
*Resides:* Tallahassee, Florida

## HAL FISCHER

*Born:* Kansas City, Missouri, 1950
*Studied:* University of Illinois, Urbana-Champaign, B.F.A., 1973; London Film School, 1973; Pennsylvania State University, University Park, 1974; San Francisco State University, M.A., 1976
*Taught:* San Jose State University, 1977; University of California Extension, San Francisco, 1978; California College of Arts and Crafts, Oakland, 1978–1980; City College of San Francisco, 1979 to the present; University of California, Berkeley, 1980
*Resides:* San Francisco

## ROBBERT FLICK

*Born:* Amersfoort, Holland, 1939
*Studied:* University of British Columbia, Vancouver, Canada, B.A., 1967; University of California, Los Angeles, M.A., 1970; M.F.A., 1971
*Taught:* University of California Extension, Los Angeles, 1970–1971; University of Illinois, Urbana-Champaign, 1971–1976; University of Southern California, Los Angeles, 1976 to the present
*Resides:* Inglewood, California

## VIDA FREEMAN

*Born:* Los Angeles, 1934
*Studied:* University of California, Los Angeles, 1955–1959; California State University, Northridge, B.A., 1971; M.A., 1975
*Taught:* California State University, Northridge, 1973 to the present; Los Angeles Valley College, Van Nuys, 1977 to the present
*Resides:* Northridge, California

## ANTHONY FRIEDKIN

*Born:* Los Angeles, 1949
*Studied:* Santa Monica College, California, 1968–1969; Art Center College of Design, Los Angeles (now in Pasadena), 1969–1970; University of California, Los Angeles, 1970–1971
*Taught:* University of California

Extension, Los Angeles, 1974–1977 and 1983; California Institute of the Arts, Valencia, 1975
*Resides:* Santa Monica, California

## JACK FULTON

*Born:* San Francisco, 1939
*Studied:* College of Marin, Kentfield, California, 1957–1958 and 1960–1961; San Francisco State College (now San Francisco State University), 1962–1963
*Taught:* San Francisco Art Institute, 1969 to the present
*Resides:* San Rafael, California

## PHILLIP GALGIANI

*Born:* San Francisco, 1951
*Studied:* University of California, Santa Cruz, 1969–1970; San Francisco Art Institute, B.F.A., 1973; M.F.A., 1977
*Taught:* San Francisco Art Institute, 1976–1978; City College of San Francisco, 1977; University of California Extension, Berkeley, 1977 to the present
*Resides:* San Francisco

## JIM GOLDBERG

*Born:* New Haven, Connecticut, 1953
*Studied:* Fairhaven College, Bellingham, Washington, B.A., 1975; San Francisco Art Institute, M.F.A., 1979
*Taught:* University of California Extension, Berkeley, 1980 to the present
*Resides:* San Francisco

## JUDITH GOLDEN

*Born:* Chicago, 1934
*Studied:* The School of the Art Institute of Chicago, B.F.A., 1973; University of California, Davis, M.F.A., 1975
*Taught:* University of California Extension, Los Angeles, 1975–1979; University of California, Los Angeles, 1975-1979; University of California, Davis, 1980; California College of Arts and Crafts, Oakland, 1980; University of Arizona, Tucson, 1981 to the present
*Resides:* Tucson, Arizona

## JOHN GUTMANN

*Born:* Breslau, Germany, 1905
*Studied:* State Academy of Arts and Crafts, Breslau, Germany, B.A., 1927; University of Breslau, Germany, 1926–1927; State Institute for Higher Education, Berlin, M.A., 1928; University of Berlin, 1929–1930; State Academy of Arts, Berlin, 1929–1930
*Taught:* San Francisco State College (now San Francisco State University), 1936–1942 and 1946– 1973
*Resides:* San Francisco

## ROBERT HEINECKEN

*Born:* Denver, 1931
*Studied:* Riverside College, California, A.A., 1951; University of California, Los Angeles, 1951–1953; B.A., 1959; M.A., 1960
*Taught:* University of California, Los Angeles, 1960 to the present; State University of New York, Buffalo, 1969; San Francisco Art Institute, 1970; School of the Art Institute of Chicago, 1970; Harvard University, Cambridge, Massachusetts, 1971; Columbia College, Chicago, 1983; Illinois Institute of Technology, Institute of Design, Chicago, 1983
*Resides:* Los Angeles and Chicago

## HARVEY HIMELFARB

*Born:* New York, 1941
*Studied:* San Francisco State College (now San Francisco State University), B.A., 1968; M.A., 1970
*Taught:* University of California, Berkeley, 1969–1970; San Francisco State College (now San Francisco State University), 1969–1970; Purdue University, Lafayette, Indiana, 1971; University of California, Davis, 1971 to the present
*Resides:* Davis, California

## PIRKLE JONES

*Born:* Shreveport, Louisiana, 1914
*Studied:* California School of Fine

Arts, San Francisco (now San Francisco Art Institute), 1946–1949
*Taught:* California School of Fine Arts, San Francisco (now San Francisco Art Institute), 1952–1958 and 1970 to the present
*Resides:* Mill Valley, California

## BARBARA KASTEN

*Born:* Chicago, 1936
*Studied:* University of Arizona, Tucson, B.F.A., 1959; California College of Arts and Crafts, Oakland, M.F.A., 1970
*Taught:* Orange Coast College, Costa Mesa, California, 1975 to the present
*Resides:* Los Angeles

## VICTOR LANDWEBER

*Born:* Washington, D.C., 1943
*Studied:* University of Iowa, Iowa City, B.A., 1966; University of California, Los Angeles, M.F.A., 1976
*Taught:* University of California Extension, Los Angeles, 1971–1973 and 1977 to the present; Orange Coast College, Costa Mesa, California, 1973–1976; Otis Art Institute, Los Angeles, 1981 to the present
*Resides:* Los Angeles

## GREGORY MacGREGOR

*Born:* La Crosse, Wisconsin, 1941
*Studied:* Wisconsin State University, Eau Claire, B.S., 1963; South Dakota School of Mines and Technology, Rapid City, M.S., 1964; San Francisco State University, M.A., 1971
*Taught:* Lone Mountain College, San Francisco, 1970–1978; California State University, Hayward, 1980 to the present
*Resides:* Oakland

## MIKE MANDEL

*Born:* Los Angeles, 1950
*Studied:* California State University, Northridge, B.A., 1972; San Francisco Art Institute, M.F.A., 1974

*Taught:* University of California Extension, San Francisco, 1976 and 1980; Hartnell College, Salinas, California, 1979 to the present; University of California, Santa Cruz, 1980–1981; University of California, Santa Barbara, 1981–1982
*Resides:* Santa Cruz, California

## KENNETH McGOWAN

*Born:* Ogden, Utah, 1940
*Studied:* University of California, Los Angeles, B.A., 1964; M.A., 1966
*Resides:* New York

## JERRY McMILLAN

*Born:* Oklahoma City, 1936
*Studied:* Chouinard Art Institute, Los Angeles, 1958–1960
*Taught:* California State University, Northridge, 1970 to the present; University of California Extension, Los Angeles, 1970 to the present; University of California, Los Angeles, 1971 and 1973; Art Center School of Design, Pasadena, California, 1976–1977
*Resides:* Pasadena, California

## ROGER MINICK

*Born:* Ramona, Oklahoma, 1944
*Studied:* University of California, Berkeley, B.A., 1969
*Taught:* ASUC (Associated Students of the University of California) Studio, Berkeley, 1964–1975; University of California Extension, Berkeley, 1969 and 1974–1975
*Resides:* Vallejo, California

## RICHARD MISRACH

*Born:* Los Angeles, 1949
*Studied:* University of California, Berkeley, B.A., 1971
*Taught:* ASUC (Associated Students of the University of California) Studio, Berkeley, 1972–1977; University of California Extension, Berkeley, 1977
*Resides:* Pinole, California

## PATRICK NAGATANI

*Born:* Chicago, 1945
*Studied:* California State University, Los Angeles, B.A., 1968; University of California, Los Angeles, M.F.A., 1980
*Taught:* West Los Angeles Community College, 1980–1981; University of California Extension, Los Angeles, 1980–1981; Loyola Marymount University, Los Angeles, 1980 to the present
*Resides:* Los Angeles

## ARTHUR OLLMAN

*Born:* Milwaukee, 1947
*Studied:* University of Wisconsin, Madison, B.A., 1969; Lone Mountain College, San Francisco, M.F.A., 1977
*Taught:* San Francisco Museum of Modern Art, 1975–1978; Chabot College, Hayward, California, 1977–1983
*Resides:* San Diego

## BILL OWENS

*Born:* San Jose, California, 1938
*Studied:* Chico State College, California, B.A., 1963
*Resides:* Livermore, California

## DONNA-LEE PHILLIPS

*Born:* Winthrop, Massachusetts, 1941
*Studied:* Cooper Union School of Art, New York, B.F.A., 1968; Pratt Institute, Brooklyn, M.F.A., 1972
*Taught:* California State University, Hayward, 1976; Sonoma State University, Rohnert Park, California, 1976–1977 and 1979–1981; University of California Extension, San Francisco, 1977–1978; California College of Arts and Crafts, Oakland, 1978; San Francisco Art Institute, 1978 and 1980; ASUC (Associated Students of the University of California) Studio, Berkeley, 1982
*Resides:* Bodega, California

## LELAND RICE

*Born:* Los Angeles, 1940
*Studied:* Arizona State University, Tempe, B.S., 1964; Chouinard Art Institute, Los Angeles, 1965; San Francisco State College (now San Francisco State University), M.A., 1969
*Taught:* California College of Arts and Crafts, Oakland, 1969–1973; University of California, Los Angeles, 1972, 1975, and 1982; California Institute of the Arts, Valencia, 1973; University of California Extension, Los Angeles, 1973 to the present; Pomona College, Claremont, California, 1973–1979; University of Southern California, Los Angeles, 1980–1981; University of Hartford, 1981
*Resides:* Inglewood, California

## LARRY SULTAN

*Born:* New York, 1946
*Studied:* University of California, Los Angeles, B.A., 1968; San Francisco Art Institute, M.F.A., 1973
*Taught:* School of Arts and Sciences, San Anselmo, California, 1972–1974; University of California Extension, Berkeley, 1973–1978; Lone Mountain College, San Francisco, 1974–1978; San Francisco Art Institute, 1978 to the present
*Resides:* Greenbrae, California

## EDMUND TESKE

*Born:* Chicago, 1911
*Taught:* Chouinard Art Institute, Los Angeles, 1962; University of California, Los Angeles, 1965–1970; California State University, Northridge, 1970; Immaculate Heart College, Los Angeles, 1974; California State University, Los Angeles, 1979
*Resides:* Los Angeles

## LEW THOMAS

*Born:* San Francisco, 1932
*Studied:* University of San Francisco, B.A., 1963; San Francisco State University, 1982
*Taught:* San Francisco Art Institute, 1977 and 1981; City College of San Francisco, 1982–1983; San Francisco State University, 1982–1983
*Resides:* San Francisco

## TODD WALKER

*Born:* Salt Lake City, 1917
*Studied:* Glendale Junior College, California, 1939–1940; Art Center School of Design, Los Angeles (now in Pasadena, California), 1939–1941
*Taught:* Art Center School of Design, Los Angeles (now in Pasadena), 1966–1970; University of California Extension, Los Angeles, 1969–1970; University of Florida, Gainesville, 1970–1977; University of Arizona, Tucson, 1977 to the present
*Resides:* Tucson, Arizona

## JACK WELPOTT

*Born:* Kansas City, Kansas, 1923
*Studied:* Indiana University, Bloomington, B.S., 1949; M.S., 1955; M.F.A., 1959
*Taught:* San Francisco State College (now San Francisco State University), 1959 to the present; University of California Extension, San Francisco, 1966–1969; California College of Arts and Crafts, Oakland, 1968–1970; University of Arizona, Tucson, 1977; Derby-Lonsdale College of Higher Education, Derby, England, 1981
*Resides:* San Francisco

## HENRY WESSEL, JR.

*Born:* Teaneck, New Jersey, 1942
*Studied:* Pennsylvania State University, University Park, B.A., 1966; State University of New York, Buffalo, in conjunction with the Visual Studies Workshop, Rochester, New York, M.F.A., 1972
*Taught:* Pennsylvania State University, University Park, 1967–1969; University of California Extension, Berkeley, 1973; San Francisco Art Institute, 1973 to the present; San Francisco State University, 1974; California College of Arts and Crafts, Oakland, 1975; University of California, Davis, 1976; College of Marin, Kentfield, California, 1977
*Resides:* Point Richmond, California

## MINOR WHITE

*Born:* Minneapolis, 1908
*Studied:* University of Minnesota, Minneapolis, B.S., 1933; Columbia University, New York, 1945–1946
*Taught:* California School of Fine Arts, San Francisco (now San Francisco Art Institute), 1946–1952; Rochester Institute of Technology, New York, 1956–1964; Massachusetts Institute of Technology, Cambridge, 1965–1976
*Died:* Boston, 1976

## DON WORTH

*Born:* Hayes County, Nebraska, 1924
*Studied:* University of Arizona, Tucson, 1945–1946; Juilliard School of Music, New York, 1946–1947; Manhattan School of Music, New York, B. Mus., 1949; M. Mus., 1951
*Taught:* San Francisco State College (now San Francisco State University), 1960 to the present
*Resides:* Mill Valley, California

## MAX YAVNO

*Born:* New York, 1911
*Studied:* City College of New York, B.S., 1932; Columbia University, New York, 1932–1933; University of California, Los Angeles, 1972–1973
*Resides:* Los Angeles

# SELECTED BIBLIOGRAPHY

Bibliographic entries are divided into three sections: books, articles, and exhibition catalogs. This bibliography by no means attempts to be exhaustive; the amount of material available on the subject of photography is overwhelming. Most entries refer specifically to photography in California, artists in the exhibition, and to sources that were particularly useful in researching the period from 1945 to 1980.

## BOOKS

Baltz, Lewis. *The New Industrial Parks near Irvine, California.* New York: Castelli Graphics, 1974.

Blaisdell, Gus. *Park City, Photographs by Lewis Baltz.* Albuquerque, N.M., and New York: Artspace and Castelli Graphics, 1980.

Blue Sky Gallery. *Some Twenty Odd Visions.* Portland: Oregon Center for the Photographic Arts, 1978.

Bullock, Barbara. *Wynn Bullock.* San Francisco: Scrimshaw Press, 1971.

Bullock-Wilson, Barbara. *Wynn Bullock, Photography: A Way of Life.* Dobbs Ferry, N.Y.: Morgan & Morgan, Inc., 1973.

Cahn, Robert, and Ketchum, Robert Glenn. *American Photographers and the National Parks.* New York: The Viking Press, 1981.

Coke, Van Deren. *The Painter and the Photograph: From Delacroix to Warhol.* Rev. ed., Albuquerque: University of New Mexico Press, 1972.

———, et al. *Oliver Gagliani.* Menlo Park, Ca.: Ideograph Publications, 1975.

Coleman, A.D. *Light Readings: A Photography Critic's Writings 1968–1978.* New York: Oxford University Press, 1979.

Connor, Linda. *Solos.* Millerton, N.Y.: Apeiron Workshops, 1979.

Danese, Renato, ed. *American Images: New Work by Twenty Contemporary Photographers.* New York: McGraw-Hill, 1979.

Dater, Judy. *Imogen Cunningham: A Portrait.* Boston: New York Graphic Society, 1979.

Eauclaire, Sally. *The New Color Photography.* New York: Abbeville Press, Inc., 1981.

Enyeart, James, et al. *Heinecken.* Carmel, Ca.: The Friends of Photography, 1980.

Featherstone, David. *Untitled 19: Vilem Kriz: Photographs.* Carmel, Ca.: The Friends of Photography, 1979.

Fischer, Hal. *Gay Semiotics.* San Francisco: NFS Press, 1977.

———. *18th Near Castro Street × 24.* San Francisco: NFS Press, 1979.

Frank, Robert. *The Americans.* New York: Grove, 1959. Rev. eds., Millerton, N.Y.: Aperture, 1969, 1978.

Gassan, Arnold. *A Chronology of Photography: A Critical Survey of the History of Photography as a Medium of Art.* Athens, Oh.: Arnold Gassan Handbook Company, 1972.

Hall, James Baker. *Minor White: Rites & Passages.* Millerton, N.Y.: Aperture, 1978.

Landweber, Victor, ed. *New California Views.* Los Angeles: Self-published, 1979.

Lyons, Nathan, ed. *Photographers on Photography.* Englewood Cliffs, N.J.: Prentice-Hall and Rochester, N.Y.: George Eastman House, 1966.

MacGregor, Gregory. *Explosions: A Self-Help Book for the Handyman.* San Francisco: Headlands Press, 1983.

Maddow, Ben. *Max Yavno.* Berkeley, Ca.: University of California Press, 1980.

Mandel, Mike. *Myself: Timed Exposures.* Los Angeles: Self-published, 1971.

Mandel, Mike, and Sultan, Larry. *How to Read Music in One Evening.* Santa Cruz, Ca.: Self-published, 1974.

———. *Evidence.* Santa Cruz, Ca.: Self-published, 1977.

Mangan, Terry W., et al. *San Francisco Bay Area Photography 1976.* San Francisco: San Francisco Museum of Modern Art, 1977.

Minick, Roger. *Delta West: The Land and People of the Sacramento–San Joaquin River Delta.* San Francisco: Scrimshaw Press, 1969.

_____. *Hills of Home: The Rural Ozarks of Arkansas.* San Francisco: Scrimshaw Press, 1975. Paperback ed., New York: Ballantine Books, 1976.

Misrach, Richard. *Telegraph 3 A.M.* Berkeley: Cornucopia Press, 1974.

_____. *(a photographic book).* San Francisco: Grapestake Gallery, 1979.

Newhall, Beaumont. *The History of Photography from 1839 to the Present.* 5th rev. ed., New York: The Museum of Modern Art, 1982.

Owens, Bill. *Suburbia.* San Francisco: Straight Arrow Books, 1973.

_____. *Working: I Do It for the Money.* New York: Simon & Schuster, 1977.

Petruck, Peninah R. *The Camera Viewed: Writings on Twentieth-Century Photography.* 2 vols. New York: E.P. Dutton, 1979.

Phillips, Donna-Lee, ed. *Eros & Photography.* San Francisco: Camerawork/NFS Press, 1977.

Plagens, Peter. *Sunshine Muse.* New York: Praeger Publishers, 1974.

Smith, Henry Holmes, and Welpott, Jack. *Women and Other Visions: Photographs by Judy Dater and Jack Welpott.* Dobbs Ferry, N.Y.: Morgan & Morgan, 1975.

Sontag, Susan. *On Photography.* New York: Farrar, Straus and Giroux, 1977.

Thomas, Lew, ed. *Photography and Language.* San Francisco: Camerawork Press, 1976.

_____. *Structural(ism) and Photography.* San Francisco: NFS Press, 1978.

Tucker, Anne, ed. *The Woman's Eye.* New York: Knopf, 1973.

Upton, John. *Photography.* Boston: Little, Brown and Co., 1970.

Wise, Kelly, ed. *The Photographer's Choice.* Danbury, N.H.: Addison House, 1975.

Witkin, Lee D., and London, Barbara. *The Photograph Collector's Guide.* Boston: New York Graphic Society, 1979.

## ARTICLES

"A Collection of Photographs from San Francisco State College." *San Francisco Camera,* no. 1 (January 1969), n.p.

Aikin, Roger. "Brett Weston and Edward Weston: An Essay in Photographic Style." *Art Journal,* Summer 1973, pp. 394–404.

Albuquerque, Lita. "American Photographers '76." *Exhibitions '76 '77,* 1976–77, n.p.

Asbury, Dana. "Linda Connor: Solos and Landscapes." *Afterimage,* no. 7 (December 1979), pp. 5–7.

Atkins, Robert. "Trends, Traditions and Dirt: The Current State of Art in Northern California." *Journal: A Contemporary Art Magazine,* Winter 1981, pp. 29–33, 36.

Badger, Gerry. "Californian Colour." *Creative Camera,* no. 202 (October 1981), pp. 246–47.

Baltz, Lewis. "A Portfolio." *On Change & Exchange, Untitled 7/8,* Carmel, Ca.: The Friends of Photography, 1974, pp. 14–19.

Belz, Carl I. "The Photography of Robert Heinecken." *Camera,* no. 1 (January 1968), pp. 6 and 13.

Borger, Irene. "Relations: Some Work by Robert Heinecken." *Exposure,* no. 17 (Summer 1979), pp. 36–45.

_____. "Stopping the World: Photographs as Myth." *Exposure,* no. 17 (Fall 1979), pp. 22–33.

_____. "Bob Heinecken: Outside on the Inside." *L.A. Weekly,* July 17–23, 1981, pp. 10–11.

Borton, James. "Teacher/Artist Jack Welpott." *City Arts Monthly,* July 1980, p. 37.

Bunnell, Peter C. "Photographs as Sculpture and Prints." *Art in America,* September/October 1969, pp. 56–57 and 60–61.

_____. "Photography into Sculpture." *Artscanada,* no. 144/145 (June 1970), pp. 21–29.

_____. "The Current Acceptance of Photography." *American Federation of Arts Newsletter,* October 1981, pp. 2, 6–7.

Camhi, Morrie. "Q & A: Ruth Bernhard." *Photoshow Magazine,* no. 2 (1980), n.p.

Coke, Van Deren. "Creative Photography 1956." *Aperture,* no. 4 (1956), pp. 4–29.

Fahey, David. "Jo Ann Callis: Between Eroticism and Morbidity." *Journal: Southern California Arts Magazine,* September/October 1979, pp. 33–37.

_____. "Richard Misrach." *Photo Bulletin,* no. 2 (July 1979), n.p.

Ferrer, Elizabeth. "Ohio Silver Rides Again." *Journal from the Los Angeles Center for Photographic Studies,* no. 2 (June 1975), pp. 6–7.

Finkel, Candida. "Photography as Modern Art: The Influence of Nathan Lyons and John Szarkowski on the Public's Acceptance of Photography as a Fine Art." *Exposure,* no. 18 (1981), pp. 22–37.

Fischer, Hal. "An Interview with Michael Bishop." *La Mamelle Magazine, Art Contemporary*, no. 2 (Summer 1976), pp. 48–49 and 73.

———. "South of Market Comes Alive." *Afterimage*, no. 4 (November 1976), pp. 18–19.

———. "Approaches to Photography: San Francisco Bay Area." *La Mamelle Magazine, Art Contemporary*, no. 2 (1977), pp. 17–25.

———. "Mike Mandel & Larry Sultan in Conversation with Hal Fischer." *La Mamelle Magazine, Art Contemporary*, no. 2 (February 1977), pp. 32–34 and 55.

———. "Contemporary California Photography: The West Is . . . Well, Different." *Afterimage*, no. 6 (November 1978), pp. 4–6.

———. "'Attitudes': Surveying the '70s." *Afterimage*, no. 7 (October 1979), pp. 10–12.

———. "Northern California Photography." *Picture Magazine*, no. 11 (1979), n.p.

———. "Curatorial Constructions." *Afterimage*, no. 7 (March 1980), pp. 7–9.

———. "California Photography: The Tradition beyond Modernism." *Studio International*, no. 195 (June 1982), pp. 6–9.

"5 Photographers, 5 Ways to the Photograph." *San Francisco Camera*, no. 1 (1972), n.p.

Garver, Thomas H. "Balboa and the Fun Zone." *Art in America*, September 1971, pp. 58–67.

Green, Jonathan. "'Aperture' in the '50s: The Word and the Way." *Afterimage*, no. 6 (March 1979), pp. 8–13.

Hagen, Charles. "Robert Heinecken: An Interview." *Afterimage*, no. 3 (April 1976), pp. 9–12.

Heinecken, Robert F. "I Am Involved in Learning to Perceive and Use Light." *On Change & Exchange, Untitled 7/8*, Carmel, Ca.: The Friends of Photography, 1974, pp. 44–46.

Herz, Nat. "Wynn Bullock: A Critical Appreciation." *Infinity*, November 1961, pp. 4–10.

Heyman, Therese Thau. "Looking at Lange Today." *Exposure*, no. 16 (Summer 1978), pp. 26–33.

Hugunin, James. "Joe Deal's Optical Democracy." *Afterimage*, no. 6 (February 1979), pp. 4–6.

———. "California Cut-ups." *Afterimage*, no. 7 (October 1979), p. 17.

———. "Mainstream Results." *Afterimage*, no. 8 (May 1981), p. 7.

———. "Photography: A Bourgeois Success Story." *Journal: A Contemporary Art Magazine*, no. 3 (September/October 1981), pp. 42–48.

"Imogen Cunningham." *Aperture*, no. 11 (1964), entire issue.

Johnstone, Mark. "John Divola: Facts of the Imagination." *Exposure*, no. 19 (1981), pp. 38–45.

———. "Unfinished Business." *Afterimage*, no. 8 (February 1981), pp. 13–18.

Kasten, Barbara. "The Altered Photograph." *Exhibitions '76'77*, 1976–77, n.p.

Kelley, Ron. "Alternative Intentions: An Interview with Sheila Pinkel." *Afterimage*, no. 8 (May 1981), pp. 5–6.

Kelly, Charles. "Todd Walker: An Interview." *Afterimage*, vol. 2, no. 1 (March 1974), pp. 2–6.

Kozloff, Max. "Photography: The Coming of Age of Color." *Artforum*, January 1975, pp. 30–35.

Lange, Dorothea, and Jones, Pirkle. "Death of a Valley." *Aperture*, no. 8 (1960), entire issue.

Latour, Ira. "West Coast Photography: Does It Really Exist?" *Photography*, no. 12 (June 1957), pp. 26–44 and 62.

Leighten, Patricia. "Critical Attitudes toward Overtly Manipulated Photography in the Twentieth Century." *Art Journal*, no. 37 (Summer 1978), pp. 313–321.

Levinson, Joel D. "Scene: Los Angeles." *Latent Image*, no. 1 (1978), pp. 57–63.

Mann, Margery, and Ehrlich, Sam. "The Exhibition of Photographs: Northern California." *Aperture*, no. 13 (1968), pp. 10–17.

McCloy, Marjorie. "Artful Perspectives: An Interview with Van Deren Coke." *Darkroom*, 1982, pp. 40–44 and 53–54.

"Minor White." *Camera*, no. 1 (January 1972), pp. 14–23.

Morgan, Robert C. "You Can't Tell a Book by Its Cover (But You Can Locate a Book by Its Spine): A Perspective on the Recent Photographic Work of Lew Thomas." *The Los Angeles Institute of Contemporary Art Journal*, no. 28 (September 1980), pp. 49–55.

Mozessen, Phiz. "The Bay Area Photographers." *Aperture*, no. 4 (1956), pp. 74–75.

North, Kenda. "Darryl Curran: Investigating the Photographic Image." *Artweek*, no. 31 (May 15, 1982), pp. 1 and 16.

Park, Edward. "The Eye of Bill Garnett Looks down on the Commonplace and Sees Art." *Smithsonian*, no. 8 (May 1977), pp. 75–81.

Parker, Fred R. "Creativity Is Contagious: A Second Look at the Creative Experience Workshop." *Untitled 2 & 3*, Carmel, Ca.: The Friends of Photography, 1972–73, pp. 48–65.

Perrone, Jeff. "'Women of Photography': History and Taste." *Artforum*, March 1976, pp. 31–35.

Porter, Allan. "A Concise Chronology of Instant Photography: 1947–74." *Camera*, no. 10 (October 1974), pp. 1–2 and 52–53.

Portner, Dinah. "An Interview with Robert Heinecken." *Journal: A Contemporary Art Magazine*, no. 3 (September/October 1981), pp. 49–55.

Rice, Leland. "Los Angeles Photography: c. 1940–60." *The Los Angeles Institute of Contemporary Art Journal*, no. 5 (April/May 1975), pp. 28–36.

Squiers, Carol. "Color Photography: The Walker Evans Legacy and the Commercial Tradition." *Artforum*, November 1978, pp. 64–67.

Starenko, Michael. "Art School Photography: The California Connection." *New Art Examiner*, December 1981, p. 11.

Szarkowski, John. "Ten Photographers Tell Their Story." *Art in America*, March 1970, pp. 66–69.

Thomas, Lew. "Photography and Ideology: Theory, Review, and Correspondence." *La Mamelle Magazine, Art Contemporary*, no. 2 (1977), pp. 44–46.

Thomas, Robert. "Photography into Sculpture." *Art and Artists*, March 1971, pp. 26–28.

Thompson, Dody. "West Coast 50's." *Exposure*, no. 18 (1981), pp. 6–14.

Thornton, Gene. "Photography's Shootout at the O.K. Corral." *Art News*, December 1978, pp. 76–78.

Warren, Dody. "Perceptions: A Photographic Showing from San Francisco." *Aperture*, no. 2 (1954), pp. 11–34.

Weiss, Margaret R., and Mayer, Grace M. "Assignment 1969: Shirley C. Burden, California." *Camera*, no. 2 (February 1969), pp. 4 and 11.

Welpott, Jack. "East Is East, and West?" *Untitled 14*, Carmel, Ca.: The Friends of Photography, 1978, pp. 11–13.

White, Minor, et al. "5 Reviews of 'Under the Sun.'" *Aperture*, no. 8 (1960), pp. 195–207.

Wiseman, Diane. "Interview: Imogen Cunningham and Judy Dater." *Camera*, no. 10 (October 1975), pp. 40–44.

"Wynn Bullock." *Camera*, no. 1 (January 1972), pp. 24–33.

Ziony, Ruth Kramer. "The Dark Rooms of Edmund Teske: Portrait of a Photographer." *Reader*, no. 3 (October 24, 1980), pp. 1, 4–5, and 13.

## EXHIBITION CATALOGS

Ackley, Clifford S. *Private Realities: Recent American Photography*. Boston: Museum of Fine Arts, 1974.

Alinder, James. *Untitled 18: Cumming Photographs*. Carmel, Ca.: The Friends of Photography, 1979.

*All California Photography Show*. Laguna Beach, Ca.: Laguna Beach Museum of Art, 1976.

*Altered Landscapes*. Palatka, Fl.: Fine Arts Gallery, Florida School of the Arts, 1979.

*American Photography: The Sixties*. Lincoln: University of Nebraska, Sheldon Memorial Art Gallery, 1966.

*As I Saw It: Photographs by John Gutmann*. San Francisco: San Francisco Museum of Modern Art, 1976.

Baird, Joseph A., Jr., et al. *Images of El Dorado: A History of California Photography: 1850–1975*. Davis: Memorial Union Art Gallery, University of California, Davis, 1975.

*Bent Photography, West Coast, USA*. Sydney, Australia: The Australian Centre for Photography, 1977.

Bohn, Dave, and Adams, Ansel. *Studio 1968*. Carmel, Ca.: Carmel Photography Gallery, 1968.

Castellón, Rolando, and Katzman, Louise. *Photographic Works: Wanda Hammerbeck, Lawrie Brown*. San Francisco: San Francisco Museum of Modern Art, 1978.

Coke, Van Deren. *Young Photographers*. Albuquerque: University Art Museum, University of New Mexico, 1968.

_____. *Fabricated to Be Photographed*. San Francisco: San Francisco Museum of Modern Art, 1979.

_____. *Jack Fulton's Puns & Diagrammatic Photographs*. San Francisco: San Francisco Museum of Modern Art, 1979.

_____. *1980 SECA Photography Invitational*. San Francisco: San Francisco Museum of Modern Art, 1980.

_____. *Photographs by Will Connell: California Photographer and Teacher (1898–1961)*. San Francisco: San Francisco Museum of Modern Art, 1981.

*Color: A Spectrum of Recent Photography*. Milwaukee: Milwaukee Art Center, 1979.

*Color Transformations: Photographs by Jo Ann Callis and John Divola*. Berkeley: University Art Museum, University of California, Berkeley, 1979.

*Continuum*. Downey, Ca.: Downey Museum of Art, 1970.

*The Crowded Vacancy: Three Los Angeles Photographers.* Davis: Memorial Union Art Gallery, University of California, Davis, 1971.

Curran, Darryl. *Graphic/Photographic.* Fullerton: California State College, 1971.

_____. *24 from L.A.* San Francisco: San Francisco Museum of Art, 1973.

_____, et al. *Untitled 11: Emerging Los Angeles Photographers.* Carmel, Ca.: The Friends of Photography, 1977.

de Gooyer, Kirk. *The Photographic Process.* Riverside: The Art Gallery, University of California, Riverside, 1974.

Desmarais, Charles, and Hagen, Charles. *Michael Bishop.* Chicago: Chicago Center for Contemporary Photography, Columbia College, 1979.

*Edmund Teske.* Barnsdall Park, Ca.: Los Angeles Municipal Art Gallery, 1974.

English, Christopher. *The Invented Landscape.* New York: The New Museum, 1979.

Fall, Frieda Kay, et al. *Beyond the Artist's Hand: Explorations of Change.* Long Beach, Ca.: California State University, 1976.

Featherstone, David. *Untitled 13: Plants: Photographs by Don Worth.* Carmel, Ca.: The Friends of Photography, 1977.

Forth, Robert. *Young Photographers '68.* Lafayette, Ind.: Purdue University, 1968.

_____. *Visual Dialogue Foundation.* Oakland, Ca.: Center of the Visual Arts, 1969.

Frank, Peter. *Hang 8: Artists from Southern California.* New York: Foundations Gallery, 1982.

Frankel, Dextra. *Object Illusion Reality.* Fullerton, Ca.: Art Gallery, California State University, Fullerton, 1979.

Garver, Thomas. *12 American Photographers and the Social Landscape.* Waltham, Mass.: Brandeis University Museum, 1966.

_____. *New Photography: San Francisco and the Bay Area.* San Francisco: M. H. de Young Memorial Museum, 1974.

Gauss, Kathleen McCarthy. *Studio Work: Photographs by Ten Los Angeles Artists.* Los Angeles: Los Angeles County Museum of Art, 1982.

Gee, Helen. *Photography of the Fifties: An American Perspective.* Tucson: Center for Creative Photography, University of Arizona, Tucson, pp. 1–21.

Glenn, Constance W., ed. *Long Beach: A Photography Survey.* Long Beach, Ca.: The Art Museum and Galleries, California State University, Long Beach, 1980.

_____. *Centric 2: Barbara Kasten: Installation/Photographs.* Long Beach, Ca.: The Art Museum and Galleries, California State University, Long Beach, 1982.

Goldberg, Aron. *Untitled 22: Images from Within: The Photographs of Edmund Teske.* Carmel, Ca.: The Friends of Photography, 1980.

Heinecken, Robert. *Contemporary Photographs.* Los Angeles: UCLA Art Galleries, 1968.

Hermann, Arthur. *Twenty Years of Imagery: Harvey Himelfarb.* Davis, Ca.: Memorial Union Art Gallery, University of California, Davis, 1980.

Heyman, Therese, and Hedgpeth, Ted. *Slices of Time: California Landscapes 1860–1880, 1960–1980.* Oakland, Ca.: The Oakland Museum, 1981.

Himelfarb, Harvey, and Clisby, Roger D. *Forty American Photographers.* Sacramento, Ca.: E. B. Crocker Art Gallery, 1978.

_____. *Large Spaces in Small Places: A Survey of Western Landscape Photography: 1850–1980.* Sacramento, Ca.: Crocker Art Museum, 1980.

Hugunin, James. *California Colour.* London: The Photographers' Gallery, 1981.

_____. *Jerry McMillan: Recent Work.* Pasadena, Ca.: Baxter Art Gallery, California Institute of Technology, 1981.

Humphrey, John. *Photographs from the Permanent Collection.* San Francisco: San Francisco Museum of Modern Art, 1978.

Jenkins, William. *The Extended Document: An Investigation of Information and Evidence in Photographs.* Rochester, N.Y.: International Museum of Photography at George Eastman House, 1975.

_____. *New Topographics: Photographs of a Man-altered Landscape.* Rochester, N.Y.: International Museum of Photography at George Eastman House, 1975.

Johnson, Deborah J., ed. *California Photography.* Providence: Museum of Art, Rhode Island School of Design, 1982.

Johnson, William S., and Cohen, Susan E. *The Photographs of Todd Walker.* Tucson: Museum of Art, University of Arizona, Tucson, 1979.

Johnstone, Mark. *Untitled 24: New Landscapes.* Carmel, Ca.: The Friends of Photography, 1981.

_____. *Robbert Flick: Selected Works 1971–1981.* Los Angeles: Los Angeles Municipal Art Gallery, 1982.

Jones, Harold, et al. *Contemporary California Photography.* San Francisco: Camerawork Press, 1978.

Katzman, Louise. *Beyond Color*. San Francisco: San Francisco Museum of Modern Art, 1979.

_____. *Jim Dong, Jim Goldberg, Chris Huie, Kate Kline May, Danuta Otfinowski: Photographs*. San Francisco: San Francisco Museum of Modern Art, 1979.

_____. *Photo/Trans/Forms by Judith Golden and Joanne Leonard*. San Francisco: San Francisco Museum of Modern Art, 1981.

Ketchum, Robert Coleman. *Photographic Directions: Los Angeles, 1979*. Los Angeles: Security Pacific Bank, 1979.

Lagoria, Georgianna. *Contemporary Hand Colored Photographs*. Santa Clara, Ca.: De Saisset Museum, University of Santa Clara, 1981.

Leavitt, Thomas W. *The Photograph as Poetry: An Invitational Exhibit of Nine West Coast Photographers*. Pasadena, Ca.: Pasadena Art Museum, 1960.

Lewis, Stephen. *Darryl Curran Photographs 1967–1981*. Alto Loma, Ca.: Rex W. Wignall Museum Gallery, Chaffey Community College, 1982.

Lifson, Ben. *Henry Wessel, Jr.* El Cajon, Ca.: Grossmont College Art Gallery, 1976.

*Light and Substance*. Albuquerque: University Art Museum, University of New Mexico, 1974.

Litschel, David, et al. *Fugitive Color*. Ann Arbor: Slusser Gallery, School of Art, The University of Michigan, Ann Arbor, 1982.

Livingston, Jane. *Linda Connor*. Washington, D.C.: The Corcoran Gallery of Art, 1982.

Lyons, Nathan. *Photography 63*. Rochester, N.Y.: George Eastman House, 1963.

_____. *Contemporary Photographers: Toward a Social Landscape*. Rochester, N.Y.: George Eastman House, 1966.

_____, ed. *Photography in the Twentieth Century*. New York: Horizon, and Rochester, N.Y.: George Eastman House, 1967.

_____, ed. *The Persistence of Vision*. Rochester, N.Y.: George Eastman House, 1967.

Mann, Margery, and Noggle, Anne. *Women of Photography: An Historical Survey*. San Francisco: San Francisco Museum of Modern Art, 1975.

Martinson, Dorothy. *Individual Visions: Harvey Himelfarb, Diana Schoenfeld, Jacqueline Thurston*. San Francisco: San Francisco Museum of Modern Art, 1980.

Mautner, Robert. *Exposing: Photographic Definitions*. Los Angeles: The Los Angeles Institute of Contemporary Art, 1976.

McDonald, Robert, and Lorenz, Richard. *Landscape Images: Recent Photographs by Linda Connor, Judy Fiskin and Ruth Thorne-Thomsen*. La Jolla, Ca.: La Jolla Museum of Contemporary Art, 1980.

Millard, Charles W. *The Photography of Leland Rice*. Washington, D.C.: Hirshhorn Museum and Sculpture Garden, Smithsonian Institution, 1976.

Muchnic, Suzanne, and Rice, Leland. *Southern California Photography 1900–65: An Historical Survey*. Los Angeles: The Photography Museum, 1980.

*Multicultural Focus: A Photography Exhibition for the Los Angeles Bicentennial*. Barnsdall Park, Ca.: Los Angeles Municipal Art Gallery, 1981.

Newhall, Beaumont. *Photography at Mid-Century*. Rochester, N.Y.: George Eastman House, 1959.

Nordland, Gerald, and Heinecken, Robert. *Catalog of the UCLA Collection of Contemporary American Photographs*. Los Angeles: Frederick S. Wight Art Gallery, University of California, Los Angeles, 1976.

Parker, Fred. *California Photographers 1970*. Davis: Memorial Union Art Gallery, University of California, Davis, 1970.

_____. *Robert Heinecken: Photographic Work*. Pasadena, Ca.: Pasadena Art Museum, 1972.

_____. *Attitudes: Photography in the 1970s*. Santa Barbara, Ca.: Santa Barbara Museum of Art, 1979.

_____. *Sequence Photography*. Santa Barbara, Ca.: Santa Barbara Museum of Art, 1980.

_____. *Contemporary Photography as Phantasy*. Santa Barbara: Santa Barbara Museum of Art, 1982.

*The Photographer and the American Landscape*. New York: The Museum of Modern Art, 1963.

*Photographic Imagery/1968*. San Diego, Ca.: San Diego State College, 1968.

*Photography '64: An Invitational Exhibition*. Rochester, N.Y.: George Eastman House, 1964.

Rechtin, Dorothy. *The End of the Red Car Line, Photographs of Long Beach: 1890–1980*. Long Beach: The Art Museum and Galleries, California State University, Long Beach, 1980.

Rice, Leland. *LA×Six*. Los Angeles: Mount St. Mary's College Art Gallery, 1976.

Riss, Murray. *Photography Invitational 1971*. Little Rock: Arkansas Arts Center, 1971.

Sheldon, James. *Photography: Recent Directions*. Lincoln, Mass.: DeCordova Museum, 1980.

Smith, Henry Holmes. *Photographer's Choice*. Bloomington, Ind.: Indiana University, 1959.

_____. *Meridian/122*. Davis, Ca.: Meridian/122 with Phos-Graphos, 1972.

Sobieszek, Robert A. *Color as Form: A History of Color Photography*. Rochester, N.Y.: George Eastman House, 1982.

Steichen, Edward, ed. *The Family of Man*. New York: The Museum of Modern Art, 1955.

Stuart, Rodney C., and Smith, Henry Holmes. *Jack Welpott: The Artist as Teacher, The Teacher as Artist, Photographs 1950–75*. San Francisco: San Francisco Museum of Modern Art, 1975.

Szarkowski, John. *The Photographer's Eye*. New York: The Museum of Modern Art, 1966.

_____. *New Images in Photography: Object and Illusion*. Miami: Lowe Art Museum, University of Miami, 1974.

_____. *Mirrors and Windows: American Photography since 1960*. New York: The Museum of Modern Art, 1978.

_____. *American Landscapes*. New York: The Museum of Modern Art, 1981.

*Three Photographers: Darryl Curran, Robert F. Heinecken, Bart Parker*. Northridge, Ca.: Fine Arts Gallery, San Fernando Valley State College, 1970.

*Three Photographers: Wynn Bullock, Edmund Teske, Frederick Sommer*. Northridge, Ca.: Fine Arts Gallery, San Fernando Valley State College, 1967.

*Translations: Photographic Images with New Forms*. Ithaca, N.Y.: Herbert F. Johnson Museum of Art, Cornell University, 1979.

Tsujimoto, Karen. *Jerry Burchard, Ingeborg Gerdes, John Spence Weir: Photographic Viewpoints*. San Francisco: San Francisco Museum of Modern Art, 1979.

_____. *Images of America: Precisionist Painting and Modern Photography*. Seattle: University of Washington Press, 1982.

Upton, John. *Minor White, Robert Heinecken, Robert Cumming*. Long Beach: Fine Arts Gallery, California State University, Long Beach, 1973.

_____. *The Photograph as Artifice*. Long Beach: The Art Galleries, California State University, Long Beach, 1978.

_____, and Hugunin, James. *Spectrum: New Directions in Color Photography*. Honolulu: University of Hawaii Art Gallery, 1979.

*The Visual Dialogue Foundation*. Carmel, Ca.: The Friends of Photography, 1972.

Walker, Frederick P. *Photography U.S.A.* Lincoln, Mass.: De Cordova Museum, 1968.

Welpott, Jack. *The Visual Dialogue Foundation at the Friends of Photography Gallery*. Davis, Ca.: Visual Dialogue Foundation, 1971.

_____, and Worth, Don. *Don Worth: Photographs 1956–1972*. San Francisco: San Francisco Museum of Art, 1973.

*West Coast Conceptual Photographers*. San Francisco: La Mamelle, Inc., 1976.

Westover, Marla Katz. *Interior Spaces*. Davis, Ca.: Memorial Union Art Gallery, University of California, Davis, 1978.

White, Minor, ed. *Light⁷: Photographs from an Exhibition on a Theme*. Cambridge, Mass.: Massachusetts Institute of Technology for *Aperture*, 1968.

Wickstrom, Richard. *Leland Rice: Photography 1968–1980*. Las Cruces, N.M.: University Art Gallery, New Mexico State University, 1980.

Winesuff, Rosalie. *Dimensional Light*. Fullerton: Art Gallery, California State University, Fullerton, 1975.

Wortz, Melinda. *Interchange*. Los Angeles: Fine Arts Gallery, Mount St. Mary's College, 1978.

James Bernstein
*Codirector, Conservation*

Debra Briehof
*Library Assistant and
Slide Librarian*

Bruce Brodie
*Assistant Gallery
Superintendent*

Tyrone Brue
*Admissions*

Beverly Buhnerkempe
*Senior Assistant Controller*

Eugenie Candau
*Librarian*

Hilda Cardenas
*Admissions*

Patti Carroll
*Curatorial Assistant,
Department of Photography*

Jeanne Collins
*Director of
Public Relations*

Lily deGroot
*Admissions*

Robert Dix
*Gallery Technician*

Vera Anne Doherty
*Receptionist*

Diana duPont
*Research Assistant II*

Robert Dziedzic
*Bookshop Assistant*

Inge-Lise Eckmann
*Codirector, Conservation*

Miriam Grunfeld
*Assistant Education
Supervisor*

Julianna Haile-Jones
*Data Processing
Coordinator*

Susan Harrington
*Bookshop Assistant*

Paul Hasegawa-Overacker
*Matting*

Katherine Church Holland
*Research/Collections and
Registration Director*

Regina Jepson
*Bookshop Assistant*

Toby Kahn
*Bookshop Manager*

Claudia Kocmieroski
*Bookshop Assistant*

Jay Krueger
*Conservator*

Debra Lande
*Assistant Manager,
Bookshop*

Susan Lefkowich
*Membership Coordinator*

Lynn Linato
*Admissions*

Pauline Mohr
*Conservator*

Sharon Moore
*Administrative Secretary,
Conservation*

Kytti Morgan
*Public Relations Assistant*

Christine Mueller
*Mail and Supplies
Coordinator*

Garna Muller
*Research/Collections,
Associate Director*

Anne Munroe
*Curatorial Assistant*

Debra Neese
*Associate Registrar*

Nancy O'Brien
*Account Clerk*

Anthony O'Malley
*Membership Assistant*

Matrisha One Person
*Bookshop Assistant*

Pamela Pack
*Assistant Registrar II*

Claudia Beth Pooley
*Modern Art Council Manager*

Richard Putz
*Gallery Technician*

Marcy Reed
*Secretary,
Research/Collections*

Kent Roberts
*Gallery Technician*

Thorton Rockwell
*Conservator*

James Scarborough
*Administrative Assistant*

Janice Schwartz
*Assistant Controller I*

Myra Shapiro
*Volunteer Coordinator*

Joseph Shield
*Gallery Attendant*

Carol Stanton
*Bookshop Assistant*

Laura Sueoka
*Research Assistant II*

Beau Takahara
*Interpretive Programs
Assistant*

Jan Thoren
*Receptionist*

Ferd Von Schlafke
*Preparator*

Julius Wasserstein
*Gallery Superintendent*

Robert A. Whyte
*Director of Education*

James Wright
*Conservator*

# INDEX

*Page numbers in italics refer to illustrations.*

All photography was done by Joe
Schopplein except the photographs on
the following pages:
Ben Blackwell: 23,47,48,51,55,84,
    88,93
Darryl Curran: 83,85,89,92
Janice Felgar: 61
Phillip Galgiani: 158 top, 159
Grapestake Gallery, San Francisco: 125
Harvey Himelfarb: 49, 100
Richard Lorenz: 98
Richard Muttley: 17, 145–47
Larry Sultan: 162–65